Blues People

Negro Music in White America

LeRoi Jones
(Amiri Baraka)

QUILL
William Morrow
New York

It is the policy of William Morrow and Company, Inc., and its imprints and affiliates, recognizing the importance of preserving what has been written, to print the books we publish on acid-free paper, and we exert our best efforts to that end.

Library of Congress Cataloging-in-Publication Data

Baraka, Imamu Amiri, 1934–
 Blues people : Negro music in white America / LeRoi Jones.
 p. cm.
 Includes bibliographical references and index.
 ISBN 0-688-18474-X (alk. paper)
 1. Afro-Americans—Music—History and criticism. 2. Blues
(Music)—History and criticism. 3. Jazz—History and criticism.
4. Afro-Americans. I. Title.
 ML3556.B16 1999
 780'.89'96073—dc21 98-49663
 CIP
 MN

Printed in the United States of America

First Quill Edition

 26 27 28 29 30

www.williammorrow.com

To My Parents . . .

the first Negroes I ever met

Contents

Blues People: *Looking Both Ways*

Blues People has always meant a great deal to me. It was a dramatic self-confirmation, as a personal intellectual and artistic "presence," but also as the expression of a set of ideas and measures that I have carried with me for many years. Most, even until today.

First, the book had a presence, even in my own head, of weightiness, that is, it rapidly acquired a gravity as it emerged and certainly when completed, in the sense that even though I was admittedly and very openly shooting from the hip (as noted in the Introduction to the first edition, "none of [these] questions . . . have been answered definitively or for all time") but like Billy the Kid, when he hit the target without aiming, I had been aiming for a long time before I reached for the machine. And there was a thrill to see my own ideas roll out, not always as "precisely stated" as would be the case later; still, they were forceful enough to convince me that I did know something about this music I have loved all my life.

Writing the book confirmed ideas that had been rolling around in my head for years and that now, given the opportunity, flashed out upon the page with a stunning self-exhilaration and certainty. The book, from its opening words, got me high. It made me reach for more and more and more of what I had carried for years, for more of what I had to say, for more of myself.

That is, how to measure this world in which we find our-selves, where we are not at all happy, but clearly able to understand and hopefully, one day, to transform. How to measure my own learning and experience and to set out a system of evaluation, weights, and meaning.

It was Sterling Brown, the great Afro-American poet and my English teacher at Howard University, who first hipped A. B. Spellman and me to the fact that the music *was* our history, in our English 212 class, where we were lolling around like the classic submature campus hipsters we most emphatically were, "Those Who Would Be Down." Amidst Sterling's heavy lectures on Shakespeare (still incredible in their spotlight on the fact that Willie S. was the antifeudal revolutionary, in whose work all the problems of capitalism were first exposed to the quick . . . George Thompson's ideas in *Marxism and Poetry* are similar . . . e.g., dig the evil Richard the Third, or Macbeth the Nut, or Othello on racism, Caesar on Democracy, Hamlet on the Liberal, the Merchant on Anti-Semitism, the Shrew on Women's Oppression, etc., the various monstrous kings and rulers of that dying feudal age.

Sterling "signified" to A. B. & me one day that we wasn't quite as hip as we thunk, even as self-proclaimed young Boppers, probably quite nasty in our altogether ignorant pseudo-wisdomic stancing. Oh, yeh, we was hip to Bird and Diz and Monk, you dig. Albeit, in a Dave Brubeck, Paul Desmond, Gerry Mulligan, Stan Getz period right then. Thanks to Miles's "Birth of the Cool," which we swore was the big number.

I imagine this must have incited Sterling to grasp us lovingly and metaphorically by the scruffs of our conceits and invite us to his crib! And man, there in a center room was a wall, which wrapped completely around our unknowing, of all the music from the spasm bands and arwhoolies and hollers, through Bessie and Jelly Roll and Louis and Duke, you know? And we watched ourselves from that vantage point of the albums staring haughtily at us, with that "tcch tcch" sound such revelations are often armed with.

The albums, Folkways and Commodores, Bluebirds and even a Gennett or three, stared at us with our own lives spelled

out in formal expression. "This is the history. This is your history, my history, the history of the Negro people." That was the phrase that lifted me, lifted us both, I'd say, since A. B.'s *Three Lives in the Be Bop Business* was another formidable thrust from that encounter.

Later, Sterling began to give a few informal talks on our history as Black Music, in the lounge of the old, then new, Cook Hall and we sat, very literally, at his feet, taking those priceless teachings in. The Music, The Music, this is our history.

But that sat, of course, for years. I had certainly heard it, very deeply, and it dug a hole in my static absolutes, but then it had dropped down inside to foam and bubble and give off ideational vapors that blinked endless analogies and revelations into my perceptions and rationales, throughout the years.

So even as I began *Blues People,* that idea, now a fundamental philosophical feature of my seeing and understanding, was not at the tip of my focus. What was, was included in the second published essay on the music, in *Metronome,* "Jazz & The White Critic" (originally, "Black Music, White Critics"). The tentative first title I gave the book was *Blues, Black & White America.* It was the contrasting aspect of the theme that first superficially captured me: That there was a body of music that came to exist from a people who were brought to this side as slaves and that throughout that music's development, it had had to survive, expand, reorganize, continue, and express itself, as the fragile property of a powerless and oppressed People.

How did it do this? What was so powerful and desperate in this music that guaranteed its continued existence? Even beyond its creators' existence? This is what pushed me. But as I began to get into the history of the music, I found that this was impossible without, at the same time, getting deeper into the history of the people. That it was the history of the Afro-American people as text, as tale, as story, as exposition, narrative, or what have you, that the music was the score, the actually expressed creative orchestration, reflection, of Afro-American life, our words, the libretto, to those actual, lived lives. That the music was an orchestrated, vocalized, hummed,

chanted, blown, beaten, scatted, corollary confirmation of the history. And that one could go from one to the other, actually, from the inside to the outside, or reverse, and be talking about the same things. That the music was explaining the history as the history was explaining the music. And that both were expressions of and reflections of the people!

So that moving from the middle passage forward (and backward), as Jacques Roumaine said, from that "railroad of human bones . . . at the bottom of the Atlantic Ocean," one traced the very path and life and development, tragedy, and triumph of Black people. How they had been "removed" from Africa and had been transformed by this hideous "trip," and by the context of their lives in the actual "West," into a Western people. By the beginning of the nineteenth century, Du Bois points out, the majority of us were "Americans." (Here, a pause, for "canned" studio laughter!)

At each juncture, twist, and turn, as Black people were transformed, so was their characteristic music. It became emphatically clear to me that by analyzing the music, you could see with some accuracy what and why that change had been. To reflect that "newer" them, which I later termed, in the book *Black Music*, "The Changing Same." In the continuously contrasting contexts of their actual lives. My deep concentration on the continuing evidence of surviving "Africanisms" and parallels between African customs and philosophies, mores, etc., and the philosophies and their Afro-American continuum were to teach myself, and whoever, that Black people did not drop out of the sky, although, "fo' sho'," they continue to be, despite the wildest of ironies, the most American of Americans.

But for all the syncretic re-presentation and continuation of African mores and beliefs, even under the hideous wrap of chattel slavery ("many have suffered as much as Black people . . . but none of them was real estate"—Du Bois), there is one thing that I have learned, since the original writing of *Blues People*, that I feel must be a critical new emphasis not understood completely by me in the earlier text. That is, that *the Africanisms are not limited to Black people, but indeed,*

American Culture, itself, is shaped by and includes a great many Africanisms. So that American culture, in the real world, is a composite of African, European, and Native or Akwesasne cultures, history, and people.

(This is why both the Ebonics and Standard English arguments as definers of spoken U.S. language are paltry from nationalism or ignorance. Try to go someplace in the Western and Southwestern United States without speaking Spanish . . . or someplace in the Black South without speaking some Bantu language, or go anyplace in the United States without speaking in the Akwesasne tongues!)

Actually, *Blues People* is a beginning text. There is yet much work to be done to properly bring the music into the open light of international understanding and collective social development and use—despite the massive commercial exploitation and proof that there is, indeed, as *Jazz Times* projects in its 1998 convention, "The International Business of Jazz." But the widespread and routine scholarly and artistic institutionalization of the music is still very limited. It needs not only to further illuminate the obscure history, but to bring all the voices, the contributors, the pioneers, the innovators, the unknown and little-known facts and people, up front where they belong. The actual stages and dimensions of the music's development—how and where and why and by whom and with what historical impact—must still be reconstructed.

The specific music of the various regions and cities has to be studied more closely. And with the social and economic and institutional stability with which European "classical" music is studied. Particularly since Blues and Jazz and their many offshoots and influences are constantly developing and changing, like every living organism, while European classical music (as contrasted to its myriad folk forms) seems, for the most part, to be fixed by a bourgeois tradition of formalism and elitism.

In addition, independent venues, networks, publications, festivals, orchestras, scholarship, institutions, schools, must be created by the diggers (musicians, audience, scholars, critics, enlightened proprietors) to expand and magnify the total

impact of the music, as well as preserve it, with all the sanctity and security and social and economic impact of the Museum of Natural History's ancient artifacts and mission or the Museum of Modern Art's great "woiks." That, and reach the new generations and great sections of the population still unhip, perhaps even prove an effective antidote to the shabby exploitative commercialism of U.S. corporate artificial "popular culture."

As for my own contributions, I have several books to release, if I can find a publisher. Books on Trane, Monk, Duke, Miles, a new book of essays called "Digging." Plus, here in Newark, for almost fifteen years, my wife, Amina, and I have operated *Kimako's Blues People,* an arts and culture space that has featured many, many local musicians as well as the internationally known, as well as poetry and political dialogue.

Now we have initiated the Newark Music Project, as an independent research and development unit; it has emerged as one city's response to the national Lost Jazz Shrines project, which seeks to archive, perform, and represent in multimedia form, the music and musicians and the historic context of their presence in the major U.S. cities. This is a project, that if properly understood and pursued, could help transform these cities and many of the people, so that a much broader and deeper part of U.S. society can utilize its own history and culture, as part of the whole fabric of the multicultural U.S., to enhance the entire society, materially, socially, economically, and psychologically.

And this is all part of what an even larger number of us ought to be doing, if we are truly Diggers of The Music, i.e., to keep on Digging!

—Amiri Baraka
1999

1 / The Negro as Non-American: Some Backgrounds

When black people got to this country, they were Africans, a foreign people. Their customs, attitudes, desires, were shaped to a different place, a radically different life. What a weird and unbelievably cruel destiny for those people who were first brought here. Not just the mere fact of being sold into slavery—that in itself was common practice among the tribes of West Africa, and the economic system in which these new slaves were to form so integral a part was not so strange either. In fact, Melville Herskovits points out, "Slavery [had] long existed in the entire region [of West Africa], and in at least one of its kingdoms, Dahomey, a kind of plantation system was found under which an absentee ownership, with the ruler as principal, demanded the utmost return from the estates, and thus created conditions of labor resembling the regime the slaves were to encounter in the New World."[1] But to be brought to a country, a culture, a society, that was, and is, in terms of purely philosophical correlatives, the complete antithesis of one's own version of man's life on earth—that is the cruelest aspect of this particular enslavement.

An African who was enslaved by Africans, or for that mat-

[1] *The Myth of the Negro Past* (Boston, Beacon Press, 1941), p. 62.

ter, a Western white man who was, or is, enslaved by another Western white man can still function as a kind of human being. An economic cipher perhaps, even subject to unmentionable cruelties—but that man, even as the lowest and most despised member of the community, remains an essential part and member of whatever community he is enslaved in; the idea being, even if an African from the Guinea Coast is sold or beaten into slavery by an African from the Gold Coast, there continues to exist, at the very least, some understanding that what the victor has reduced into whatever cruel bondage is a man—another human being. There remains some condition of communication on strictly human terms between Babylonian and Israelite or Assyrian and Chaldean that allows finally for acceptance of the slave caste as merely an economically oppressed group. To the Romans, slaves were merely vulgar and conquered peoples who had not the rights of Roman citizenship. The Greeks thought of their slaves as unfortunate people who had failed to cultivate their minds and wills, and were thus reduced to that lowly but necessary state. But these slaves were still human beings. However, the African who was unfortunate enough to find himself on some fast clipper ship to the New World was not even accorded membership in the human race.

From the actress Frances Anne Kemble's, *Journal of a Residence on a Georgia Plantation:* "The only exception that I have met with yet among our boat voices to the high tenor which they seem all to possess is in the person of an individual named Isaac, a basso profundo of the deepest dye, who nevertheless never attempts to produce with his different register any different effects in the chorus by venturing a second, but sings like the rest in unison, perfect unison, of both time and tune. By-the-by, this individual *does* speak, and therefore I presume he is not an ape, orangoutang, chimpanzee, or gorilla; but I could not, I confess, have conceived it possible that the presence of articulate sounds, and the absense of an articulate tail, should make, exter-

nally at least, so completely the only appreciable difference between a man and a monkey, as they appear to do in this individual 'black brother.' Such stupendous long thin hands, and long flat feet, I did never see off a large quadruped of the ape species. But, as I said before, Isaac speaks, and I am much comforted thereby." [2]

There was no communication between master and slave on any strictly human level, but only the relation one might have to a piece of property—if you twist the knob on your radio you expect it to play. It was this essential condition of nonhumanity that characterized the African slave's lot in this country of his captivity, a country which was later and ironically to become *his land* also.

Perhaps more weight will be added to the idea of the foreignness of the African in the New World if we consider that not only were the Africans completely different in appearance from their captors, but there was not even a semblance of similarity between the various dialects those Africans spoke and colonial English. In Greece, there were slaves who taught Greek children their grammar and conducted classes in botany, as well as performing more menial tasks. The Romans employed slaves in the theater, in gladiatorial combats, and utilized the highly-educated foreign slaves as instructors. Epictetus, Terence, and Phaedrus were slaves. But the black slave in America had no chance for such intelligent diversion based on his skills or prominence in his own country. The African's sole purpose in America was, for the most part, to provide the cheapest agricultural labor possible to procure. Any deviation from this purpose was either accidental or extremely rare. (Even such a normal phenomenon as the "house nigra" was nonexistent on the smaller farms; on the larger plantation there were only one or two. Sometimes the house slave was merely the oldest or most infirm member of the owner's retinue; even after the

[2] *Journal of a Residence on a Georgia Plantation in 1838-1839* (New York, Alfred A. Knopf, 1961), p. 260.

The Negro as Non-American / • • • / 3

advent of the African slave, for some time house servants on the larger plantations were indentured white persons.)

It is certain that it was this foreignness and the reluctance of the white American to think of the African as another *man* that helped early to fix the African's, and later the Afro-American's, place in American society—just as the color of the African's skin set him apart from the rest of the society blatantly and permanently. A freed serf, if he was lucky, could hope at least to matriculate into the lower rungs of the general society and perhaps find some genuine niche in the mainstream of that society in which to function as a *citizen*, a man. But the African, and later even the freed black, was always apart. A freed Negro, and there were quite a few of them even before the so-called Emancipation, would always remain an *ex-slave*. Otherwise, what was he doing in this country?

I mentioned before that colonial America was the complete antithesis of the African's version of human existence. This idea seems to me one of the most important aspects of the enslavement of the African: the radically different, even opposing, *Weltanschauung*'s which the colonial American and the African brought to each other. Each man, in whatever "type" of culture he inhabits, must have a way of looking at the world—whatever that means to him—which is peculiar to his particular culture. It is extremely important to understand that these diametrically opposed interpretations of life would be in conflict normally in the most minute human contacts. But when a man who sees the world one way becomes the slave of a man who interprets the world in an exactly opposite way, the result is, to my mind, the *worst* possible kind of slavery.

Colonial America was the country of the new *post-Renaissance* man, the largest single repository for *humanism* in the New World. It witnessed the complete emergence of secular man. The Church and religion had become only a part of a

man's life. They were no longer, as in the pre-Renaissance Western World, the one reason for man's existence. The idea that came through in the Renaissance and took hold of the West was that life was no mere anteroom for something greater or divine. Life itself was of value—and could be made *perfect*. And if mysticism and the religious attitude were greatly weakened in Renaissance Europe, they were almost completely negated in the New World. If the England of Henry VIII was the beginning of the superiority of the "economic mind," as Brooks Adams says, the American colonies, and especially the English-speaking colonies, certainly demonstrated the ascendancy of this new species. The exaltation of secular man and man's life on earth, which we have called humanism, was responsible for the colonies and was the most salient characteristic of the *Weltanschauung* of the colonists. Only the Catholic countries conquered in the name of the Christian Church—which was largely a credo of convenience. The North American settlements were *strictly* economic enterprises, with the possible exception of the Pilgrims'.

Wars before the Renaissance were usually "holy" wars, where one faith, sect, religion, would try to extend its beliefs in all directions throughout the known world. The Crusades, even admitting the hypocrisy and opportunism of the Christians, and the prostitution of Christianity in such debacles as the sack of Constantinople, etc., were still, in essence, "holy" wars. The only other kind of war before the Renaissance was waged for the acquisition of more arable land, or any land that seemed more fertile to the conquerors, *viz.*, the Huns, or Genghis Khan. But the advent of Renaissance thought and the subsequent accumulation of monetary wealth in cities made war a strictly commercial enterprise. With the rise to prominence of the storekeeping class, war became one way to simplify bookkeeping, or at least to keep certain markets exclusive. The straw that broke the camel's back and sent the American colonists scrambling headlong

for independence from Great Britain was *an excessive tax on dry goods*. Instead of "The Will of [our] God Must Be Done," the rallying cry for a war could be "No Taxation Without Representation."

I am stressing so emphatically the socio-economic psychological disposition of the colonial American only to set in full contrast the opposing *Weltanschauung* of the African. I believe that this drastic opposition of world-view contributed importantly not only to the attitude of the Americans to the African slaves but just as certainly to the *final* place of the Africans' descendants in the various societies of the New World.

So-called nonliterate peoples (called by Western man "primitive"), whose languages, and therefore whose cultural and traditional histories, are not written, are the antithesis of Western man and his highly industrialized civilization. But the idea of the "primordial man," or "undeveloped peoples," becomes absurd if we dismiss for a change the assumption that only the ideas and attitudes which the West finds useful or analogous to concepts forwarded within its own system are of any real value or profundity. For instance, a highly organized society predicated on the existence of mystical, omniscient superior beings who are in complete control of the lives and fates of all humans might seem a trifle "primitive" if viewed through the eyes of a society whose existence is predicated on exactly opposite hypotheses. That is, the *goals* or "canons of satisfaction," as T. E. Hulme called them, of a culture with complex concepts of predetermination and the subservience of the human being to a complex of gods cannot easily be understood by a culture which forwards the "ultimate happiness of mankind" as the sole purpose of the universe. And the cruelty of such ignorance when contained within the already terrifying circumstance of slavery should be readily apparent. The most profound concepts and beliefs of one culture become merely

absurd fancies for the other. The cult of man must view the cult of the divine as absurd. Where the Renaissance cliché "Man is the measure" is the most salient attitude, the idea that "man is only a pawn of the gods" is ugly if looked at distantly, "childish" if one must deal with it intimately.

I am re-emphasizing what men like Hulme and Herskovits have pointed out in diverse ways a long time ago—that reference determines value. My only addition is that in a situation like slavery, and especially the enslavement of the West Africans by the American colonists, this concept is especially useful. Americans brought slaves to their country who were not only physical and environmental aliens but products of a completely alien philosophical system.

One of the main points of the Herskovits book is that most of the attitudes, customs, and cultural characteristics of the American Negro can be traced directly, or indirectly, back to Africa. And while I am inclined to accept this view, with whatever reservations my individual concepts propose, I would also have to insist that the African, because of the violent differences between what was native and what he was forced to in slavery, developed some of the most complex and complicated ideas about the world imaginable. Afro-Americans (by whom I mean the first few generations of American-born black people, who still retained a great many *pure* Africanisms), and later, American Negroes, inherited all these complexities with, of course, whatever individual nuances were dictated by their particular lives. But the ugly fact that the Africans were forced into an alien world where none of the references or cultural shapes of any familiar human attitudes were available is the determinant of the *kind* of existence they had to eke out here: not only slavery itself but the particular circumstances in which it existed. The African cultures, the retention of some parts of these cultures in America, and the *weight* of the stepculture produced the American Negro. A new race. I want to use music as my

persistent reference just because the development and transmutation of African music to American Negro music (a *new* music) represents to me this whole process in microcosm.

Herskovits also points out that most of the "myths" about the Negro past were formed by the new masters' refusal to understand that the Africans were not governed by the same mores and culture references as Western man, that they had come from an alien land and culture. But one of the most persistent traits of the Western white man has always been his fanatical and almost instinctive assumption that his systems and ideas about the world are the most desirable, and further, that people who do not aspire to them, or at least think them admirable, are *savages* or *enemies*. The idea that Western thought might be *exotic* if viewed from another landscape never presents itself to most Westerners. As rulers of the world or as owners of these black people, they, Americans, were certainly in a position to declare that all thought outside their known systems was at least "backward." But a Byzantine man *could not* understand the existence of a structure like the Empire State Building that was not erected to praise Jehovah. What made the American most certain that he was "superior" to the African (aside from the fact that the African *was* his slave)—as self-righteously certain as Cortez and his *conquistadores* when they had, in the name of Spain, the King, and their Spanish God, reduced to abject slavery the "heathen" race of Montezuma and brought to a horrifying end one of the longest-lived, most sophisticated and exalted traditions of human life on this planet—was the foreignness of African culture. This came to be the African's chief liability in the New World: in the context of slavery, the most undesirable attitudes the foreign slave and his many generations of American-born offspring could possess. In fact, twentieth-century American society finds many of these same offspring denying any connection with this culture, in what may seem to most Americans a perfectly natural attempt to dive headlong into and immerse themselves

completely in the tepid safety of the mainstream of contemporary America.

But quite aside from any talk of what is known as complete "assimilation," which I think is *still* an imagined rather than a real concept, what seems most pertinent to the ideas I want to advance are Herskovits' thrusts at the question of "how, in the contact of Africans with Europeans and American Indians, cultural accommodation and cultural integration had been achieved." [3]

When a Yoruba tribesman from Dahomey, who thought that "the universe is ruled by fate and the destiny of each man worked out according to a predetermined scheme," but that "there were ways of escape through invoking the good will of the god," was enslaved and began to be reshaped by a philosophy that attributed all glory to the mind of man, what was the result? When the concept of "deification of Accident in a universe where predetermination is the rule" is thrown against the concept of a world where all things are explainable and the result of "rational processes," something emerges that must contain both ideas. Not immediately, but gradually. It is absurd to assume, as has been the tendency, among a great many Western anthropologists and sociologists, that all traces of Africa were erased from the Negro's mind because he learned English. The very nature of the English the Negro spoke and still speaks drops the lie on that idea. An idea like the attribution of an "innate and natural fear" (of everything) to Negroes must, as Herskovits inferred, be given the same environment as its origin. The African's belief in the supernatural was carried over into the life of the American slave. The retort to the Western derision of the African's "fear" of the supernatural is simply that the white man conducts his life without thought to the gods. If the former idea seemed "childish" to the master, the latter idea seemed extremely dangerous to the slave. So one man becomes a child, and the other a fool.

[3] *Op. cit.*, p. 62.

"You are black . . . which means you lived too close to the sun. Black is evil." "You are white . . . which means you lived too far from the sun. You have no color . . . no soul." These are equally logical arguments. The twist is that if you are black and believe in the supernatural, and are issued from an ecological determinant that does not permit of such a psychological extreme as American Puritanism (which, said William Carlos Williams, is a "thing, strange, inhuman, powerful, like a relic of some died out tribe whose practices were revolting"), the circumstance of finding yourself in a culture of white humanist pseudo-Puritanical storekeepers must be revolting. And if you are the slave of such a culture, your sorrow must be indeterminable.

2 / The Negro as Property

It is extremely important in a "study" of any aspect of the history of the American Negro to emphasize how strange and unnatural the initial contacts with Western slavery were for the African, in order to show how the black man was set apart throughout the New World from the start. This should enable one to begin to appreciate the amazing, albeit agonizing, transformation that produced the contemporary black American from such a people as were first bound and brought to this country.

Sociologists are always making fearsome analogies between minorities regarding their *acculturation* in this country (usually when confronted by, say, statistics on how many of the total crimes committed in any given year are attributable to Negroes). They claim that each one of the "newcomers" (a euphemism for "furriners") shows parallel development in the race toward ultimate Americanization. They say, flaunting their statistics, "See how, after such and such time, the sons and daughters of the once-despised Irish immigrants moved into genteel middle-class social respectability." So, with the Italians, they point out the decrease in crimes "directly attributable to persons of Italian extraction" after enough time had passed to enable this minority also to

enter into the mainstream of American life. And certainly, there are some analogies to be made between minority groups who have, since their initial removal to this country from their homelands, edged out from their first ghetto existences into the promise and respectability of this brave New World. But no such strict analogy will serve for Afro-Americans. There are too many aspects of these "newcomers'" existence in America that will not sit still under those kinds of statistics.

First of all, we know that of all the peoples who form the heterogeneous yet almost completely homogenous mass that makes up the United States population, Negroes are the only descendants of people who were not happy to come here. The African was brought to this country in bondage and remained in bondage more than two hundred and fifty years. But most of the black people who were freed from formal slavery in 1865 *were not* Africans. They were Americans. And whether or not we choose to characterize the post-Emancipation existence of Negroes in the United States as "freedom," we must still appreciate the idea that a group of people who became familiar with the mores, attitudes, language, and other culture references of this country while being enslaved by it cannot be seen as analogous to peoples who move toward complete assimilation of these same mores by *choice*, even though these peoples are also despised by the "natives" of the country as "furriners." The African as slave was one idea, *i.e.*, these people from another country were brought to this country against their wills. But the American-born slaves offer a less easily defined situation.

The first-born of these Africans in America knew about Africa only through the stories, tales, riddles, and songs of their older relatives. But usually the children born in this country were separated from their African parents. No mother could be sure she would see her child after it was weaned. The American-born African children were much prized, and the masters had to exercise extreme care that

the women didn't do away with these children to save them from the ugliness of slavery. (Many African mothers smothered their first-born American children, and the owners thought this was the result of carelessness, or callousness, characteristic of "savages.") These children also had to learn about slavery, but there were no centuries of culture to unlearn, or old long-held habits to suppress. The only way of life these children knew was the accursed thing they had been born into.

If we think about the importation of Africans into the New World as a whole, rather than strictly into the United States, the most apparent difference that can be seen is that Africans throughout the rest of the Americas were much slower to become Westernized and "acculturated." All over the New World there are still examples of pure African traditions that have survived three hundred years of slavery and four hundred years of removal from their source. "Africanisms" are still part of the lives of Negroes throughout the New World, in varying degrees, in places like Haiti, Brazil, Cuba, Guiana. Of course, attitudes and customs of the noncontinental Negroes were lost or assumed other less apparent forms, but still the amount of pure Africanisms that have been retained is amazing. However, in the United States, Africanisms in American Negroes are not now readily discernible, although they certainly do exist. It was in the United States only that the slaves were, after a few generations, unable to retain any of the more obvious of African traditions. Any that were retained were usually submerged, however powerful their influence, in less recognizable manifestations. So after only a few generations in the United States an almost completely different individual could be born and be rightly called an American Negro.

Herskovits says about this phenomenon: "The contact between Negroes and whites in continental United States as compared to the West Indies and South America goes far to explain the relatively greater incidence of Africanisms in

the Caribbean. In the earliest days, the number of slaves in proportion to their masters was extremely small, and though as time went on thousands and tens of thousands of slaves were brought to satisfy the demands of the southern plantations, nonetheless the Negroes lived in constant association with whites to a degree not found anywhere else in the New World. That the Sea Islands off the Carolina and Georgia coast offer the most striking retention of Africanisms to be encountered in the United States is to be regarded as but a reflection of the isolation of these Negroes when compared to those on the mainland." [1]

Some of this "constant association" between the white masters and the black slaves that took place in this country can be explained by comparing the circumstances of the slaves' "employment" in America with the circumstances of their employment in the rest of the New World. It was only in the United States that slaves were used on the smaller farms. Such a person as the "poor white" was a strictly American phenomenon. To turn again to Herskovits: "Matters were quite different in the Caribbean islands and in South America. Here racial numbers were far more disproportionate; estates where a single family ruled dozens, if not hundreds, of slaves were commonplace and the 'poor white' was found so seldom that he receives only cursory mention . . . The white man with but a few slaves was likewise seldom encountered." [2]

But in the United States, the Utopia of the small businessman, the small farmer was the rule, rather than the exception, and these farmers could usually afford to own only a very small number of slaves.

On these small farms intimate contact between master and slave was unavoidable (I will just mention here the constant extra-curricular sexual activities that were forced on the slave women by their white masters). In 1863, Frederick

[1] *Op. cit.*, p. 120.
[2] *Ibid.*, p. 121.

Olmstead reported: "The more common sort of habitations of the white people are either of logs or loosely-boarded frame, a brick chimney running up outside, at one end; and black and white children, are commonly lying very promiscuously together, on the ground about the doors. I am struck with the close co-habitation and association of black and white—negro women are carrying black and white babies together in their arms; black and white children are playing together [not going to school together]; black and white faces constantly thrust together out of doors to see the train go by." [3] One result of this intimacy between the poorer master and his slaves was, of course, the invention of still another kind of Afro-American, the mulatto. But certainly the most significant result was the rapid acculturation of the African in this country. With no native or tribal references, except perhaps the stories of his elders and the performance of nonreligious dances and songs, the American-born slave had only the all-encompassing mores of his white master. Africa had become a foreign land, and none of the American-born slaves could ever hope to see it.

A graph could be set up to show just exactly what aspects of African culture suffered most and were most rapidly suppressed by this constant contact with Euro-American culture. It is certainly immediately apparent that all forms of political and economic thought, which were two of the most profound sophistications of African culture, were suppressed immediately. The extremely intricate political, social, and economic systems of the West Africans were, of course, done away with completely in their normal manifestations. The much praised "legal genius" that produced one of the strictest and most sophisticated legal systems known could not function, except very informally, in the cotton fields of America. The technology of the Africans, iron-working, wood-carving, weaving, etc., died out quickly in the United States. Almost every material aspect of African culture took

[3] A Journey in the Seabord Slave States (New York, 1863), p. 17.

a new less obvious form or was wiped out altogether. (The famous wood sculpture of the Yoruba could not possibly have fallen into an area less responsive to its beauties than colonial America. The artifact was, like any other material manifestation of pure African culture, doomed. It is strange to realize that even in the realm of so-called high culture, Western highbrows have only in this century begun to think of African, Pre-Columbian, and Egyptian art, as well as the art of other pre-literate and/or "primitive" cultures, as art rather than archaeology. Of course, nowadays, it is a must in the home of any Westerner who pays homage to the arts to include in his collection of *objets d'art* at least a few African, Egyptian, and Pre-Columbian pieces.)

Only religion (and magic) and the arts were not completely submerged by Euro-American concepts. Music, dance, religion, do not have *artifacts* as their end products, so they were saved. These nonmaterial aspects of the African's culture were almost impossible to eradicate. And these are the most apparent legacies of the African past, even to the contemporary black American. But to merely point out that blues, jazz, and the Negro's adaptation of the Christian religion all rely heavily on African culture takes no great amount of original thinking. How these activities derive from that culture is what remains important.

3 / African Slaves / American Slaves: Their Music

It is a comparatively short period of history that passes between the time, when Richard Francis Burton could say of African music that "it is monotonous to a degree, yet they delight in it," or when H. E. Krehbiel could ask (1914), "Why savages who have never developed a musical or other art should be supposed to have more refined aesthetic sensibilities than the peoples who have cultivated music for centuries, passes my poor powers of understanding . . ." [1] until the time (1920) when a great mass of white Americans are dancing a West African (Ashanti) ancestor dance they know as the "Charleston."

Jazz is commonly thought to have begun around the turn of the century, but the musics jazz derived from are much older. Blues is the parent of all legitimate jazz, and it is impossible to say exactly how old blues is—certainly no older than the presence of Negroes in the United States. It is a native American music, the product of the black man in this country: or to put it more exactly the way I have come to think about it, blues could not exist if the African captives had not become American captives.

[1] H. E. Krehbiel, *Afro-American Folksongs* (New York, G. Schirmer, 1914), p. 73.

The immediate predecessors of blues were the Afro-American/American Negro work songs, which had their musical origins in West Africa. The religious music of the Negro also originates from the same African music. However, while the general historical developments of Negro secular and religious music can be said to be roughly parallel, *i.e.*, they follow the same general trends in their development, and in later forms are the result of the same kind of accultural processes, a Negro religious music contingent on Christianity developed later than the secular forms. An Afro-American work song could come about more quickly in slavery than any other type of song because even if the individual who sang it was no longer working for himself, most of the physical impetuses that suggested that particular type of singing were still present. However, Africans were not Christians, so their religious music and the music with which they celebrated the various cultic or ritualistic rites had to undergo a distinct and complete transfer of reference.

For the African in the United States there was little opportunity for religious syncretism (the identification of one set of religious dogma or ritual with analogous dogma or ritual in a completely alien religion). In the essentially Catholic New World cultures, the multitudes of saints were easily substituted for the many *loa* or deities in the various West African religions. But in Protestant America this was not possible.

So the music which formed the *link* between pure African music and the music which developed after the African slave in the United States had had a chance to become exposed to some degree of Euro-American culture was that which contained the greatest number of Africanisms and yet was foreign to Africa. And this was the music of the second generation of slaves, their work songs. The African slave had sung African chants and litanies in those American fields. His sons and daughters, and their children, began to use America as a reference.

As late as the nineteenth century, pure African songs could be heard and pure African dances seen in the Southern United States. Congo Square, in New Orleans, would nightly rock to the "master drums" of new African arrivals. In places like Haiti or Guiana, these drums still do remind the West that the black man came from Africa, not Howard University. But in the United States pure African sources grew scarce in a relatively short time after the great slave importations of the eighteenth century.

The work song took on its own peculiar qualities in America for a number of reasons. First, although singing to accompany one's labor was quite common in West Africa, it is obvious that working one's own field in one's own land is quite different from forced labor in a foreign land. And while the physical insistence necessary to suggest a work song was still present, the references accompanying the work changed radically. Most West Africans were farmers and, I am certain, these agricultural farm songs could have been used in the fields of the New World in the same manner as the Old. But the lyrics of a song that said, "After the planting, if the gods bring rain,/My family, my ancestors, be rich as they are beautiful," could not apply in the dreadful circumstance of slavery. Secondly, references to the gods or religions of Africa were suppressed by the white masters as soon as they realized what these were—not only because they naturally thought of any African religious customs as "barbarous" but because the whites soon learned that too constant evocation of the African gods could mean that those particular Africans were planning on leaving that plantation as soon as they could! The use of African drums was soon prevented too, as the white man learned that drums could be used to incite revolt as well as to accompany dancers.

So the work song, as it began to take shape in America, first had to be stripped of any purely African ritual and some cultural reference found for it in the New World. But this

was difficult to do within the African-language songs themselves. The diverse labors of the African, which were the sources of this kind of song, had been funneled quite suddenly into one labor, the cultivation of the white man's fields. The fishing songs, the weaving songs, the hunting songs, all had lost their pertinence. But these changes were not immediate. They became the realized circumstances of a man's life after he had been exposed sufficiently to their source and catalyst—his enslavement.

And this is the basic difference between the first slaves and their offspring. The African slave continued to chant his native chants, sing his native songs, at work, even though the singing of them might be forbidden or completely out of context. But being forbidden, the songs were after a time changed into other forms that weren't forbidden in contexts that were contemporary. The African slave might have realized he was losing something, that his customs and the memory of his land were being each day drained from his life. Still there was a certain amount of forbearance. No one can simply decree that a man change the way he thinks. But the first black Americans had no native cultural references other than the slave culture. A work song about fishing when one has never fished seems meaningless, especially when one works each day in a cotton field. The context of the Africans' life had changed, but the American-born slaves never knew what the change had been.

It is impossible to find out exactly how long the slaves were in America before the African work song actually did begin to have extra-African references. First, of course, there were mere additions of the foreign words—French, Spanish or English, for the most part, after the British colonists gained power in the United States. Krehbiel lists a Creole song transcribed by Lafcadio Hearn, which contains both French (or patois) and African words (the italicized words are African):

Ouendé, ouendé, macaya!
 Mo pas barrasse, *macaya!*
Ouendé, ouendé, macaya!
 Mo bois bon divin, *macaya!*
Ouendé, ouendé, macaya!
 Mo mange bon poulet, *macaya!*
Ouendé, ouendé, macaya!
 Mo pas barrasse, *macaya!*
Ouendé, ouendé, macaya!
 Macaya!

Hearn's translation was:

Go on! go on! eat enormously!
 I ain't one bit ashamed—*eat outrageously!*
Go on! go on! eat prodigiously!
 I drink good wine!—*eat ferociously!*
Go on! go on! eat unceasingly!
 I eat good chicken—*gorging myself!*
Go on! go on! etc.

It is interesting to note, and perhaps more than coincidence, that the portions of the song emphasizing excess are in African, which most of the white men could not understand, and the portions of the song elaborating some kind of genteel, if fanciful, existence are in the tongue of the masters. But there was to come a time when there was no black man who understood the African either, and those allusions to excess, or whatever the black man wished to keep to himself, were either in the master's tongue or meaningless, albeit rhythmical, sounds to the slave also.

Aside from the actual transfer or survival of African words in the songs and speech of the early slaves, there was also some kind of syntactical as well as rhythmical transfer since Africans and their descendants tended to speak their new languages in the same manner as they spoke their West Afri-

can dialects. What is called now a "Southern accent" or "Negro speech" was once simply the accent of a foreigner trying to speak a new and unfamiliar language, although it was characteristic of the white masters to attribute the slave's "inability" to speak perfect English to the same kind of "childishness" that was used to explain the African's belief in the supernatural. The owners, when they bothered to listen, were impressed that even the songs of their native American slaves were "incomprehensible" or "unintelligible." However, as Herskovits says of early Afro-American speech:

". . . since grammar and idiom are the last aspects of a new language to be learned, the Negroes who reached the New World acquired as much of the vocabulary of their masters as they initially needed or was later taught to them, pronounced these words as best they were able, but organized them into aboriginal speech patterns. Thus arose the various forms of Negro-English, Negro-French, Negro-Spanish and Negro-Portugese spoken in the New World, their "peculiarities" due to the fact that they comprise European words cast into an African grammatical mold. But this emphatically does not imply that those dialects are without grammar, or that they represent an inability to master the foreign tongue, as is so often claimed." [2]

A few of the "unintelligible" songs are not as unintelligible as their would-be interpreters would have it. For instance, Mr. Krehbiel lists as unintelligible two "corn songs"—songs sung while working the corn fields. Only a fragment of one song remains, the words "Shock along, John." It seems to me incredible that Krehbiel could not see that *shock* is the word *shuck,* meaning to strip the corn of its outer covering, which is what the slaves did.

> Five can't ketch me and ten can't hold me—
> Ho, round the corn, Sally!

[2] *Op. cit.,* p. 80.

Here's your iggle-quarter and here's your count-aquils—
　　Ho, round the corn, Sally!
I can bank, 'ginny bank, 'ginny bank the weaver—
　　Ho, round the corn, Sally!

All of the above seems obvious to me except the third and fifth lines. But *iggle* is, of course, *eagle,* and an eagle quarter was American money. It would also seem that *count* in the phrase "your count-aquils" is either a reference to that money or the count of merchandise being harvested—in this instance, the corn. *Aquil* could be either an appropriation of the Spanish *aquí,* meaning *here,* or more likely an appropriation of the French word *kilo,* which is a term of measure.

Another less "obscure" song of probably an earlier period:

> Arter you lub, you lub you know, boss. You can't broke lub. Man can't broke lub. Lub stan'—he ain't gwine broke—Man heb to be very smart for broke lub. Lub is a ting stan' just like tar, arter he stick, he stick, he ain't gwine move. He can't move less dan you burn him. Hab to kill all two arter he lub fo' you broke lub.[3]

Though the above should be considered an American song, it still retains so much of the African that it might be difficult for some people to understand. Yet I think the references quite American. But now, however, by *African,* I do not mean actual surviving African words, but rather the African accent and the syntactical construction of certain West African dialects. It is relatively easy to see the connection in the syntax of this song and the literal translation into English of African phrases. For example, the literal English rendering of an Ashanti (Twi dialect) phrase meaning "to calm a person" is "cool he heart give him." (And here, I think, even the word *cool* should bear further consideration.)

[3] From Maud Cuney-Hare, *Negro Musicians and Their Music* (Washington, D.C., Associated Publishers, 1936), p. 27.

African speech, African customs, and African music all changed by the American experience into a native American form. But what was a pure African music? Were there similarities between African and European music before the importation of the slaves? What strictly musical changes occurred to transform African music into American? How did this come about?

The role of African music in the formulation of Afro-American music was misunderstood for a great many years. And the most obvious misunderstanding was one that perhaps only a Westerner would make, that African music ". . . although based on the same principles of European music, suffers from the African's lack of European technical skill in the fashioning of his crude instruments. Thus the strangeness and out-of-tune quality of a great many of the played notes." Musicologists of the eighteenth and nineteenth centuries, and even some from the twentieth, would speak of the "aberration" of the diatonic scale in African music. Or a man like Krehbiel could say: "There is a significance which I cannot fathom in the circumstance that the tones which seem *rebellious* [my italics] to the negro's sense of intervallic propriety are the fourth and seventh of the diatonic major series and the fourth, sixth and seventh of the minor." [4] Why did it not occur to him that perhaps the Africans were using not a diatonic scale, but an African scale, a scale that would seem ludicrous when analyzed by the normal methods of Western musicology? Even Ernest Borneman says: "It seems likely now that the common source of European and West African music was a simple non-hemitonic pentatone system. Although indigenous variants of the diatonic scale have been developed and preserved in Africa, modern West Africans who are not familiar with European music will tend to become uncertain when asked to sing in a tempered scale. This becomes particularly obvious when the third and sev-

[4] *Ibid.*, p. 73.

enth steps of a diatonic scale are approached. The singer almost invariably tries to skid around these steps with slides, slurs or vibrato effects so broad as to approach scalar value." [5]

These sliding and slurring effects in Afro-American music, the basic "aberrant" quality of a blues scale, are, of course, called "blueing" the notes. But why not of "scalar value?" It is my idea that this is a different scale.

Sidney Finkelstein, in *Jazz: A People's Music:* ". . . these deviations from the pitch familiar to concert music are not, of course, the result of an inability to sing or play in tune. They mean that the blues are a non-diatonic music. . . . Many books on jazz . . . generally describe the blues as a sequence of chords, such as the tonic, subdominant and dominant seventh. Such a definition, however, is like putting the cart before the horse. There are definite patterns of chords which have been evolved to support the blues, but these do not define the blues, and the blues can exist as a melody perfectly recognizable as the blues without them. Neither are the blues simply a use of the major scale with the 'third' and 'seventh' slightly blued or flattened. The fact is that both this explanation, and the chord explanation, are attempts to explain one musical system in terms of another; to describe a non-diatonic music in diatonic terms." [6]

The most apparent survivals of African music in Afro-American music are its rhythms: not only the seeming emphasis in the African music on rhythmic, rather than melodic or harmonic, qualities, but also the use of polyphonic, or contrapuntal, rhythmic effects. Because of this seeming neglect of harmony and melody, Westerners thought the music "primitive." It did not occur to them that Africans might have looked askance at a music as vapid rhythmically as the West's.

[5] "The Roots of Jazz," in Nat Hentoff and Albert J. McCarthy, eds., *Jazz* (New York, Rinehart, 1959), p. 13.
[6] *Jazz: A People's Music* (New York, Citadel, 1948), p. 68.

The reason for the remarkable development of the rhythmic qualities of African music can certainly be traced to the fact that Africans also used drums for communication; and not, as was once thought, merely by using the drums in a kind of primitive Morse code, but by the phonetic reproduction of the words themselves—the result being that Africans developed an extremely fine and extremely complex rhythmic sense, as well as becoming unusually responsive to timbral subtleties. Also, the elaborately developed harmonic system used in the playing of percussion instruments, *i.e.*, the use of drums or other percussion instruments of different timbres to produce harmonic contrasts, was not immediately recognizable to the Western ear; neither was the use of two and three separate rhythmic patterns to underscore the same melody a concept easily recognizable to Westerners used to less subtle musical devices.

Melodic diversity in African music came not only in the actual arrangements of notes (in terms of Western transcription) but in the singer's vocal interpretation. The "tense, slightly hoarse-sounding vocal techniques" of the work songs and the blues stem directly from West African musical tradition. (This kind of singing voice is also common to a much other non-Western music.) In African languages the meaning of a word can be changed simply by altering the *pitch* of the word, or changing its stress—basically, the way one can change the word *yeh* from simple response to stern challenge simply by moving the tongue slightly. Philologists call this "significant tone," the "combination of pitch and timbre" used to produce changes of meaning in words. This was basic to the speech and music of West Africans, and was definitely passed on to the Negroes of the New World.

Another important aspect of African music found very readily in the American Negro's music is the antiphonal singing technique. A leader sings a theme and a chorus answers him. These answers are usually comments on the leader's theme or comments on the answers themselves in im-

provised verses. The amount of improvisation depends on how long the chorus wishes to continue. And improvisation, another major facet of African music, is certainly one of the strongest survivals in American Negro music. The very character of the first work songs suggests that they were largely improvised. And, of course, the very structure of jazz is the melodic statement with an arbitrary number of improvised answers or comments on the initial theme.

Just as some of the African customs survived in America in their totality, although usually given just a thin veneer of Euro-American camouflage, so pure African songs, dances, and instruments showed up on this side of the water. However, I consider this less significant because it seems to me much more important, if we speak of music, that features such as basic rhythmic, harmonic, and melodic devices were transplanted almost intact rather than isolated songs, dances, or instruments.

The very nature of slavery in America dictated the way in which African culture could be adapted. Thus, a Dahomey river god ceremony had no chance of survival in this country at all unless it was incorporated into an analogous rite that was present in the new culture—which is what happened. The Christians of the New World called it baptism. Just as the African songs of recrimination survive as a highly competitive game called "the dozens." (As any young Harlemite can tell you, if someone says to you, "Your father's a woman," you must say, as a minimal comeback, "Your mother likes it," or a similar putdown.) And in music: where the use of the African drum was strictly forbidden, other percussive devices had to be found, like the empty oil drums that led to the development of the West Indian steel bands. Or the metal wash basin turned upside down and floated in another basin that sounds, when beaten, like an African hollow-log drum. The Negro's way in this part of the Western world was adaptation and reinterpretation. The banjo (an African word) is an African instrument, and the xylophone,

used now in all Western concert orchestras, was also brought over by the Africans. But the survival of the *system* of African music is much more significant than the existence of a few isolated and finally superfluous features. The notable fact is that the only so-called popular music in this country of any real value is of African derivation.

Another important aspect of African music was the use of folk tales in song lyrics, riddles, proverbs, etc., which, even when not accompanied by music, were the African's chief method of education, the way the wisdom of the elders was passed down to the young. The use of these folk stories and legends in the songs of the American Negro was quite common, although it was not as common as the proportion of "Americanized" or American material grew. There are however, definite survivals not only in the animal tales which have become part of this country's tradition (the Uncle Remus/Br'er Rabbit tales, for example) but in the lyrics of work songs and even later blues forms.

And just as the lyrics of the African songs were usually as important or *more* important than the music, the lyrics of the work songs and the later blues were equally important to the Negro's concept of music. In fact the "shouts" and "field hollers" were little more than highly rhythmical lyrics. Even the purely instrumental music of the American Negro contains constant reference to vocal music. Blues-playing is the closest imitation of the human voice of any music I've heard; the vocal effects that jazz musicians have delighted in from Bunk Johnson to Ornette Coleman are evidence of this. (And it seems right to conclude that the African and blues scales proceed from this concept of vocal music, which produces note values that are almost impossible to reproduce on the fixed Western tempered scale, but can nevertheless be played on Western instruments.)

If we think of African music as regards its intent, we must see that it differed from Western music in that it was a purely *functional* music. Borneman lists some basic types of

songs common to West African cultures: songs used by young men to influence young women (courtship, challenge, scorn); songs used by workers to make their tasks easier; songs used by older men to prepare the adolescent boys for manhood, and so on. "Serious" Western music, except for early religious music, has been strictly an "art" music. One would not think of any particular *use* for Haydn's symphonies, except perhaps the "cultivation of the soul." "Serious music" (a term that could only have extra-religious meaning in the West) has never been an integral part of the Westerner's life; no art has been since the Renaissance. Of course, before the Renaissance, art could find its way into the lives of almost all the people because all art issued from the Church, and the Church was at the very center of Western man's life. But the discarding of the religious attitude for the "enlightened" concepts of the Renaissance also created the schism between what was art and what was life. It was, and is, inconceivable in the African culture to make a separation between music, dancing, song, the artifact, and a man's life or his worship of his gods. *Expression* issued from life, and *was* beauty. But in the West, the "triumph of the economic mind over the imaginative," as Brooks Adams said, made possible this dreadful split between life and art. Hence, a music that is an "art" music as distinguished from something someone would whistle while tilling a field.

There are still relatively cultivated Westerners who believe that before Giotto no one *could* reproduce the human figure well, or that the Egyptians painted their figures in profile because they *could not* do it any other way. The idea of progress, as it has infected all other areas of Western thought, is thus carried over into the arts as well. And so a Western listener will criticize the tonal and timbral qualities of an African or American Negro singer whose singing has a completely alien *end* as the "standard of excellence." The "hoarse, shrill" quality of African singers or of their cultural progeny, the blues singers, is thus attributed to their

lack of proper vocal training, instead of to a conscious desire dictated by their own cultures to produce a prescribed and certainly calculated effect. A blues singer and, say, a Wagnerian tenor cannot be compared to one another in any way. They issue from cultures that have almost nothing in common, and the musics they make are equally alien. The Western concept of "beauty" cannot be reconciled to African or Afro-American music (except perhaps now in the twentieth century, Afro-American music has enough of a Euro-American tradition to make it seem possible to judge it by purely Western standards. This is not quite true.) For a Westerner to say that the Wagnerian tenor's voice is "better" than the African singer's or the blues singer's is analogous to a non-Westerner disparaging Beethoven's Ninth Symphony because it wasn't improvised.

The Western concept of the cultivation of the voice is foreign to African or Afro-American music. In the West, only the artifact can be beautiful, mere expression cannot be thought to be. It is only in the twentieth century that Western art has moved away from this concept and toward the non-Western modes of art-making, but the principle of the beautiful thing as opposed to the natural thing still makes itself felt. The tendency of white jazz musicians to play "softer" or with "cleaner, rounder tones" than their Negro counterparts is, I think, an insistence on the same Western artifact. Thus an alto saxophonist like Paul Desmond, who is white, produces a sound on his instrument that can almost be called legitimate, or classical, and the finest Negro alto saxophonist, Charlie Parker, produced a sound on the same instrument that was called by some "raucous and uncultivated." But Parker's sound was *meant* to be both those adjectives. Again, reference determines value. Parker also would literally imitate the human voice with his cries, swoops, squawks, and slurs, while Desmond always insists he is playing an instrument, that it is an artifact separate from himself. Parker did not admit that there was any sepa-

ration between himself and the agent he had chosen as his means of self-expression.

By way of further illustration of this, another quote from Mr. Borneman:

"While the whole European tradition strives for regularity —of pitch, of time, of timbre and of vibrato—the African tradition strives precisely for the negation of these elements. In language, the African tradition aims at circumlocution rather than at exact definition. The direct statement is considered crude and unimaginative; the veiling of all contents in ever-changing paraphrases is considered the criterion of intelligence and personality. In music, the same tendency towards obliquity and ellipsis is noticeable: no note is attacked straight; the voice or instrument always approaches it from above or below, plays around the implied pitch without ever remaining any length of time, and departs from it without ever having committed itself to a single meaning. The timbre is veiled and paraphrased by constantly changing vibrato, tremolo and overtone effects. The timing and accentuation, finally, are not *stated*, but *implied* or *suggested*. The denying or withholding of all signposts." [7]

[7] *Loc. cit.*, pp. 23-24.

4 / *Afro-Christian Music and Religion*

When the first slaves were brought to this country, there was no idea at all of converting them. Africans were thought of as beasts, and there was certainly no idea held among the whites that, somehow, these beasts would benefit by exposure to the Christian God. As late as the twentieth century there have been books "proving" the Negro's close relationship to lower animals that have been immensely popular in the South. The idea that perhaps slavery could be condoned as a method for converting heathens to the Christian God did not become popular until the latter part of the eighteenth century, and then only among a few "radical" Northern missionaries. There could be no soul-saving activities, N. N. Puckett points out in his book *Folk Beliefs of the Southern Negro,* where there was no soul.[1]

But still Christianity was adopted by Negroes before the great attempts by missionaries and evangelists in the early part of the nineteenth century to convert them. The reasons for this grasping of the white man's religion by the North American Negro are fairly simple. First, his own religion was prohibited in this country. In some parts of the South, "con-

[1] *Folk Beliefs of the Southern Negro* (Chapel Hill, University of North Carolina Press, 1926).

juring" or use of "hoodoo" or "devil talk" was punishable by death or, at the very least, whipping. Also, the African has always had a traditional respect for his conqueror's gods. Not that they are always worshiped, but they are at least recognized as powerful and placed in the hierarchy of the conquered tribe's gods.

The growing "social awareness" of the slave can be mentioned as another reason for the African's swift embrace of the white man's God: social awareness in the sense that the African, or at least his progeny, soon realized that he was living in a white man's world. Not only was it an ancient African belief that the stronger tribe's gods were to be revered, but the African was also forced to realize that all the things he thought important were thought by the white man to be primitive nonsense. The constant contact between black and white in the United States must have produced in the black man a profound anxiety regarding the reasons for his status and the reasons for the white man's dominance. The African's belief in "stronger gods" assuaged or explained slavery for the African slave and was, perhaps, a partial explanation for his rapid adoption of pre-missionary Christianity. But for the American slave, Christianity was attractive simply because it was something the white man did that the black man could do also, and in the time of the missionaries, was encouraged to do. The house Negroes, who spent their lives finding new facets of the white culture that they could imitate, were the first to adopt Christianity. And they and their descendants, even today, practice the most European or American forms of Christianity. The various black Episcopal and Presbyterian churches of the North were invariably started by the black freedmen, who were usually the sons and daughters of "house niggers." The strange "melting pot" of the United States, where after a few decades the new African slaves were ridiculed by their "American" brothers because they were African! And this was for purely "social" reasons. That is, the slaves who had

come to America only a few years earlier began to apply what they thought were the white man's standards to their own behavior as well as to that of their newly arrived brothers.

Sinner, what you gonna do
When de World's on fi-er?
Sinner, what you gonna do
When de world's on fi-er?
Sinner, what you gonna do
When de world's on fi-er?
O my Lawd.[2]

Because the African came from an intensely religious culture, a society where religion was a daily, minute-to-minute concern, and not something relegated to a specious once-a-week reaffirmation, he had to find other methods of worshiping gods when his white *captors* declared that he could no longer worship in the old ways. (The first slaves thought of the white men as captors; it was later, after they had become Americans, that they began to think of these captors as masters and themselves as slaves, rather than captives.) The immediate reaction, of course, was to try to worship in secret. The more impressive rites had to be discarded unless they could be performed clandestinely; the daily rituals, however, continued. The common day-to-day stance of the African toward his gods could not be erased overnight. In fact, many of the "superstitions" of the Negroes that the whites thought "charming" were holdovers from African religions. Even today in many Southern rural areas, strange mixtures of voodoo, or other primarily African fetish religions, and Christianity exist. Among less educated, or less sophisticated, Negroes the particular significance of dreams, luck and lucky charms, roots and herbs, is directly attributable to African religious beliefs. Also, many aphorisms used

[2] From Howard W. Odum and Guy B. Johnson, *Negro Workaday Songs* (Chapel Hill, University of North Carolina Press, 1926), p. 195.

by Negroes in strictly social situations spring from African religion.

For example, there was recently a rhythm & blues song that talked of "Spreading goober dust all around your bed/When you wake up you find your own self dead." To most whites (and indeed to most modern sophisticated city Negroes) the song was probably catchy but essentially unintelligible. But now in 1963, one hundred years after the Emancipation of slaves, there exists a song integrated somewhat into the mainstream of American society that refers directly to an African religious belief. (A *goober* is what a peanut is called by many Southern Negroes. The word itself comes from the African word *gooba,* which is a kind of African nut. In Africa the ground-up *gooba* was used to conjure with, and was thought to give one person power over another if the ground *gooba* ("goober dust") was spread around the victim's hut. In the South, peanut shells spread in front of someone's door supposedly cause something terrible to happen to him.)

"Never go to bed on an empty stomach," my grandmother has told me all my life. Perhaps the origins of this seemingly health-conscious aphorism have been forgotten even by her. But the Africans believed that evil spirits could steal your soul while you slept if your body was empty. "If the sun is shining and it is raining at the same time, the devil's beating his wife." "Sweeping out the house after dark is disrespectful." Both these aphorisms I heard when I was younger, and they are both essentially African. The latter refers to the African's practice of praying each night for the gods to protect him while he slept from evil spirits; it was thought that the benevolent gods would actually descend and sit in one's house. Sweeping at night, one might sweep the guardian out since he was invisible. The "gods" of the African eventually became "The Holy Ghos' " of the American Negro.

And so to "outlaw" the African slave's religion completely was impossible, although the circumstance of slavery did

Afro-Christian Music and Religion / • • • / 35

relegate religious practice to a much smaller area of his life. But the African could not function as a human being without religion; he daily invoked the "conjure men," herb doctors and root healers, cult priests and sorcerers—the mystical forces he thought controlled the world. The sorcerer was consulted each day to find out the disposition of the gods toward a man and his activities, just as we dial our phones for the weather report.

The first attempts by Negroes to openly embrace the white Christ were rebuffed, sometimes cruelly, because of the Christian theologists' belief that Africans were beasts, literally, lower animals. "You would not give oxen the holy scripture." Also, on a slightly more humane level, it was thought by white Christians that if the Africans were given Christianity, there could be no real justification for enslaving them, since they would no longer be heathens or savages. In spite of this, the slaves did go off into the woods to hold some semblance of a Christian rite when they could. By the beginning of the nineteenth century, however, against the wishes of most of the planters and slave owners, attempts were made to convert the slaves because of the protests of the Quakers and other religious groups.

Fannie Kemble, in her journal of 1838 and 1839, reported: *"You have heard, of course, many* and contradictory statements as to the degree of religious instruction afforded to the Negroes of the South, and their opportunities of worship, etc. Until the late abolition movement, the spiritual interests of the slaves were about as little regarded as their physical necessities. The outcry which has been raised with threefold force within the last few years against the whole system has induced its upholders and defenders to adopt, as measures of personal extenuation, some appearance of religious instruction (such as it is), and some pretense at physical indulgences (such as they are), bestowed apparently voluntarily upon their dependents. At Darien a church is appropriated to the especial use of the slaves, who are almost

all of them Baptists here; and a gentleman officiates it (of course, white) who, I understand, is very zealous in the cause of the spiritual well-being. He, like most Southern men, clergy or others, jump the present life in their charities to the slaves, and go on to furnish them with all requisite conveniences for the next." [3]

She added: "Some of the planters are entirely inimical to any such proceedings and neither allow their Negroes to attend worship, or to congregate together for religious purposes. . . . On other plantations, again, the same rigid discipline is not observed; and some planters and overseers go even farther than toleration, and encourage these devotional exercises and professions of religion, having actually discovered that a man may become more faithful and trustworthy, even as a slave, who acknowledges the higher influences of Christianity. . . ." [4]

The ambivalent attitude of the slave-holders toward the conversion of the slaves to Christianity is further illustrated by another of Miss Kemble's observations: ". . . this man is known to be a hard master; his Negro houses are sheds not fit to stable beasts in; his slaves are ragged, half-naked, and miserable; yet he is urgent for their religious comforts, and writes to Mr. Butler about 'their souls—their precious souls.'" [5]

The Quakers and other religious groups began to realize that the only justification for slavery was that the slaves could be converted to Christianity, and the great missionary and evangelical movements of the nineteenth century began. Some of the churches, such as the Methodist and Baptist, began to send ministers among the slaves to convert them. Soon the grossest disparagement the "religious" Negro could make of another was that he or she was "a heathen." (When I spilled food on the table or otherwise acted with

[3] *Op. cit.*, pp. 92-93.
[4] *Ibid.*, p. 106.
[5] *Ibid.*

boyish slovenliness, my grandmother would always think to dress me down by calling me "a heathen.")

The emotionalism and evangelism of the Methodists and Baptists appealed much more to the slaves than any of the other denominations. Also, the Baptists, especially, allowed the Negroes to participate in the services a great deal and began early to "appoint" black ministers or deacons to conduct the services while the missionaries themselves went on to other plantations. And on the poorer plantation the lower-class white was more apt to be Baptist or Methodist than Episcopal or Presbyterian. Another, possibly more important, reason why the Negroes were drawn to the Baptist Church was the method of conversion. Total immersion in water, which is the way Baptists symbolize their conversion to the "true church" and the teachings of Christ, in imitation of Christ's immersion by Saint John "The Baptist," was perhaps particularly attractive to the early slaves because in most of the religions of West Africa the river spirits were thought to be among the most powerful of the deities, and the priests of the river cults were among the most powerful and influential men in African society.

The Christian slave became more of an American slave, or at least a more "Westernized" slave, than the one who tried to keep his older African traditions. The slave masters also learned early that the Africans who had begun to accept the Christian ethic or even some crude part of its dogma were less likely to run away or start rebellions or uprisings. Christianity, as it was first given to the slaves (as Miss Kemble pointed out), was to be used strictly as a code of conduct which would enable its devotees to participate in an afterlife; it was from its very inception among the black slaves, a slave ethic. It acted as a great pacifier and palliative, although it also produced a great inner strength among the devout and an almost inhuman indifference to pain. Christianity was to prepare the black man for his Maker, and

the anthropomorphic "heben" where all his "sins and suffering would be washed away." One of the very reasons Christianity proved so popular was that it was the religion, according to older Biblical tradition, of an oppressed people. The struggles of the Jews and their long-sought "Promised Land" proved a strong analogy for the black slaves.

> Mary, don't you weep an' Marthie don't you moan,
> Mary, don't you weep an' Marthie don't you moan;
> Pharaoh's army got drown-ded,
> Oh Mary don't you weep.

> I thinks every day an' I wish I could
> Stan' on de rock whar Mose stood
> Oh, Pharaoh's army got drown-ded,
> Oh Mary don't you weep.

The Christianity of the slave represented a movement away from Africa. It was the beginning of Africa as "a foreign place." In the early days of slavery, Christianity's sole purpose was to propose a metaphysical resolution for the slave's natural yearnings for freedom, and as such, it literally made life easier for him. The secret African chants and songs were about Africa, and expressed the African slave's desire to return to the land of his birth. The Christian Negro's music became an expression of his desire to "cross Jordan" and "see his Lord." He no longer wished to return to Africa. (And one can see, perhaps, how "perfect" Christianity was in that sense. It took the slave's mind off Africa, or material freedom, and proposed that if the black man wished to escape the filthy paternalism and cruelty of slavery, he wait, at least, until he died, when he could be transported peacefully and majestically to the Promised Land.)

> Gonna shout trouble over
> When I get home,
> Gonna shout trouble over
> When I get home.

Afro-Christian Music and Religion / • • • • / 39

No mo' prayin', no mo' dyin'
When I get home.
No mo' prayin' an' no mo' dyin'
When I get home.

Meet my father
When I get home.
Meet my father
When I get home.

The religious imagery of the Negro's Christianity is full of references to the suffering and hopes of the oppressed Jews of Biblical times. Many of the Negro spirituals reflect this identification: *Go Down, Moses, I'm Marching to Zion, Walk Into Jerusalem Just Like John,* etc. "Crossing the river Jordan" meant not only death but also the entrance into the very real heaven and a release from an earthly bondage; it came to represent all the slave's yearnings to be freed from the inhuman yoke of slavery. But at the time, at least for the early black Christian, this freedom was one that could only be reached through death. The later secular music protested conditions *here,* in America. No longer was the great majority of slaves concerned with leaving this country (except, perhaps, the old folks who sat around and, I suppose, remembered). *This* was their country, and they became interested in merely living in it a little better and a little longer.

The early black Christian churches or the pre-church "praise houses" became the social focal points of Negro life. The relative autonomy of the developing Negro Christian religious gathering made it one of the only areas in the slave's life where he was relatively free of the white man's domination. (Aside from the more formally religious activities of the fledgling Negro churches, they served as the only centers where the slave community could hold strictly social functions.) The "praise nights," or "prayer meetings," were

also the only times when the Negro felt he could express himself as freely and emotionally as possible. It is here that music becomes indispensable to any discussion of Afro-Christian religion.

"The spirit will not descend without song."

This is an old African dictum that very necessarily was incorporated into Afro-Christian worship. The Negro church, whether Christian or "heathen," has always been a "church of emotion." In Africa, ritual dances and songs were integral parts of African religious observances, and the emotional frenzies that were usually concomitant with any African religious practice have been pretty well documented, though, I would suppose, rarely understood. This heritage of emotional religion was one of the strongest contributions that the African culture made to the Afro-American. And, of course, the tedious, repressive yoke of slavery must well have served to give the black slave a huge reservoir of emotional energy which could be used up in his religion.

"Spirit possession," as it is called in the African religions, was also intrinsic to Afro-Christianity. "Gettin' the spirit," "gettin' religion" or "gettin' happy" were indispensable features of the early American Negro church and, even today, of the non-middle-class and rural Negro churches. And always music was an important part of the total emotional configuration of the Negro church, acting in most cases as the catalyst for those worshipers who would suddenly "feel the spirit." "The spirit will not descend without song."

The first Afro-Christian music differed from the earlier work songs and essentially nonreligious shouts first of all in its subject matter and content. Secondly, the religious music became much more melodic and musical than the field hollers because it was sung rather than grunted or "hollered." (Though no aspect of Negro song is completely without the shout, if later, only as an element of style.) Also, this reli-

gious music was drawn from many sources, and represented, in its most mature stage, an amalgam of forms, styles, and influences.

Christianity was a Western form, but the actual practice of it by the American Negro was totally strange to the West. The American Negro's religious music developed quite similarly, taking its superficial forms (and instrumentation, in many cases) from European or American models, but there the imitation ended. The lyrics, rhythms, and even the harmonies were essentially of African derivation, subjected, of course, to the transformations that American life had brought into existence. The Negro's religious music was his original creation, and the spirituals themselves were probably the first completely *native American* music the slaves made. When I refer to the Negro's religious music, however, I mean not only the spiritual, which is used, I am aware, as a general catchall for all the nonsecular music made by the American black man, but I am referring as well to the church marches, ring and shuffle shouts, "sankeys," chants, camp or meetin' songs, and hymns or "ballits," that the Afro-Christian church produced.

But even as the masses of Negroes began to enter the Christian Church and get rid of their "heathenisms," Africa and its religious and secular traditions could not be completely shaken off. In fact, as Borneman points out: "The Methodist revival movement began to address itself directly to the slaves, but ended up not by converting the Africans to a Christian ritual, but by converting itself to an African ritual." [6]

The more conscientious Christian ministers among the slaves sought to get rid of "all dem hedun ways," but it was difficult. For instance, the Christian Church saw dancing as an evil worldly excess, but dancing as an integral part of the African's life could not be displaced by the still white notes of the *Wesleyan Hymnal*. The "ring shouts" or "shuffle

[6] *Loc. cit.,* p. 21.

shouts" of the early Negro churches were attempts by the black Christians to have their cake and eat it: to maintain African tradition, however veiled or unconscious the attempt might be, yet embrace the new religion. Since dancing was irreligious and sinful, the Negro said that only "crossing the feet" constituted actual dancing. So the ring shout developed, where the worshipers link arms and shuffle, at first slowly but then with increasing emotional display, around in a circle, singing hymns or chanting as they move. This shuffle, besides getting around the dogma of the stricter "white folks" Christianity also seems derived from African religious dances of exactly the same nature. "Rocking Daniel" dances and the "Flower Dance" were among the dances that the black Christians allowed themselves to retain. The so-called "sanctified" Protestant churches still retain some of these "steps" and "moo-mens" today. And indeed, the "sanctified" churches always remained closer to the African traditions than any of the other Afro-Christian sects. They have always included drums and sometimes tambourines in their ceremonies, something none of the other sects ever dared do.

A description of a typical Afro-Christian church service is found in H. E. Krehbiel's book. Krehbiel had excerpted it from the May 30, 1867, issue of *The Nation:*

". . . the benches are pushed back to the wall when the formal meeting is over, and old and young, men and women, sprucely dressed young men, grotesquely half-clad field hands—the women generally with gay handkerchiefs twisted about their heads and with short skirts—boys with tattered shirts and men's trousers, young girls bare-footed, all stand up in the middle of the floor, and when the 'sperichil' is struck up begin first walking and by and by shuffling around, one after the other, in a ring. The foot is hardly taken from the floor, and the progression is mainly due to a jerking, hitching motion which agitates the entire shouter and soon brings out streams of perspiration. Sometimes they dance

silently, sometimes as they shuffle they sing the chorus of the spiritual, and sometimes the song itself is also sung by the dancers. But more frequently a band, composed of some of the best singers and of tired shouters, stand at the side of the room to 'base' the others, singing the body of the song and clapping their hands together or on the knees. Song and dance are alike extreme energetic, and often, when the shout lasts into the middle of the night, the monotonous thud, thud of feet prevents sleep within half a mile of the praise house." [7]

The music that was produced by Negro Christianity was the result of diverse influences. First of all, there was that music which issued from pure African ritual sources and which was changed to fit the new religion—just as the ring shouts were transformed from pure African religious dances to pseudo-Christian religious observance, or the Dahomey river cult ceremonies were incorporated into the baptism ceremony. Early observers also pointed out that a great many of the first Negro Christian religious songs had been taken almost untouched from the great body of African religious music. This was especially true of the melodies of certain black Christian spirituals that could also be heard in some parts of Africa.

Maude Cuney-Hare, in her early book *Negro Musicians and Their Music*, cites the experience of a Bishop Fisher of Calcutta who traveled to Central Africa: ". . . in Rhodesia he had heard natives sing a melody so closely resembling *Swing Low, Sweet Chariot* that he felt that he had found it in its original form: moreover, the region near the great Victoria Falls have a custom from which the song arose. When one of their chiefs, in the old days, was about to die, he was placed in a great canoe together with trappings that marked his rank, and food for his journey. The canoe was set afloat in midstream headed toward the great Falls and the vast column of mist that rises from them. Meanwhile the

[7] *Op. cit.*, p. 33.

tribe on the shore would sing its chant of farewell. The legend is that on one occasion the king was seen to rise in his canoe at the very brink of the Falls and enter a chariot that, descending from the mists, bore him aloft. This incident gave rise to the words 'Swing Low, Sweet Chariot,' and the song, brought to America by African slaves long ago, became anglicized and modified by their Christian faith." [8]

It would be quite simple for an African melody that was known traditionally to most of the slaves to be used as a Christian song. All that would have to be done was change the words (which is also the only basic difference between a great many of the "devil music" songs and the most devout of the Christian religious songs. Just as many high school students put their own words to the tune *Yankee Doodle Dandy*, for whatever purpose, the converted slave had only to alter his lyrics to make the song "Christian"). Of course, the point here is that the slave had *to be able* to change the words, that is, he had to know enough of the language in which the new religion was spoken so that he could make up lyrics in that language. Christian songs in African tongues are extremely rare, for obvious reasons. (What is the word for *God* in any of the African dialects? The answer would be: Which god?)

Almost all parts of the early Negro Christian church service had to do in some way with music, which was also true of the African religions. And not only were African songs transformed into a kind of completely personal Christian liturgical music but African prayers and chants as well. The black minister of an early Christian church (as well as the Negro ministers of today's less sophisticated black churches) himself contributed the most musical and most emotional parts of the church service. The long, long, fantastically rhythmical sermons of the early Negro Baptist and Methodist preachers are well known. These men were singers, and they sang the word of this new God with such passion and

[8] *Op. cit.*, p. 69.

belief, as well as skill, that the congregation had to be moved. The traditional African call-and-response song shaped the form this kind of worship took on. The minister would begin slowly and softly, then build his sermon to an unbelievable frenzy with the staccato punctuation of his congregation's answers. "Have you got good religion?/Certainly, Lord," is the way one spiritual goes, modeled on the call-and-response, preacher-to-congregation type of song. When the preacher and the congregation reach their peaks, their music rivals any of the more formal Afro-American musics in intensity and beauty.

> Oh, my Lawd, God, what happened when Adam took de apple? (Amen, Amen). Yas, didn't de Lawd tell dat po' foolish sinner not to listen to that spiteful wo-man? (Amen, Amen). Yas, Lawd, Did he tell him or no? (Amen, Amen, Yas he told him, brother). And what did Adam do, huh? Yas, Lawd, after you told him not to, what did he do? (Amen, Amen, brother, preach, preach).

Another kind of song that the Negro church produced in America was one based on European or American religious (and sometimes secular) songs. In these songs the words often remained the same (with, of course, the natural variances of Negro speech). For instance, Puckett seemed puzzled by the use of the word *fellom-city* in Negro spirituals. The word, most old Negroes say, means some kind of peace, so I would think the word to be *felicity*. The melodies of many of the white Christian and European religious songs which the Negroes incorporated into their worship remained the same, but the Negroes changed the rhythms and harmonies of these songs to suit themselves. The very fact that the Negroes sang these songs in their peculiar way, with not only the idiosyncratic American idiom of early Negro speech but the inflection, rhythm, and stress of that speech, also served to shape the borrowed songs to a strictly Negro idiom.

Blues People / • • • / 46

And usually, no matter how closely a Negro spiritual might resemble superficially one of the white hymns taken from sources like the *Bay Psalm Book,* the *Wesleyan Hymnal,* the *Anglican Hymnal,* or the *Moody Hymnal,* when the song was actually sung, there could be no mistake that it had been made over into an original Negro song. A very popular white Christian hymn like *Climb Jacob's Ladder* is completely changed when sung in the Negro church as *Climin' Jacob's Ladda. Jesus, Lover of my Soul,* a song out of the *Sankey Hymnal,* is changed by the Shouting Baptists of Trinidad into an unmistakably African song. And, as Herskovits noted, in a great many parts of the West Indies, all the Protestant pseudo-Christian religious songs are called "sankeys."

Rhythmic syncopation, polyphony, and shifted accents, as well as the altered timbral qualities and diverse vibrato effects of African music were all used by the Negro to transform most of the "white hymns" into Negro spirituals. The pentatonic scale of the white hymn underwent the same "aberrations" by which the early musicologists characterized African music. The same chords and notes in the scale would be flattened or diminished. And the meeting of the two different musics, the white Christian hymn and the Negro spiritual using that hymn as its point of departure, also produced certain elements that were later used in completely secular music. The first instrumental voicings of New Orleans jazz seem to have come from the arrangement of the singing voices in the early Negro churches, as well as the models for the "riffs" and "breaks" of later jazz music. The Negro's religious music contained the same "rags," "blue notes" and "stop times" as were emphasized later and to a much greater extent in jazz.

The purely social function of the early Negro Christian churches is of extreme importance if one is trying to analyze any area of American Negro culture. First of all, as I have

said, because the church for a long time was the *only* place the slave had for any kind of vaguely human activity. The black churches, as they grew more and more autonomous and freer of the white man's supervision, began to take on social characteristics that, while imitative of their white counterparts in many instances, developed equally, if not more rigid social mores of their own. Not only did the churches sponsor the various social affairs, such as the barbecues, picnics, concerts, etc., but they became the sole arbiters of what kind of affair would be sponsored.

During the time of slavery, the black churches had almost no competition for the Negro's time. After he had worked in the fields, there was no place to go for any semblance of social intercourse but the praise houses. It was not until well after the Emancipation that the Negro had much secular life at all. It is no wonder then that early books about Negro music talked about "the paucity of Negro secular music." The churches called sinful all the "fiddle sings," "devil songs," and "jig tunes"—even the "corn songs" were outlawed by some church elders. Also, certain musical instruments, such as the violin and banjo, were said to be the devil's own. The Negro church, as it was begun, was the only place where the Negro could release emotions that slavery would naturally tend to curtail. The Negro went to church, literally, to be free, and to prepare himself for his freedom in the Promised Land. But as the church grew more established and began to shape itself more and more in its image of the white man's church, the things it desired to achieve for Negroes began to change. The church began to produce social stations as well. The ministers, deacons, elders, trustees, even the ushers, of the Baptist and Methodist churches formed a definite social hierarchy, and that hierarchy dominated the whole of the Negro society. The "backslider" (the sinning churchgoer) and the "heathen" became in the new theocracy the lowest rungs of the social ladder. And during slavery, the churches controlled by the house

Negroes or the "freedmen" imposed even stricter social categories than did the other Negro churches. The churches after a time, of course, became as concerned with social matters as with religion, although all such concerns were still couched in religious terms. And what came to be known as "progress," or "advance," to the growing numbers of willing congregations came to mean merely the imitation of the white man—in practice, if not in theory.

As some indication of this practice, in W. F. Allen's book, published in 1867, when mentioning the "paucity of secular songs" among the Negroes, Allen goes on to say: "We have succeeded in obtaining only a very few songs of this character. Our intercourse with the colored people has been chiefly through the work of the Freedmen's Commission, which deals with the serious and earnest side of the negro character. . . . It is very likely that if we had found it possible to get at more of their secular music we should have come to another conclusion as to the proportion of the barbaric element." [9]

But the end of slavery had, in many ways, a disintegrating effect on the kind of slave culture the church had made possible. With the legal end of slavery, there was now proposed for the Negro masses a much fuller life *outside* the church. There came to be more and more backsliders, and more and more of the devil music was heard.

[9] *Slave Songs of the United States* (New York, 1867).

5 / *Slave and Post-Slave*

It is impossible to say simply, "Slavery created blues," and be done with it—or at least it seems almost impossible to make such a statement and sound intelligent saying it. Yet this kind of oversimplification has created a whole intellectual climate for the appreciation of blues in this country. Blues is *not,* nor was it ever meant to be, a strictly social phenomenon, but is primarily a verse form and secondarily a way of making music. By "strictly social phenomenon," I refer, of course to the din of nineteenth-century American social reform and European sociological concern.

Blues as a verse form has as much social reference as any poetry, except for the strict lyric, and that also is found in blues. Love, sex, tragedy in interpersonal relationships, death, travel, loneliness, etc., are all social phenomena. And perhaps these are the things which actually create a poetry, as things, or ideas: there can be no such thing as poetry (or blues) exclusive of the matter it proposes to be about.

Blues did begin in slavery, and it is from that "peculiar institution," as it was known euphemistically, that blues did find its particular form. And if slavery dictated certain aspects of blues form and content, so did the so-called Eman-

cipation and its subsequent problems dictate the path blues would take.

One important result of the Emancipation was the decentralization of the Negro population. Even though there were about 500,000 Negro freedmen in the country at the time of the Emancipation, concentrated predominantly in cities like New York, Philadelphia, Boston, Albany, Newark, Pittsburgh, and in the border states, the major part of the Negro population lived in the South as slaves. The Emancipation, or at least the movement of the Union soldiers through the South and the subsequent departure of the plantation owners, produced an immediate movement among a great many Negroes. As soon as the Union Army approached, most of the slaves struck out to find themselves new places to live, or at least safer places. The great majority of ex-slaves remained in the South, but some left immediately for the West and North. And even the Negroes who remained in the South were more scattered than before, though, to be sure, there were Negro communities set up almost immediately.

The period of Reconstruction was a very chaotic period for the South and the North. It was especially confusing for the newly freed slaves. The establishment of black Reconstruction governments in some parts of the South and the cries in Congress by so-called Northern radicals (Thaddeus Stevens, John A. Griswold, and others) for "40 acres and a mule" for the freed slaves must have caused a great deal of optimism among the Negroes. But as W. A. Williams says in his book: "Coinciding with the south's lack of capital with which to regenerate and diversify its economy, and with the Negro's difficulty in finding employment at anything but agricultural labor . . . [the] northern businessmen's coalition consolidated the new economic slavery of tenant farming, sharecropping, and the planter store. Shackled to the cotton crop, the Negro (and his white counterpart) became perennial debtors to their new overseers. While it exagger-

Slave and Post-Slave / • • • / 51

ates the reality, there is a significant measure of truth in the idea that the Civil War gave more freedom—at least in the short run—to the white upper class of the south than it did to the slave. Both were liberated, but the one group far more effectively." [1]

However ineffectual Emancipation might have proven in its entirety, it did have a great deal of positive effect on the Negro. The black Reconstruction governments of the South, although hampered at every turn, managed to effect a few beneficial changes. The post-bellum government of South Carolina, for instance, provided public schooling for *500 per cent* more children than the antebellum government had. These governments tried to institute some basic social and political reforms, but because for most of the Northern whites the Reconstruction had never been anything but a token proposition, and the actual transfer of political and economic power had never been intended, the Negroes were finally powerless. The Reconstruction governments fell because the Northern industrialists joined with the Southern planters to disenfranchise the Negro once again, fearful that a coalition of the poor and disenfranchised Southern whites, the disillusioned agrarian interests, and the newly freed Negroes, might prove too strong a threat to their design of gaining absolute political and economic control of the South. But the Reconstruction did give the Negro a certain feeling of autonomy and self-reliance that could never be fully eradicated even after the repressive segregation measures that followed the so-called "Redemption of the South" in 1876:

". . . the demagogues assumed leadership of the 'poor whites' and provided a solution of the class conflict among whites that offered no challenge to the political power and economic privileges of the industrialists and the planter class. The program, which made the Negro the scapegoat, contained the following provisions: (1) The Negro was completely disfranchised by all sorts of legal subterfuges, with

[1] *The Contours of American History* (Cleveland, World, 1961).

the threat of force in the background; (2) the funds which were appropriated on a *per capita* basis for Negro school children were diverted to white schools; and (3) a legal system of segregation in all phases of public life was instituted. In order to justify this program, the demagogues, who were supported by the white propertied classes, engaged for twenty-five years in a campaign to prove that the Negro was sub-human, morally degenerate and intellectually incapable of being educated." [2]

It was during this period of legal subversion of the Negroes' rights as new citizens that such organizations as the Ku Klux Klan, Pale Faces, Men of Justice, Knights of the White Camelia, etc., appeared. These organizations, composed mostly of disenfranchised poor whites, but often inspired by the more well-to-do planter-merchant combine, sought to frighten Negroes into abandoning their newly won rights, particularly the right to vote, and in a great many cases these attempts succeeded.

There was, of course, a great deal of protest and resistance from Negroes, and especially the educated class of Negroes, but soon too many accepted the idea of segregation as the only way the Negro could continue to live in the white South. The Negro elite—professional men: doctors, lawyers, or small, financially ambitious merchants—soon were quite eager to promote the concept of "separate but equal." Thus in only about ten years after the Emancipation, there was already a great social reaction setting in. All the legal chicanery and physical suppression the South used to put the Negro back in his place was, in effect, aided and abetted by a great many so-called Negro leaders. For instance, after the North had more or less washed its hands of the whole "Southern dilemma," and it was a generally accepted idea that Negroes had ruined the Reconstruction simply because they were incapable of governing them-

[2] E. Franklin Frazier, *The Black Bourgeoisie* (Glencoe, Free Press, 1957), p. 18.

selves, Booker T. Washington became prominent and influential because he accepted the idea of segregation as a solution to the race problem and because he advocated that Negroes learn trades rather than go into any of the more ambitious professions. W. A. Williams notes, "Coming from Booker T. Washington, who enjoyed entrée into the society of Standard Oil executives, railroad magnates, and Andrew Carnegie, the strategy was persuasive. Washington avowed his loyalty to laissez faire, took his stand in the south as a southerner, and accepted social inequality for the foreseeable future. Blocked by the power of the whites and told by their own spokesman that 'white leadership is preferable,' most Negroes followed. . . ." [3]

Thus the idea of the "separate but equal" society, with equality almost completely nonexistent, came into being—although, to be sure, there arose in the South a black bourgeoisie who oftentimes were better off financially than a great many of the poor white farmers they had to say "suh" to. However, they swallowed the socio-economic concepts of their white upper-class models whole. It is my idea that the Civil War and the Emancipation served to create for the first time among Negroes a separate meta-society, one whose members strove to emulate exactly the white society. The black Christian church was the preface to this society during slavery, but after slavery the relatively great amount of personal freedom was sufficient to insure, at least among the more opportunistic freedmen, the impetus necessary to create within the newly formed black communities a socio-economic structure based almost entirely on the social structure of the white man.

As a slave, the black man in America performed an integral function in the mainstream of white American society. One that was easy to ascertain, and almost as easy to provide for. Slavery was, most of all, a paternal institution. The slave was property just like the cows, fruit trees, or wagons.

[3] *Op. cit.*

And he was handled in much the same way, with perhaps some small deference accorded him because after a while he began to understand what his white master was saying. All the minimal requirements necessary to sustain human life were provided for the slave by his owner; there was almost no need for any initiative or ambition. But with the release of the millions of black men to what was supposed to be the pursuit of happiness, the whole of American society, and particularly the Southern society, underwent a huge change. When the first attempts at a consolidation of the downtrodden Southerners, black and white, failed; and when the radical plans of men like Sumner and Stevens to redistribute the land of the South among the freedmen, breaking up the large plantations and making small farms for both black and white, also failed; and the separateness of black and white in the South was insured by the repressive Redemption methods; for what was really the first time, Negroes became actually isolated from the mainstream of American society. The newly activated Jim Crow laws (Virginia's were not passed until 1901) and other social repressions served to separate the Negro more effectively from his former masters than ever before.

With the old paternalistic society of the South went the simple role of the Negro in the Western world. Now the Negro was asked to throw himself into what was certainly still an alien environment and to deal with that environment in the same manner as his newly found white "brother" had been doing for centuries.

What is so often forgotten in any discussion of the Negro's "place" in American society is the fact that it was only as a slave that he really had one. The post-slave society had no place for the black American, and if there were to be any area of the society where the Negro might have an integral function, that area would have to be one that he created for himself. The Jim Crow laws were the white South's attempts to limit the new citizen's presence and rights in the

mainstream of the society, and they were extremely effective.

Also, for most of the ex-slaves, even the most banal of Western mores had to be relearned, as it were, from the point of view of the autonomous individual. For instance, the Negro had to realign himself with the concept of what a family is and of what it means to be working separately to keep oneself and/or one's family alive. The family had to be recognized again as a basic social unit, and the dominant image of the patriarchal society restored to full meaning. During slavery, one of the fundamental social breakdowns the Negro experienced was the disintegration of familial ties, especially the role of the man as the complete master of the familial unit. Under this disintegration, the role of the woman within the society became much less fixed. In West Africa there was a very definite division of labor. For the most part, women did the lighter work and the men, the heavier or more specialized. In agriculture, men did the preparing of the fields, and women tended to the actual growing and harvesting of the crops. But in America, the woman, like as not, worked alongside the man in the same fields. Here, as in other areas of the African captives' lives, the traditional order was broken down. The breakdown or disappearance of African mores and traditions in the New World proposed, paradoxically, a more egalitarian society among the slaves. Tribal and familial titles were gone in most cases, and the only hegemony that could be gotten by the slaves had to be extended by the white masters. Hence, Afro-American women, though raped and outraged by the slave South, usually assumed a status that was a good deal more "elevated" than the status of the average West African woman. And so it was that certain traditions that were usually given their impetus by the male members of an African community could, in the strange context of the slave and post-slave New World society, be developed equally by women, and in some cases could even be brought to their perfection by women. Blues, at a certain point of its develop-

ment, was one of those traditions, as I will attempt to show later.

So the post-slave black society in America was a completely unique thing to the ex-slaves as well as to the rest of America. There was also such a thing as the "slave mentality," which had a large part in shaping the new black society. By "slave mentality" I mean what had been the most socially unfortunate psychic adjustments the slave had made during two hundred years of slavery. The very speed with which the white South dealt with the ex-slave's formal aspirations to complete freedom and social and economic autonomy can be attributed to the negative influence of the slave mentality upon the great mass of Negroes. Two hundred years of bending to the will of the white man had to leave its mark. And that mark was indelibly on the very foundations of the new separate black society.

Another aspect of the white society that the Negroes patterned their new meta-society upon was the idea of stations within the social order, a hierarchy relatively impossible before the formal end of slavery. Of course, there had been some differentiation even in the slave society. The house slave, as I mentioned before, certainly enjoyed a bit of hegemony, no matter how artificial, over the field Negro. Also, Negroes who managed to learn trades were held in somewhat high esteem by the rest of the slaves. And the church officials, when the Negroes finally embraced Christianity, enjoyed perhaps the greatest prestige of all during slavery. Still, even in those relatively rare cases where a Negro did enjoy some privilege or special position, he was still a slave, and the added privilege could hardly serve to make the institution of slavery enjoyable. After slavery, the stratification of the social order among Negroes was rapid. At the bottom of the new social ladder were the tenant farmers and migrant laborers, and at the other end were the ministers, storekeepers, and professional men. It was the latter who naturally came to be regarded as the leaders of the

Slave and Post-Slave / • • • / 57

many Negro communities; usually they set the stance the new society would take. The emulation of white society proved to be not only a pattern for the new leaders, but an end in itself. Negroes who were highest in the social and economic hierarchy also became the most fanatic imitators of white society, while the great masses of Negroes were much slower in their attempts at complete imitation. This phenomenon caused a split in the psychical disposition of the Negro's temperament which certainly affected all areas of his life.

The developing middle class and the mainstream of black society found themselves headed two different ways. This disparity within the black community is of such importance that it cannot be overemphasized, and it became more and more pronounced as the Negro achieved more latitude and status in America. At its ugliest, this attitude was symbolized by the abandonment by a great many Negroes of the mores or customs they considered slave customs, or "too Negroid." Some black churches began to use as much of the white church music as they could. (My own church in Newark, New Jersey, a Baptist church, has almost no resemblance to the older, more traditional Negro Christian churches. The music, for instance, is usually limited to the less emotional white church music, and the choir usually sings Bach or Handel during Christmas and Easter. In response to some of its older "country" members, the church, which is headed by a minister who is the most respected Negro in Newark, has to *import* gospel groups, or singers having a more traditional "Negro church" sound.)

Robert A. Bone discusses a Negro author, Charles Chestnutt, who wrote a novel, *The Marrow of Tradition*, around the time a great many of the better class of Negroes were reacting against two hundred years of slavery by trying to abandon almost all their "Negro traits." Chestnutt's novel shows the kind of attitude that was adopted by some. The "hero" is a "refined Afro-American," a doctor, who is forced

to share a Jim Crow car with dirty, boisterous, and drunken Negroes. He is revolted by these people, farm laborers, in the coach, and Chesnutt says, "These people were just as offensive to him as to the whites in the other end of the train." [4]

This kind of hideous attitude in a Negro (and most of the Negro novelists of the time were quite close to Chesnutt in their social attitudes) could only stem from an acceptance of the idea of the superiority of the white man, or at least the proposition that the Negro, somehow, must completely lose himself within the culture and social order of the ex-master. It is another aspect of the slave mentality.

Blues, too, or at that time the shouts, chants, hollers, which later took more lasting form as blues, received the same treatment from these "refined Afro-Americans." The Negro's music was the most impressive reminder for these people of slavery and of their less cultivated brothers. And it, too, was to be abandoned on the altar of assimilation and progress. During the time immediately after the Emancipation, this kind of thinking was limited to only a few Negroes; the growth to "maturity" of this finally anti-Negro attitude among Negroes comes a little later. It is sufficient to note here some of the reasons for its genesis.

The Negro, during those few years after the end of slavery, just before the exodus to the Northern cities, stood further away from the mainstream of American society than at any other time. It was also during these years that the Negro's music lost a great many of the more superficial forms it had borrowed from the white man, and the forms that we recognize now as blues began to appear. There were still black "ballit" singers who sang songs that used centuries-old classical Anglo-Saxon ballad forms and spirituals that were pure "lifts" from the Protestant hymnals. But in a few years after the Emancipation, the shouts, hollers, yells, spirituals, and ballits began to take shape as blues.

[4] *The Negro Novel in America* (New Haven, Yale University Press, 1958), p. 18.

6 / Primitive Blues and Primitive Jazz

A slave cannot be a man. A man does not, or is not supposed to, work all of his life without recourse to the other areas of human existence. The emotional limitations that slavery must enforce are monstrous: the weight of his bondage makes impossible for the slave a great many alternatives into which the shabbiest of free men can project himself. There is not even a separate identity the ego can claim. "What are you going to be when you grow up?" "A slave."

The work song is a limited social possibility. The shouts and hollers were strident laments, more than anything. They were also chronicles, but of such a mean kind of existence that they could not assume the universality any lasting musical form must have. The work songs and later blues forms differ very profoundly not only in their form but in their lyrics and *intent*.

> Oh, Lawd, I'm tired, uuh
> Oh, Lawd, I'm tired, uuh
> Oh, Lawd, I'm tired, uuh
> Oh, Lawd, I'm tired, a dis mess.
>
> (*repeated*)

Primitive blues-singing actually came into being because of the Civil War, in one sense. The emancipation of the slaves proposed for them a normal human existence, a humanity impossible under slavery. Of course, even after slavery the average Negro's life in America was, using the more ebullient standards of the average American white man, a shabby, barren existence. But still this was the black man's first experience of time when he could be alone. The leisure that could be extracted from even the most desolate sharecropper's shack in Mississippi was a novelty, and it served as an important catalyst for the next form blues took.

Many Negroes who were sharecroppers, or who managed to purchase one of the tiny farms that dotted the less fertile lands of the South, worked in their fields alone or with their families. The old shouts and hollers were still their accompaniment for the arduous work of clearing land, planting, or harvesting crops. But there was a solitude to this work that had never been present in the old slave times. The huge plantation fields had many slaves, and they sang together. On the smaller farms with fewer slaves where the older African forms died out quicker, the eight- and sixteen-bar "ballits," imitations of the songs of the white masters, were heard along with the shouts. Of course, there must have been lyrics to some of the songs that the slave could not wisely sing in front of his master. But the small farms and sharecroppers' plots produced not only what I think must have been a less self-conscious work song but a form of song or shout that did not necessarily have to be concerned with, or inspired by, *labor*. Each man had his own voice and his own way of shouting—his own life to sing about. The tenders of those thousands of small farms became almost identified by their individual shouts. "That's George Jones, down in Hartsville, shoutin' like that."

Along with this leisure there was also that personal freedom to conduct or ruin one's life as one saw fit. In the 1870's there were thousands of black migrant workers moving all

through the South. There were also men who just moved around from place to place, not really migratory laborers, just footloose wanderers. There could come now to these ex-slaves a much fuller idea of what exactly America was. A slave on a Georgia plantation, unless he was sold or escaped, usually was born, grew to manhood, and died right in Georgia. To him, the whole of America would be Georgia, and it would have to conform strictly to what he had experienced. St. Louis, Houston, Shreveport, New Orleans, simply did not exist (and certainly not New York). But now for many Negroes there was a life of movement from farm to farm, or town to town. The limited social and emotional alternatives of the work song could no longer contain the growing experience of this country that Negroes began to respond to. Also, the entrance of Negroes into the more complicated social situation of self-reliance proposed multitudes of social and cultural problems that they never had to deal with as slaves. The music of the Negro began to reflect these social and cultural complexities and change.

Very early blues did not have the "classic" twelve-bar, three-line, AAB structure. For a while, as I mentioned before, blues-type songs utilized the structure of the early English ballad, and sometimes these songs were eight, ten, or sixteen bars. The shout as much as the African call-and-response singing dictated the form blues took. Blues issued directly out of the shout and, of course, the spiritual. The three-line structure of blues was a feature of the shout. The first two lines of the song were repeated, it would seem, while the singer was waiting for the next line to come. Or, as was characteristic of the hollers and shouts, the single line could be repeated again and again, either because the singer especially liked it, or because he could not think of another line. The repeated phrase also carries into instrumental jazz as the *riff*.

Another reason for the changes in musical form was the change of speech patterns among a great many Negroes.

By now the language of America was mastered for casual use by most Negroes. While the work song or shout had only a few English words, or was composed of Africanized English words or some patois-like language that seemed more a separate language than an attempt at mastering English, early blues had already moved toward pure American lyrics (with the intent that the song be understood by other Americans). The endlessly repeated line of the shout or holler might also have been due to the relative paucity of American words the average field Negro possessed, the rhyme line being much more difficult to supply because of the actual limitation singing in American imposed. The lines came more easily as the language was mastered more completely. Blues was a kind of singing that utilized a language that was almost strictly American. It was not until the ex-slaves had mastered this language in whatever appropriation of it they made that blues began to be more evident than shouts and hollers.

The end of the almost exclusive hold of the Christian Church on the black man's leisure also resulted in a great many changes of emphasis in his music. The blues is formed out of the same social and musical fabric that the spiritual issued from, but with blues the social emphasis becomes more personal, the "Jordan" of the song much more intensely a *human* accomplishment. The end of slavery could be regarded as a Jordan, and not a metaphysical one either, although the analogy of the deliverance of the Jews and the Emancipation must have been much too cogent a point for proselytizing to be lost on the local black minister. There was a definite change of *direction* in the primitive blues. The metaphysical Jordan of life after death was beginning to be replaced by the more pragmatic Jordan of the American master: the Jordan of what the ex-slave could see vaguely as self-determination. Not that that idea or emotion hadn't been with the very first Africans who had been brought here; the difference was that the American Negro wanted

some degree of self-determination where he was living. The desperation to return to Africa had begun to be replaced by another even more hopeless one. The Negro began to feel a desire to be more in this country, America, than chattel. "The sun's gonna shine in my back door someday!"

The leisure and movement allowed to Negroes after the Civil War helped to standardize the new blues form as well as spread the best verses that were made up. Although there were regional differences in the way blues began to be sung, there were also certain recurring, soon "classical," blues verses and techniques that turned up in a great many places simply because a man had been there from Georgia or Louisiana or South Carolina and shown the locals what his town or region produced.

But the thousands of black blues shouters and ballit singers who wandered throughout the South around the turn of the century moved from place to place not only because Negroes were allowed to travel after the Civil War, but because for a great many Negroes, emancipation meant a constant desperate search for employment (although there must also have been those people who, having been released from their bondage, set out at once to see what this country was really about). Not only the migratory workers who followed the crop harvests but the young men who wanted any kind of work had to tramp all over the South in search of it. It is also a strange note that once the Negroes were free, it was always the men who had the harder time finding work. Women could always find work as domestics wherever they were. But the black man who had done agricultural labor, as most Negroes had, found it difficult to find work because the impoverished whites of the South suddenly had to pay wages to their workers. The Negro had to have wages to live: for the first time he needed money and had to enter into the fierce struggle for economic security like any other poor man in this country. Again, even the economic status of the Negro after his freedom proposed new changes for

his music. "I never had to have no money befo'/And now they want it everywhere I go." The content of blues verse had become much changed from the strictly extemporized lyrics of the shouts and hollers.

It seems possible to me that some kind of graph could be set up using samplings of Negro music proper to whatever moment of the Negro's social history was selected, and that in each grouping of songs a certain frequency of reference could pretty well determine his social, economic, and psychological states at that particular period. From the neo-African slave chants through the primitive and classical blues to the scat-singing of the beboppers: all would show definite insistences of reference that would isolate each group from the others as a social entity. No slave song need speak about the slave's lack of money; no early Afro-American slave song would make reference to the Christian Church; almost no classical blues song would, or could, make direct or *positive* mention of Africa. Each phase of the Negro's music issued directly from the dictates of his social and psychological environment. Hence the black man who began after slavery to eliminate as much of the Negro culture from his life as possible became by this very act a certain kind of *Negro*. And if this certain kind of Negro still endeavored to make music, albeit with the strict provision that this music not be a Negro music, he could still not escape the final "insult" of this music being evaluated socially, psychologically, and musically as a kind of *Negro* music. The movement of the Negro into a position where he would be able to escape even this separation from the white mainstream of America is a central theme of this book.

Even with the relative formalization of secular Negro music, blues was still an extremely personal music. There were the songs extolling the merits and adventures of heroes or heroic archetypes, John Henry, Stagger Lee, Dupree, etc., but even as the blues began to expand its references it still remained a kind of singing that told about the exploits of

the singer. Heroic archetypes or cowardly archetypes were used to point up some part of the singer's life.

> In come a nigger named Billy Go-helf
> Coon was so mean was skeered of hisself;
> Loaded wid razors an' guns, so they say,
> Cause he killed a coon most every day.

And this intensely personal nature of blues-singing is also the result of what can be called the Negro's "American experience." African songs dealt, as did the songs of a great many of the preliterate or classical civilizations, with the exploits of the social unit, usually the tribe. There were songs about the gods, their works and lives, about nature and the elements, about the nature of a man's life on the earth and what he could expect after he died, but the insistence of blues verse on the life of the individual and his individual trials and successes on the earth is a manifestation of the whole Western concept of man's life, and it is a development that could only be found in an American black man's music. From the American black leader's acceptance of Adam Smith "laissez faire" social inferences to some less fortunate black man's relegation to a lonely patch of useless earth in South Carolina, the weight of Western tradition, or to make it more specific and local, the weight of just what social circumstance and accident came together to produce the America that the Negro was part of, had to make itself part of his life as well. The whole concept of the *solo*, of a man singing or playing by himself, was relatively unknown in West African music.

But if the blues was a music that developed because of the Negro's adaptation to, and adoption of, America, it was also a music that developed because of the Negro's peculiar position in this country. Early blues, as it came to differ from the shout and the Afro-Christian religious music, was also perhaps the most impressive expression of the Negro's individuality within the superstructure of American society.

Even though its birth and growth seems connected finally to the general movement of the mass of black Americans into the central culture of the country, blues still went back for its impetus and emotional meaning to the individual, to his completely personal life and death. Because of this, blues could remain for a long time a very fresh and singular form of expression. Though certain techniques and verses came to be standardized among blues singers, the singing itself remained as arbitrary and personal as the shout. Each man sang a different blues: the Peatie Wheatstraw blues, the Blind Lemon blues, the Blind Willie Johnson blues, etc. The music remained that personal because it began with the performers themselves, and not with formalized notions of how it was to be performed. Early blues developed as a music to be sung for *pleasure*, a casual music, and that was its strength and its weakness.

> I don't want you to be no slave,
> I don't want you to work all day,
> I don't want you to be true,
> I just want to make love to you.

Since most Negroes before and after slavery were agricultural laborers, the corn songs and arwhoolies, the shouts and hollers, issued from one kind of work. Some of the work songs, for instance, use as their measure the grunt of a man pushing a heavy weight or the blow of a hammer against a stone to provide the metrical precision and rhythmical impetus behind the singer. ("Take this hammer, uh,/Take it to the captain, uh,/Take it to the captain, uh,/Tell him I'm gone.") Contemporary work songs, for example, songs recorded by Negro convicts working in the South—laying railroad ties, felling trees, breaking rocks, take their impetus from the work being done, and the form of the singing itself is dictated by the work. These workers for the most part do not sing blues. The labor is central to the song: not only is the recurring grunt or moan of these work songs some kind

of metrical and rhythmical insistence, it is the very catalyst for the song. On one recent record, the Louisiana Folklore Society's, *Prison Worksongs* recorded in Angola, Louisiana, at the Louisiana State Penitentiary there, one song listed as *Take This Hammer* begins as that song, but lasts as that for only about three "bars" (three strokes of the hammer) and then wanders irresolutely into *Alberta, Berta,* several blues verses, and a few lines from a spiritual. The point is that the primitive blues was at once a more formal music since the three-line, twelve-bar song became rapidly standardized, and was also a more liberated music since there was literally *more* to sing about. In one's leisure one can begin to formalize a method of singing as well as find new things to sing about. (It is an interesting thought that perhaps all the music that Negroes in America have made might have been quite different if the work that they were brought here to do had been different. Suppose Negroes had been brought to this country to make vases or play basketball. How might the blues have developed then from the impetus of work songs geared to those occupations?)

Work songs and shouts were, of course, almost always *a capella.* It would have been extremely difficult for a man to pick cotton or shuck corn and play an instrument at the same time. For this reason pre-blues secular singing did not have the discipline or strict formality that a kind of singing employing instruments must have. But it is obvious from the very earliest form of the blues that instrumental accompaniment was beginning to be taken into consideration. The twelve-bar blues—the more or less final form of blues—is constructed so that each verse is of three lines, each line about four bars long. The words of the song usually occupy about one-half of each line, leaving a space of two bars for either a sung answer or an instrumental response.

It may seem strange that the formal blues should evolve *after* slavery, after so many years of bondage and exposure

by the slaves to the larger Western cultural unit, into a form that is patently non-Western; the three-line verse form of the blues springs from no readily apparent Western source. But the use of instruments on a large scale was also something that happened after the Emancipation; the very possession of instruments, except those few made from African models, was rare in the early days of slavery. The stereotyped pictures that many of the apologists for the Southern way of life used as flyleaves for their numerous novels after the Civil War, depicting a happy-go-lucky black existentialist strumming merrily on his banjo while sitting on a bale of cotton, were, I'm sure, more romantic fiction than fact. The slave would hardly have had the time to sit on his master's bale of cotton during the work day, and the only instruments that were in common usage among the slaves were drums, rattles, tambourines, scrapers (the jawbone of a horse over which a piece of wood was scraped), and the like; even such an African instrument as the banjo was very scarce. The guitar was not commonly played by Negroes until much after the Civil War. An instrument like the harmonica grew in popularity among a great many Negroes simply because it took up almost no space and was so easy to carry around. But even the harmonica did not come into common use until after slavery, and certainly the possession and mastery of European instruments did not occur until much later.

When primitive or country blues did begin to be influenced by instruments, it was the guitar that had the most effect on the singers. And when the great masses of Negroes were just beginning to learn the instrument, the relatively simple chords of the country blues were probably what they learned. Conceivably, this also brought about another change: blues, a vocal music, was made to conform to an instrument's range. But, of course, the blues widened the range of the instrument, too. Blues guitar was not the same as classical or "legitimate" guitar: the strings had to make

vocal sounds, to imitate the human voice and its eerie cacophonies. Perhaps the reason why the guitar was at once so popular was not only because it was much like the African instrument, the banjo (or *banjor*), but because it was an instrument that still permitted the performer to *sing*.

When the Negro finally did take up the brass instruments for strictly instrumental blues or jazz, the players still persisted in singing in the "breaks." This could be done easily in the blues tradition with the call-and-response form of blues. Even much later in the jazz tradition, not only were instruments made to sound like the human voice but a great many of the predominantly instrumental songs were still partially sung. The first great soloist of jazz, Louis Armstrong, was a formidable blues singer, as was the great jazz pianist Jelly Roll Morton. Both men sang blues almost as beautifully as they played their instruments.

The primitive blues was still very much a vocal music; the singers relied on the unpredictability and mobility of the human voice for their imaginative catalysts. But the growing use of European instruments such as brass and reeds almost precluded song, except as accompaniment or as an interlude. When Negroes began to master more and more "European" instruments and began to think musically in terms of their timbres, as opposed to, or in conjunction with, the voice, blues began to change, and the era of jazz was at hand.

"Jazz began in New Orleans and worked its way up the river to Chicago," is the announcement most investigators of mainstream popular culture are apt to make when dealing with the vague subject of jazz and its origins. And while that is certainly a rational explanation, charmingly simple, etc., it is more than likely untrue. Jazz, or purely instrumental blues, could no more have begun in one area of the country than could blues. The mass migrations of Negroes throughout the South and the general liberating effect of

the Emancipation make it extremely difficult to say just exactly where and when jazz, or purely instrumental blues (with European instruments), originated. It *is* easy to point out that jazz is a music that could not have existed without blues and its various antecedents. However, jazz should not be thought of as a *successor* to blues, but as a very original music that developed out of, and was concomitant with, blues and moved off into its own path of development. One interesting point is that although jazz developed out of a kind of blues, blues in its later popular connotation came to mean *a way of playing jazz,* and by the swing era the widespread popularity of the blues singer had already been replaced by the jazz player's. By then, blues was for a great many people no longer a separate music.

Even though New Orleans cannot be thought of with any historical veracity as "the birthplace of jazz," there has been so much investigation of the jazz and earlier music characteristic there in the first part of the twentieth century, that from New Orleans conclusions may be drawn concerning the social and cultural phenomena that led to the creation of jazz. Also, the various effects of the development of this music upon Negroes in the area can be considered and certain essential analogies made.

I have mentioned Congo Square in New Orleans as a place where African Negroes in the earlier years of slavery met to play what was certainly an African music. Marshall Stearns quotes an architect, Benjamin Latrobe, who visited Congo Square in 1819:

"The music consisted of two drums and a stringed instrument. An old man sat astride of a cylindrical drum about a foot in diameter, and beat it with incredible quickness with the edge of his hand and fingers. The other drum was an open staved thing held between the knees and beaten in the same manner. . . . The most curious instrument, however, was a stringed instrument which no doubt was imported from Africa. On the top of the finger board was

the rude figure of a man in a sitting posture, and two pegs behind him to which the strings were fastened. The body was a calabash . . . One, which from the color of the wood seemed new, consisted of a block cut into something of the form of a cricket bat with a long and deep mortice down the center . . . being beaten lustily on the side by a short stick. In the same orchestra was a square drum, looking like a stool . . . also a calabash with a round hole in it, the hole studded with brass nails, which was beaten by a woman with two short sticks." [1]

This kind of gathering in Congo Square was usually the only chance Negroes had to sing and play at length. And, of course, even this was supervised by the local authorities: the slaves were brought to the square and brought back by their masters. Still, the Congo Square sessions were said to have included many African songs that were supposedly banned by the whites for being part of the vodun or voodoo rites. The slaves also danced French quadrilles and sang patois ditties in addition to the more African chants that they shouted above the "great drums."

Nowhere else in the United States is the French influence so apparent as in New Orleans; it was this predominantly French culture that set the tone for the Europeanization of African slaves in the area. The mulattoes, or light-skinned Negroes, in New Orleans, who were the result usually of some less than legal union between the French masters and black slave women, even adopted the name *Creole* to distinguish themselves from the other Negroes, although this term originally meant any white settler of French or Spanish blood. The Creoles, in much the same manner as the house Negroes on plantations in other areas, adopted as much of the French culture as they could and turned their backs on the "darker" culture of their half-brothers. It is safe to assume, for instance, that there were no black Creoles dancing in Congo Square.

[1] *The Story of Jazz* (New York, Oxford University Press, 1956), p. 43.

The black man must have been impressed not only by the words and dances of the quadrilles and minuets he learned from the French settlers of New Orleans, but by the instruments the white Creoles employed to play them. So New Orleans Negroes became interested in the tubas, clarinets, trombones, and trumpets of the white marching bands, which were also popular in New Orleans as well as in many other Southern cities. (In the time of Napoleon, the popularity of the military band soon spread from France to all the settlements in the New World influenced by French culture.) The "exotic" rhythms of the quadrilles (2/4 and 6/8) and the military marching bands (4/4) also made a great impression on the slaves, and they tried to incorporate these meters into their own music. The black Creoles, however, tried to adopt these elements of French culture completely, learning the quadrilles by rote. Still slavery and the circumstance of the Negroes' bondage played a big role in this kind of assimilation as well. Many of the Creoles were freedmen by virtue of the accident of their birth, or at least were house servants long before the Emancipation. They had direct access to European music and instruments long before the rest of the Negroes in the area.

The marching bands that were started by Negroes in imitation of the Napoleonic military marching bands of the white Creoles also fell into two distinct categories. There were the comparatively finely trained bands of the Creoles and the untutored, raw bands of the Uptown, darker New Orleans Negroes (which did not begin until well after slavery was abolished). These bands were used for all kinds of affairs; in addition to the famous funeral processions, they played for picnics, dances, boating trips, and the like. One reason for the formation of these bands was the organization of a great number of clubs and secret societies and fraternities in the Negro communities (white and black) after the Emancipation. These societies and fraternities were an important part of the Negro's life, and drained a lot of

the black community away from the Christian Church, which had been the sole place the slaves could spend their leisure time. But it was not unusual for a Negro to belong to the Christian Church (in New Orleans, after the Black Codes of 1724, Negroes were only allowed to become Catholics) and to also belong to a number of secret societies. These societies still thrive today all over the country in most Negro communities, though for the most part their actual "secrecy" is the secrecy of any fraternal organization. The Masons and the Elks have claimed most urban and Northern Negroes, and the old vodun-tinged secret orders, sometimes banned by whites, have for the most part (except in the rural areas) disappeared completely.

One example of the way Negroes used European rhythms in conjunction with their own West African rhythms was the funeral processions. The march to the cemetery was played in slow, dirgelike 4/4 cadence. It was usually a spiritual that was played, but made into a kind of raw and bluesy Napoleonic military march. The band was followed by the mourners—relatives, members of the deceased's fraternal order or secret society, and well-wishers. (All night before the burial, or on as many nights as there were that intervened between the death and the burial, the mourners came into the house of the deceased to weep and wail and kiss the body. But these "wakes" or "mourning times" usually turned into house parties.) After the burial, the band, once removed some good distance from the cemetery, usually broke into the uptempo part of the march at some approximation of the 2/4 quadrille time. *Didn't He Ramble* and *When the Saints Go Marchin' In* were two of the most frequently played tunes—both transmuted religious songs. Even in this kind of march music the influence of the blues was very heavy, at least for the Uptown or "darker" brass bands—the Downtown Creole bands would have nothing to do with the "raw and raucous playing of those dark folks." The form of the Creole funerals must have differed also if the Downtown mourners were

emulating their white Creole models. Certainly a great many self-respecting Creoles must have frowned on the antics the darker Negroes performed when burying a member of their community. The long period of jovial mourning, complete with banquets and dancing, was certainly outside the pale of either Catholic or Protestant religious practice. Herskovits cites these burial customs as originating in West Africa, especially among the large Dahomey tribes. (An interesting note about the New Orleans funeral is that recently, in 1955, *Ebony*, the vehicle of American middle-class Negro aspirations, announced that when PaPa Celestin, the great New Orleans trumpet player, died, no jazz was played—"out of respect for PaPa.")

By the time the marching and brass bands were in vogue in New Orleans and some other parts of the South, Negroes had already begun to master a great many other European instruments besides the guitar and the harmonica. The trumpets, trombones, and tubas of the brass bands were played with a varying amount of skill, though when a man has learned enough about an instrument to play the music he wants to play, "skill" becomes an arbitrary consideration. The black brass bands of New Orleans around the turn of the century had certainly mastered the European brass instruments as well as the Downtown Creole bands, but by now they were simply "doing it the way they felt it." By the time the first non-marching, instrumental, blues-oriented groups started to appear in numbers, *i.e.*, the "jass" or "dirty" bands, the instrumentation was a pastiche of the brass bands and the lighter quadrille groups. In 1897, Buddy Bolden's group consisted of cornet, trombone, clarinet (the first reed instrument Negroes began to play with any frequency), violin, guitar, string bass (already an innovation over the tuba, the first "time-keeping" instrument in these bands), and drums.

The repressive "white supremacy" measures that were put into effect after the Civil War had a great deal of effect on the music of New Orleans. By 1894, there was a legislative act

enforcing segregation which hit the black Creoles hardest. It also, in the long run, helped redirect their social and musical energies. Up until the time of the infamous discriminative codes, the Creoles enjoyed an autonomy of social and economic status; to a certain extent they had the same economic and social advantages as the whites. Many of them had been educated in France and also sent their children to France to be educated, where many remained. Quite a few Creole families were among the richest families in New Orleans, and still others were well-known artisans and craftsmen. In a great many cases Creoles worked side by side with whites. They also enjoyed the cultural side of eighteenth- and nineteenth-century New Orleans life: Creoles had their own boxes at the opera, and they participated in all the Downtown or white parades with their own highly trained military-style marching bands. But with the segregation acts of the late nineteenth century, Creoles began to lose the jobs where they had been working with whites, and they were no longer permitted to play Downtown, neither in the homes of the rich whites nor in the military parades.

It was about this time that the darker, blues-oriented musicians from Uptown New Orleans were beginning to play their "dirty" instrumental music in saloons and dance halls, at parties, picnics, and some of the places where the older brass marching bands used to hold forth. It was still a "marchy" kind of music, but the strict 4/4 march tempo had given way to the ragged 2/4 tempo, and the timbres and tones that people like Bolden began to use were radically removed from the pure sonorities of European-style marching bands. Theirs was a much more vocal kind of playing compared to the way brass horns had been used before. Again, this seems part of a definable cycle in the response of the Negro to the cultural and social stimuli of this country. The blues moved through much the same cycle, developing out of what seemed like imitations of European music into a form (and content) that was relatively autonomous. Primi-

tive blues is much more a Negro music than a great deal of the music it grew out of.

Miss Kemble in her diary reports hearing Negroes singing a song "while they labored" on river boats that was very much like *Coming Through the Rye*. It is quite probable that it was *Coming Through the Rye*. Most slaves in the early part of the nineteenth century could not have sung the words to the song, but could change them into: "Jenny shake her toe at me,/Jenny gone away;/Jenny shake her toe at me,/Jenny gone away./Hurrah! Miss Susy, oh!/Jenny gone away;/Hurrah! Miss Susy, oh!/Jenny gone away." Also relevant are the best of Miss Kemble's observations about Negro music—presumably their work songs, since she would hardly have observed them at any other time:

"Except the extemporaneous chants in our honor . . . I have never heard the Negroes . . . sing any words that could be said to have any sense. To one, an extremely pretty, plaintive, and original air, there was but one line, which was repeated with a sort of wailing chorus—

Oh! my massa told me, there's no grass in Georgia.

Upon inquiring the meaning of which, I was told it was supposed to be the lamentation of a slave from one of the more northerly states, Virginia or Carolina, where the labor of hoeing the weeds, or grass as they call it, is not nearly so severe as here, in the rice and cotton lands of Georgia. Another very pretty and pathetic tune began with words that seemed to promise something sentimental—

Fare you well, and good-by, oh, oh!
I'm goin' away to leave you, oh! oh!

but immediately went off into nonsense verses about gentlemen in the parlor drinking wine and cordial, and ladies in the drawing room drinking tea and coffee, etc. I have heard that many of the masters and overseers on these plantations prohibit melancholy tunes or words, and encourage nothing

but cheerful music and senseless words, deprecating the effect of sadder strains upon the slaves, whose peculiar musical sensibility might be expected to make them especially excitable by any songs of a plaintive character, and having any reference to their peculiar hardships." [2]

And so we have perhaps another reason why the Negro's secular music matured only after the end of slavery. The blues, as it came into its own strict form, was the most plaintive and melancholy music imaginable. And the content, the meaning, Miss Kemble searched for in vain in the work songs, was certainly quite evident in the later music.

Although the instrumental music moved toward an autonomous form only after the Emancipation, in only a few years after the beginning of the twentieth century, there was such a thing as a jazz band. And in a few more years this kind of band was throwing off most of its musical ties with the brass marching bands or the string groups of the white Creoles.

When the Creoles "of color" began to lose their Downtown jobs or found that they were no longer permitted to play for white affairs, some of them began to make the trip Uptown to sit in with their darker half-brothers. By this time, near the turn of the century, there was a marked difference in the playing and music of the Uptown and Downtown Negroes. The Creoles had received formal musical training, sometimes under the aegis of white French teachers. They had mastered the European instrumental techniques, and the music they played was European. The Uptown Negroes, who had usually learned their instruments by ear and never received formal and technical training, developed an instrumental technique and music of their own, a music that relied heavily on the non-European vocal tradition of blues. Many Creoles who had turned their backs on this "darker" tradition now began to try to learn it again.

An important idea to consider here is that jazz as it developed was predominantly a blues-based music. The blues

[2] *Op. cit.*, pp. 163-64.

timbre and spirit had come to jazz virtually unchanged, even though the early Negro musicians using European instruments had to learn to play them with the strict European march music as a model. The "classical" timbre of the trumpet, the timbre that Creoles imitated, was not the timbre that came into jazz. The purity of tone that the European trumpet player desired was put aside by the Negro trumpeter for the more humanly expressive sound of the voice. The brass sound came to the blues, but it was a brass sound hardly related to its European models. The rough, raw sound the black man forced out of these European instruments was a sound he had cultivated in this country for two hundred years. It was an American sound, something indigenous to a certain kind of cultural existence in this country.

Creoles like violinist Paul Domingues, when he said, "See, us Downtown people, we didn't think so much of this rough Uptown jazz until we couldn't make a living otherwise. . . . I don't know how they do it. But goddam, they'll do it. Can't tell you what's there on the paper, but just play the hell out of it," [3] were expressing perhaps the basic conflict to arise regarding the way the ex-slave was to make his way in America. Adaptation or assimilation? It was not much of a problem for most Negroes in the nineteenth century, although, to be sure, there must have been quite a few who had already disappeared (culturally) into the white world. The Creoles, for instance, had already made that move, but New Orleans was a special situation. Adaptation was the Negro's way earlier; he had little choice. He had not sufficient knowledge of, or experience in, the dominant culture to become completely assimilated within it. He went along the path of least resistance, which was to fashion something out of that culture for himself, girded by the strength of the still evident African culture. The Uptown musicians made jazz in this manner. The Creoles resisted "Negro" music because they thought

[3] Alan Lomax, *Mr. Jelly Roll* (New York, Duell, Sloan & Pearce, 1950), pp. 15-16.

they had found a place within white society which would preclude their being Negroes. But they were unsuccessful in their attempt to "disappear" because the whites themselves reminded them that they were still, for all their assimilation, "coons." And this seems to me an extremely important idea since it is just this bitter insistence that has kept what can be called Negro culture a brilliant amalgam of diverse influences.

There was always a border beyond which the Negro could not go, whether musically or socially. There was always a possible limitation to any dilution or excession of cultural or spiritual references. The Negro could not ever become white and that was his strength; at some point, always, he could not participate in the dominant tenor of the white man's culture. It was at this juncture that he had to make use of other resources, whether African, subcultural, or hermetic. And it was this boundary, this no man's land, that provided the logic and beauty of his music.

What has been called "classic blues" was the result of more diverse sociological and musical influences than any other kind of American Negro music called blues. Musically, classic blues showed the Negro singer's appropriation of a great many elements of popular American music, notably the music associated with popular theater or vaudeville. The instrumental music that accompanied classic blues also reflected this development, as it did the Negro musician's maturing awareness of a more instrumental style, possibly as a foil to be used with his naturally vocal style. Classic blues appeared in America at about the same time as ragtime, the most instrumental or nonvocal music to issue from Negro inspiration. Ragtime is also a music that is closely associated with the popular theater of the late nineteenth and early twentieth centuries. Although ragtime must be considered as a separate kind of music, borrowing more European elements than any other music commonly associated with Negroes, it contributed greatly to the development of Negro music from an almost purely vocal tradition to one that could begin to include the melodic and harmonic complexities of instrumental music.

Socially, classic blues and the instrumental styles that

went with it represented the Negro's entrance into the world of professional entertainment and the assumption of the psychological imperatives that must accompany such a phenomenon. Blues was a music that arose from the needs of a group, although it was assumed that each man had his *own* blues and that he would sing them. As such, the music was private and personal, although the wandering country blues singers of earlier times had from time to time casual audiences who would sometimes respond with gifts of food, clothes, or even money. But again it was assumed that *anybody* could sing the blues. If someone had lived in this world into manhood, it was taken for granted that he had been given the content of his verses, and as I pointed out earlier, musical training was not a part of African tradition—music like any art was the result of natural inclination. Given the deeply personal quality of blues-singing, there could be no particular method for *learning* blues. As a verse form, it was the lyrics which were most important, and they issued from life. But classic blues took on a certain degree of professionalism. It was no longer strictly the group singing to ease their labors or the casual expression of personal deliberations on the world. It became a music that could be used to entertain others *formally*. The artisan, the professional blues singer, appeared; blues-singing no longer had to be merely a passionately felt avocation, it could now become a way of making a living. An external and sophisticated idea of performance had come to the blues, moving it past the casualness of the "folk" to the conditioned emotional gesture of the "public."

This professionalism came from the Negro theater: the black minstrel shows, traveling road shows, medicine shows, vaudeville shows, carnivals, and tiny circuses all included blues singers and small or large bands. The Negro theater, in form, was modeled on the earlier white minstrel shows and traveling shows which played around America, especially in rural areas where there was no other formal entertainment.

The Negro theater did not, of course, come into being until after the Civil War, but the minstrel show is traceable back to the beginning of the nineteenth century. White performers using blackface to do "imitations of Negro life" appeared in America around 1800, usually in solo performances. By the 1840's, however, blackface was the rage of the country, and there were minstrel shows from America traveling all over the world. It was at least thirty more years before there were groups of traveling entertainers who did not have to use burnt cork or greasepaint.

It is essential to realize that minstrelsy was an extremely important sociological phenomenon in America. The idea of white men imitating, or caricaturing, what they consider certain generic characteristics of the black man's life in America to entertain other white men is important if only because of the Negro's reaction to it. (And it is the Negro's *reaction to* America, first white and then black and white America, that I consider to have made him such a unique member of this society.)

The reasons for the existence of minstrelsy are important also because in considering them we find out even more about the way in which the white man's concept of the Negro changed and why it changed. This gradual change, no matter how it was manifested, makes a graph of the movement of the Negro through American society, and provides an historical context for the rest of my speculations.

I suppose the "childlike" qualities of the African must have always been amusing to the American. I mentioned before how the black man's penchant for the supernatural was held up for ridicule by his white captors, as were other characteristics of African culture. Also, I am certain that most white Americans never thought of the plight of the black man as tragic. Even the Christian Church justified slavery until well into the nineteenth century. The "darky" at his most human excursion into the mainstream of American society was a comic figure. The idea that somehow the slavery of the

black man in America was a tragic situation did not occur to white Americans until the growth of the Abolition movement. But it is interesting that minstrelsy grew as the Abolition movement grew. I would say that as the "wild savage" took on more and more of what New England Humanists and church workers considered a human aspect, there was also more in his way of life that Americans found amusing. (As who has not laughed at the cork-faced "Negro" lawmakers in D. W. Griffiths' *Birth of a Nation?* It is a ridiculous situation, ignorant savages pretending they know as much as Southern senators.) As the image of the Negro in America was given more basic human qualities, *e.g.*, the ability to feel pain, perhaps the only consistent way of justifying what had been done to him—now that he had reached what can be called a post-bestial stage—was to demonstrate the ridiculousness of his inability to act as a "normal" human being. American Negroes were much funnier than Africans. (And I hope that Negro "low" comedy persists even long after all the gangsters on television are named Smith and Brown.)

The white minstrel shows were, at their best, merely parodies of Negro life, though I do not think that the idea of "the parody" was always present. It was sufficiently amusing for a white man with a painted face to attempt to reproduce some easily identifiable characteristic of "the darky." There was room for artistic imprecision in a minstrel show because it wasn't so much the performance that was side-splitting as the very idea of the show itself: "Watch these Niggers." Among the typical "Negro" material performed by the white minstrels are these two songs which perhaps indicate the nature of the parody white minstrelsy proposed to make of Negro life:

The Traveling Coon

Once there was a traveling coon
Who was born in Tennessee.
He made his living stealing chickens

. . . And everything else he could see.
Well, he traveled and he was known for miles around,
And he didn't get enough, he didn't get enough,
Till the police shot him down.

The Voodoo Man

I've been hoodooed, hoodooed
Hoodooed by a negro voodoo;
I've been hoodooed, hoodooed,
Hoodooed by a big black coon.

A coon for me had a great infatuation;
Wanted for to marry me but had no situation.
When I refused, that coon he got wild.
Says he, "I'm bound for to hoodoo this child."

He went out and got a rabbit's foot and burned
 it with a frog
Right by the road where I had to pass along.
Ever since that time my head's been wrong.[1]

The black minstrel shows were also what might be called parodies, or exaggerations, of certain aspects of Negro life in America. But in one sense the colored minstrel was poking fun at himself, and in another and probably more profound sense he was poking fun at the white man. The minstrel show was appropriated from the white man—the first Negro min-strels wore the "traditional" blackface over their own—but only the general form of the black minstrel show really re-sembled the white. It goes without saying that the black minstrels were "more authentic," and the black shows, al-though they did originate from white burlesques of Negro mores, were given a vitality and solid humor that the earlier shows never had.

[1] From Newman Ivey White, ed., *The Frank C. Brown Collection of North Carolina Folklore* (Durham, Duke University Press, 1962), pp. 88-89.

The minstrel shows introduced new dance steps to what could then be considered a mass audience. The cakewalk was one of the most famous dance steps to come out of minstrelsy; it has been described as "a take-off on the high manners of the white folks in the 'big house.'" (If the cakewalk is a Negro dance caricaturing certain white customs, what is that dance when, say, a white theater company attempts to satirize it as a Negro dance? I find the idea of white minstrels in blackface satirizing a dance satirizing themselves a remarkable kind of irony—which, I suppose, is the whole point of minstrel shows.)

Early Negro minstrel companies like the Georgia Minstrels, Pringle Minstrels, McCabe and Young Minstrels, provided the first real employment for Negro entertainers. Blues singers, musicians, dancers, comedians, all found fairly steady work with these large touring shows. For the first time Negro music was heard on a wider scale throughout the country, and began to exert a tremendous influence on the mainstream of the American entertainment world; a great many of the shows even made extensive tours of England and the Continent, introducing the older forms of blues as well as classic blues and early jazz to the entire world.

Classic blues is called "classic" because it was the music that seemed to contain all the diverse and conflicting elements of Negro music, plus the smoother emotional appeal of the "performance." It was the first Negro music that appeared in a formal context as entertainment, though it still contained the harsh, uncompromising reality of the earlier blues forms. It was, in effect, the perfect balance between the two worlds, and as such, it represented a clearly definable step by the Negro back into the mainstream of American society. Primitive blues had been almost a conscious expression of the Negro's *individuality* and equally important, his *separateness*. The first years after the Civil War saw the Negro as far away from the whole of American society as it was ever possi-

ble for him to be. Such a separation was never possible again. To the idea of the meta-society is opposed the concept of integration, two concepts that must always be present in any discussion of Negro life in America.

The emergence of classic blues indicated that many changes had taken place in the Negro. His sense of place, or status, within the superstructure of American society had changed radically since the days of the field holler. Perhaps what is so apparent in classic blues is the sense for the first time that the Negro felt he was a *part* of that superstructure at all. The lyrics of classic blues become concerned with situations and ideas that are recognizable as having issued from one area of a much larger human concern. Classic blues is less obscure to white America for these reasons, less involuted, and certainly less *precise*. Classic blues attempts a universality that earlier blues forms could not even envision. But with the attainment of such broad human meaning, the meanings which existed in blues *only for Negroes* grew less pointed. The professionalism of classic blues moved it to a certain extent out of the lives of Negroes. It became the stylized response, even though a great many of the social and emotional preoccupations of primitive blues remained. Now large groups of Negroes could sit quietly in a show and listen to a performer re-create certain serious areas of their lives. The following blues was written by Porter Grainger and sung by Bessie Smith:

Put It Right Here or Keep It Out There

I've had a man for fifteen years, give him his room and
 board;
Once he was like a Cadillac, now he's like an old, worn-
 out Ford;
He never brought me a lousy dime and put it in my
 hand;
So there'll be some changes from now on, according to
 my plan:

He's got to get it, bring it, and put it right here,
Or else he's goin' to keep it out there;
If he must steal it, beg it, or borrow it somewhere,
Long as he gets it, I don't care.

I'm tired of buyin' porkchops to grease his fat lips,
And he has to find another place for to park his old hips;
He must get it, and bring it, and put it right here.
Or else he's goin' to keep it out there.

The bee gets the honey and brings it to the comb,
Else he's kicked out of his home sweet home.
To show you that they brings it, watch the dog and the
 cat;
Everything even brings it, from a mule to a gnat.

The rooster gets the worm and brings it to the hen;
That oughta be a tip to all you no-good men.
The groundhog even brings it and puts it in his hole,
So my man is got to bring it—dog gone his soul.

He's got to get it, bring it; and put it right here,
Or else he's goin' to keep it out there.
If he must steal it, beg it, borrow it somewhere,
Long as he gets it, chile, I don't care.

I'm goin' to tell him like the Chinaman when you don't
 bring-um check,
You don't get-um laundry, if you break-um neck;
You got to get it, bring it; and put it right here,
Or else you goin' to keep it out there.

The "separate society" was moving to make some parallels
with the larger world. An idea of theater had come to the
blues, and this movement toward performance turned some
of the emotional climate of the Negro's life into artifact and
entertainment. But there was still enough intimacy between

the real world and the artifact to make that artifact beautiful and unbelievably moving.

Classic blues formalized blues even more than primitive blues had formalized earlier forms of Negro secular music. Just as the wandering primitive blues singers had spread a certain style of blues-singing, the performers of classic blues served as models and helped standardize certain styles. Singers like Gertrude "Ma" Rainey were responsible for creating the classic blues style. She was one of the most imitated and influential classic blues singers, and perhaps the one who can be called the *link* between the earlier, less polished blues styles and the smoother theatrical style of most of the later urban blues singers. Ma Rainey's singing can be placed squarely between the harsher, more spontaneous country styles and the somewhat calculated emotionalism of the performers. Madame Rainey, as she was sometimes known, toured the South for years with a company called the Rabbit Foot Minstrels and became widely known in Negro communities everywhere in America. It was she who taught Bessie Smith, perhaps the most famous of all the classic blues singers. Both these women, along with such performers as Clara Smith, Trixie Smith, Ida Cox, Sarah Martin, Chippie Hill, Sippie Wallace, brought a professionalism and theatrical polish to blues that it had never had before. They worked the innumerable little gin towns with minstrel shows.

By the turn of the century there were hundreds of tiny colored troupes, and some larger ones like The Rabbit Foot, Silas Green's, Mahara's. There were medicine shows, vaudevilles, and circuses when minstrel shows finally died. By the early twenties there were also certain theater circuits that offered tours for blues singers, jazz bands, and other Negro entertainers. One of the most famous, or most infamous, was the old T.O.B.A. (Theatre Owners' Booking Agency), or as the performers called it, "Tough On Black Artists" (or "Asses"). Tours arranged by these agencies usually went through the larger Southern and Midwestern cities.

While the country singers accompanied themselves usually on guitar or banjo, the classic blues singers usually had a band backing them up. They worked well with the jazz and blues bands, something the earlier singers would not have been able to do. Classic blues was much more an instrumental style; though the classic singers did not lose touch with the vocal tradition, they did augment the earlier forms in order to utilize the more intricate styles of the jazz bands to good effect.

It is valid to assume that ragtime developed from the paradox of minstrelsy insofar as it was a music the Negro came to in imitating white imitations of Negro music. Ragtime (which is not to be confused with the verb *rag*, which merely meant *syncopation*) moved so far away from the vocal origins of Negro music that it was easily popularized and diluted, and its purer forms disappeared. It was a composed music—going that far toward the European, or "legitimate," concept of musical performance. It was perhaps the most instrumental, or more precisely, the most pianistic, of any Negro music.

The piano was one of the last instruments to be mastered by Negro performers, and it was not until the advent of boogie woogie that Negro musicians succeeded in creating a piano music that was within the emotional tradition of Negro music. Unlike ragtime piano, the earlier blues piano styles were not really pianistic, Negro blues pianists tended to use the piano in a percussive and vocal fashion, almost never utilizing or, almost never *able* to utilize, the more florid "hundred-finger'd" approach. I mention ragtime here because it seems to me important to consider what kind of music resulted when the Negro abandoned too much of his own musical tradition in favor of a more formalized, less spontaneous concept of music. The result was a pitiful popular debasement that was the rage of the country for almost twenty years.

The great classic blues singers were women. Ma Rainey, Bessie Smith, and the others all came into blues-singing as professionals, and all at comparatively early ages. (Ma Rainey started at fourteen, Bessie Smith before she was twenty.) Howard W. Odum and Guy B. Johnson note from a list of predominantly classic blues titles, taken from the record catalogues of three "race" companies. "The majority of these formal blues are sung from the point of view of woman . . . upwards of seventy-five per cent of the songs are written from the woman's point of view. Among the blues singers who have gained a more or less national recognition there is scarcely a man's name to be found." [2] However, the great country blues singers, with exceptions like Ida May Mack or Bessie Tucker, were almost always men. But the country blues singers were not recorded until much later, during the great swell of blues and "race" recordings when the companies were willing to try almost any black singer or musician because they were still ecstatic about their newly discovered market. The first recordings of blues were classic blues; it was the classic singers who first brought blues into general notice in the United States.

There were several reasons why women became the best classic blues singers. Most of the best-known country singers were wanderers, migratory farm workers, or men who went from place to place seeking employment. In those times, unless she traveled with her family it was almost impossible for a woman to move about like a man. It was also unnecessary since women could almost always obtain domestic employment. Until the emergence of the Negro theater, Negro women either sang in the church (they were always more consistent in their churchgoing) or sang their own personal sadnesses over brown wood tubs. In the slave fields, men and women worked side by side—the work songs and hollers

[2] *Negro Workaday Songs* (Chapel Hill, University of North Carolina Press, 1926), p. 38.

served both. (Given such social circumstance, one must assume that it was only the physiological inequality of the black woman, *e.g.*, not infrequent pregnancies, that provided some measure of superiority for the male, or at least some reticence for the female.)

> I'm a big fat mama, got the meat shakin' on my bones
> I'm a big fat mama, got the meat shakin' on my bones
> And every time I shake, some skinny gal loses her home.

Only in the post-bellum society did the Christian Church come to mean social placement, as it did for white women, as much as spiritual salvation. (Social demeanor as a basic indication of spiritual worth is not everybody's idea. Sexual intercourse, for instance, is not thought filthy by a great many gods.) It was possible to be quite promiscuous, if it came to that, and still be a person capable of "being moved by the spirit." But in post-bellum Negro society, Christianity did begin to assume the spirituality of the social register; the Church became an institution through which, quite sophisticatedly, secular distinction was bestowed. The black woman had to belong to the Church, even if she was one of the chief vestals of the most mysterious cult of Shango, or be thought "a bad woman." This was a legacy of white American Protestantism. But the incredibly beautiful Jesus of Negro spirituals is so much a man of flesh and blood, whether he is sung of by the church women or those women who left the Church to sing the "devil songs."

> Dark was de night an' cold was de groun'
> On which de Lawd had laid;
> Drops of sweat run down,
> In agony he prayed.

> Would thou despise my bleedin' lam'
> An' choose de way to hell,
> Still steppin' down to de tomb,
> An' yet prepared no mo'?

Blues People / • • • • / 92

I love Jesus,
I love Jesus,
I love Jesus,
O yes, I do,
Yes, Lawdy.[3]

Minstrelsy and vaudeville not only provided employment for a great many women blues singers but helped to develop the concept of the professional Negro female entertainer. Also, the reverence in which most of white society was held by Negroes gave to those Negro entertainers an enormous amount of prestige. Their success was also boosted at the beginning of this century by the emergence of many white women as entertainers and in the twenties, by the great swell of distaff protest regarding women's suffage. All these factors came together to make the entertainment field a glamourous one for Negro women, providing an independence and importance not available in other areas open to them—the church, domestic work, or prostitution.

The emergence of classic blues and the popularization of jazz occurred around the same time. Both are the results of social and psychological changes within the Negro group as it moved toward the mainstream of American society, a movement that tended to have very significant results. The Negro's idea of America as the place where he lived and would spend his life was broadened; there was a realization by Negroes (in varying degrees, depending upon their particular socio-economic status) of a more human hypothesis on which to base their lives. Negro culture was affected: jazz is easily the most cosmopolitan of any Negro music, able to utilize almost any foreign influence within its broader spectrum. And blues benefited: it was richer, more universal, and itself became a strong influence on the culture it had depended upon for its growth.

Ragtime, dixieland, jazz, are all American terms. When

[3] From *Negro Workaday Songs*, p. 196.

they are mentioned anywhere in the world, they relate to America and an American experience. But the term *blues* relates directly to the Negro, and his *personal* involvement in America. And even though ragtime, dixieland, and jazz are all dependent upon blues for their existence in any degree of authenticity, the terms themselves relate to a broader reference than blues. *Blues* means a Negro experience, it is the one music the Negro made that could not be transferred into a more general significance than the one the Negro gave it initially. Classic blues differs a great deal from older blues forms in the content of its lyrics, its musical accompaniment, and in the fact that it was a music that moved into its most beautiful form as a *public entertainment*, but it is still a form of blues, and it is still a music that relates directly to the Negro experience. Bessie Smith was not an American, though the experience she relates could hardly have existed outside America; she was a Negro. Her music still remained outside the mainstream of American thought, but it was much closer than any Negro music before it.

8 / The City

At the turn of the century most Negroes still lived in rural areas of the South, but by 1914 the largest exodus began. Masses of Negroes began to move to the Northern industrial centers such as Chicago, Detroit, New York. Between the years 1910 and 1920, for example, 60,000 Negroes migrated from the South to the city of Chicago. There were many reasons for this mass flight from the South, not all of them as obvious as the phrase "greater opportunity" would seem to indicate. Economically, the South was lagging behind the rest of the country in its move toward industrialization. America had once been primarily an agricultural country, but now, a few years after the turn of the century, the country was fast on its way to becoming the largest industrialized country in the world. But the South was behind, and as always, it was the black man who suffered most because of it. The North became the Promised Land, another Jordan—not only because of the tales of high-paying jobs for everyone there but because the South would always remain in the minds of most Negroes, even without the fresh oppression of the post-bellum Jim Crow laws, the scene of the crime.

What seems to me most important about these mass migrations was the fact that they must have represented a still fur-

ther change within the Negro as far as his relationship with America was concerned. It can be called a psychological realignment, an attempt to reassess the worth of the black man within the society as a whole, an attempt to make the American dream work, if it were going to. It was a *decision* Negroes made to leave the South, not an historical imperative. And this decision must have been preceded by some kind of psychological shift; a reinterpretation by the Negro of his role in this country. It was the same kind of human "movement" that made jazz and classic blues possible—the discovery of America or its culture as would-be Americans. And the idea of a Jordan persisted, albeit this Jordan, to be sure, was of a much less supernatural nature. It was a Jordan that could almost be identified within the general emotional tenor of the whole of the American people. "Jobs, Homes, Dignity" was the way one Negro paper put it in the early twenties in constant editorials proselytizing for Negro migration to the North. But even more, the North suddenly represented a *further* idea of what this country and what a black man's life might be. Not every Negro left the South to get a better job. Some left so they could find a greater degree of freedom, and some so they could walk the streets after 10 P.M. (many Southern towns having ordinances against "night rambling nigras"). Some, like my father, left very suddenly after unfortunate altercations with white ushers in movies; some, like my grandfather, to start small thriving businesses (having had two grocery stores and a funeral parlor burned out from under him in Alabama). But whatever the peculiar reason for any one individual's flight northward, the significant idea is that the North now represented for Negroes a place where they could begin again, this time, perhaps, on more human footing.

The *Negro*, now, becomes more definitely *Negroes*. For the first time, after and during these mass flights to the North, Negroes spread out throughout the country. The South was no longer the only place where there were Negroes in great

numbers. Chicago, Detroit, New York, Los Angeles, Washington, Philadelphia, all received in very short periods of time relatively large Negro populations. But more important, one essential uniformity, the provinciality of place, the geographical and social constant within the group, was erased. There were now such concepts as a Northern and a Southern Negro, and they would soon be, to a certain extent, different people.

By 1920, the proportion of Negroes in the North had increased to 14.1 per cent; five-sixths of those in the North were in large cities. Of course the new Jordan proved to be almost as harsh and slighting to Negroes as the South. Negroes received the lowest wages and did the hardest and most socially debasing work. Paul Oliver reports that "In the steel factories many of the jobs were restricted, but the 'open hearth' sections offered ready employment for Negroes; few others would work under the almost insufferable heat from the furnaces. Field hands weighed their chances against the disadvantages of severing themselves from their homes; the mills of Bessemer and Gary called, and they were gone." [1] But even faced with such a situation, the very idea of working inside a steel mill seemed glamorous to most Negroes, who had never done any work but agricultural labor in their lives. Five dollars a day was what Mr. Ford said, and Negroes came hundreds of miles to line up outside his employment offices.

It is interesting to note that there are a great many blues written about the Ford company and Ford products. One reason for this is the fact that Ford was one of the first companies to hire many Negroes, and the name *Ford* became synonymous with Northern opportunity, and the Ford Model-T was one of the first automobiles Negroes could purchase—"the poor man's car."

Oliver, however, writes about Ford's policies of hiring Negroes:

[1] *Blues Fell This Morning* (London, Cassell, 1960), p. 30.

"In 1914 the continual flow of immigrants from Europe to the United States ceased and the Northern industrialists, whose work was expanding with the demands of impending war, required cheap labor in quantity. Restricted immigration still operates today but it now has no major influence on the national economy; during the years of World War I when the stream of European unskilled labourers was halted, there was an acute labour shortage in the industrial North. Recruitment officers were sent South to draw Negroes from the plantations, and special freight cars were chartered to bring them to the North. . . . The cessation of the influx of European immigrants coincided with Henry Ford's announcement, in 1914, that none of his workers would earn less than five dollars per day, and it was in that year also that he commenced to employ Negroes on his assembly lines. As his huge plants in Detroit continued to expand and more coloured workers were taken on, the news reached the remotest corners of the South and attracted men who had been living in penury." [2]

> Say, I'm goin' to get me a job now, workin' in Mr. Ford's place
> Say, I'm goin' to get me a job now, workin' in Mr. Ford's place,
> Say, that woman tol' me last night, "Say, you cannot even stand Mr. Ford's ways."

Blues, until the time of the classic blues singers, was largely a *functional* music; and it emerged from a music, the work song, that did not exist except as a strictly empirical communication of some part of the black slave's life. But the idea of the blues as a form of music that could be used to entertain people on a professional basis, *i.e.*, that people would actually pay to see and hear blues performed, was a revelation. And it was a revelation that gave large impetus to the concept of the "race" record.

[2] *Ibid.*, pp. 31-32.

Race records were commercial recordings aimed strictly toward the Negro market (what large companies would call their "special products division" today, in this era of social euphemism). The appearance and rapid growth of this kind of record was perhaps a formal recognition by America of the Negro's movement back toward the definable society. This recognition was indicated dramatically by the Okeh Record Company's decision to let a Negro singer make a commercial recording. Strangely enough, the first Negro blues singer to make a commercial recording was not Ma Rainey or Bessie Smith, or any of the other great classic or country blues singers, but a young woman, Mamie Smith, whose style of singing was more in the tradition of the vaudeville stage than it was "bluesy." Mamie's style, ironically enough, though blues-oriented, was much closer in overall effect to the woman she replaced at that first recording session—Sophie Tucker (Miss Tucker was too ill to record). Nevertheless, Mamie Smith and her recording of Perry Bradford's *Crazy Blues* ushered in the era of race records.

> I can't sleep at night
> I can't eat a bite
> Cause the man I love
> He didn't treat me right.
>
> Now, I got the crazy blues
> Since my baby went away
> I ain't got no time to lose
> I must find him today.

Actually, *Crazy Blues* was Mamie Smith's second recording. Her first recording for the Okeh Company in New York was a disc containing two songs, *You Can't Keep a Good Man Down* and *That Thing Called Love*, and although the immediate sales of the first record weren't that spectacular, the company did see fit to have Miss Smith record again. The next recording made history. This was on

February 14, 1920, the beginning of the "Jazz Age." (But a really strange phenomenon was the fact that the first jazz records had been made three years before, in 1917, by a white group, the Original Dixieland Jazz Band. So actually the Jazz Age had begun three years before the first blues recording. By 1920 Paul Whiteman was making millions as "King of Jazz"—the word, at least, had entered the popular vocabulary. With such displays as Whiteman's Aeolian Hall concert, complete with "European Style" orchestra and Heifetz and Rachmaninoff in the audience, jazz had rushed into the mainstream without so much as one black face. Whiteman's only reference to the earlier, less lucrative days of this "new" music ("symphonized syncopation") was the first selection of his concert, which was *Livery Stable Blues* done à la minstrel show jazz to demonstrate, as Whiteman said, ". . . the crude jazz of the past." The Jazz Age can also be called the age of *recorded* blues and jazz because it was in the twenties that the great masses of jazz and blues material began to be recorded, and not only were the race records sold in great numbers but Americans began to realize for the first time that there was a *native* American music as traditionally wild, happy, disenchanted, and unfettered as it had become fashionable for them to think they themselves had become.

Of course, looking at the phenomenon of race records from a more practical point of view, as I am certain the owners of Okeh must have done, Mamie Smith's records proved dramatically the existence of a not yet exploited market. *Crazy Blues* sold for months at a rate of 8,000 records a week. Victoria Spivey's first record, *Black Snake Blues,* recorded six years later, sold 150,000 copies in one year. So it is easy to see that there were no altruistic or artistic motives behind the record companies' decision to continue and enlarge the race category. Race records swiftly became big business. The companies also began to hire Negroes as talent scouts and agents so that they would be able to get

the best Negro talent available for their new race catalogues.

Early advertising for the race records might now seem almost ridiculously crass, but apparently it was effective and very much of the times. This is an example taken from a Columbia Records advertisement that appeared in 1926; the song being advertised was something called *Wasn't It Nice:* "There sure am mean harmonizing when Howell, Horsley and Bradford start in on 'Wasn't it Nice.' You're a gonna think it's nice when you once get the old disc a-spinning. The boys are still going strong when they tackle the coupling 'Harry Wills, the Champion.' This trio sneaks right up on a chord, knocks it down, and jumps all over it." [3] Certainly this is a far cry from the light-skinned well-groomed Negroes who sip their sociable Pepsi Colas in the pages of today's Negro periodicals; but the intent, I think, is quite similar.

The Negro as *consumer* was a new and highly lucrative slant, an unexpected addition to the strange portrait of the Negro the white American carried around in his head. It was an unexpected addition for the Negro as well. The big urban centers, like the new "black cities" of Harlem, Chicago's South Side, Detroit's fast-growing Negro section, as well as the larger cities of the South were immediate witnesses to this phenomenon. Friday nights after work in those cold gray Jordans of the North, Negro workingmen lined up outside record stores to get the new blues, and as the money rolled in, the population of America, as shown on sales prognostication charts in the offices of big American industry, went up by one-tenth.

Another important result of the race records was that with the increased circulation of blues, certain styles of singing became models for a great many aspiring blues artists. (The classic urban singers were recorded first, for obvious reasons; it was some years later before the country singers were recorded.) Before race records, blues form was usually de-

[3] From Samuel B. Charters, *The Country Blues* (New York, Rinehart, 1959), illus. opposite p. 160.

pendent on strictly local tradition. Of course, the coming of the traveling shows changed this somewhat, as I have mentioned, but the race recordings really began to put forth extra-local models and styles of blues-singing which must have influenced younger Negroes. (Even in rural areas of the South, there was always at least one family that had a "victrola," which drew their neighbors from miles around. The coming of radio, which I will discuss later, also had a profound effect on blues in a similar fashion.) It has been said, for instance, that a great many of the blues singers from Missouri, St. Louis especially, sing through their noses. A woman like Ida Cox, who certainly does sing through her nose, would, in the pre-vaudeville, pre-phonograph era only have influenced people in her immediate vicinity. But when Ida began to work with the traveling shows, her style was heard and copied by a great many more people. And in one sense, as I have explained, this was why the so-called classic blues singers were classic. Not only because their styles were a kind of beautiful balance between the urban and country styles of blues, but because these classic singers were heard by more people and were widely imitated. The phonograph record increased one thousandfold the widespread popularity and imitation of certain blues singers; and because of this, phonograph records themselves actually *created* whole styles of blues-singing. And even though the local traditions remained, the phonograph record produced the first blues stars and nationally known blues personalities. For instance, a singer like Victoria Spivey, who was a typical example of the popular, post-classic, race-record blues singer (she became so popular she had a starring role while still under twenty, in King Vidor's "experiment" *Hallelujah*), was first drawn to blues-singing by the records of Bessie Smith and Sarah Martin, who, at the time, sold more blues records than anyone else. It is easy to see how this must have affected the existing folk tradition and created another kind of tradition that was unlike any other in the past. And if

the old calendar picture of Negroes sitting around a little shack, strumming guitars and singing happily and carelessly, had by the nature of certain sociological factors been caused to dim, certainly the new stereotype to replace that vanishing paternalistic image could have been a group of Negroes sitting around listening to records by their favorite blues artists.

Martin Williams mentions another effect the phonograph record had on blues form. Blues was traditionally an improvised music that could be sung or played as long as the performer could come up with fresh improvisations, but recorded performance meant that there was a certain definite and limited space of time in which the singer could perform. "At their own right tempo each of these singers could get in about four blues stanzas on a ten-inch recording. Many singers . . . responded to the limitations of time on records by simply stringing together four stanzas on (more or less) the same subject; others . . . attempted some kind of narrative continuity." [4]

Speaking of classic blues singers Sarah Martin and Ida Cox, Williams says: "Both of these singers do more; they give each blues a specifically poetic development which takes subtle advantage of the four-stanza limitation and creates a kind of classic form within it." [5]

Fogyism

Why do people believe in some old sign?
Why do people believe in some old sign?
You hear a hoot owl holler, someone is surely dyin'.

Some will break a mirror and cry, "Bad luck for seven
 years,"

[4] "Recording Limits and Blues Form" in Martin T. Williams, ed., *The Art of Jazz* (New York, Oxford University Press, 1959), pp. 91-92.
[5] *Ibid.*, p. 92.

Some will break a mirror and cry, "Bad luck for seven
 years,"
And if a black cat crosses them, they'll break right
 down in tears.

To dream of muddy water—trouble is knocking at your
 door,
To dream of muddy water—trouble is knocking at your
 door,
Your man is sure to leave you and never return no
 more.

When your man comes home evil, tells you you are
 getting old,
When your man comes home evil, tells you you are
 getting old,
That's a *true* sign he's got someone else bakin' his jelly
 roll.

While the classic singers were making records, theater ap-
pearances, national tours, another more private kind of
blues had grown up, given the catalyst of the Negro's move
to the large urban centers. A new city, or urban, blues
had appeared outside the main theatrical tradition being
created by the classic singers. The city blues grew in the
various after-hours joints, house rent parties (parties where
the low admission helped pay the rent—or at least that was
used as the excuse for the party), and barbecue and gut
parties (where either chitterlings or hog maws were served).
This music, like the country blues, was something directly
out of the lives of the people involved:

My baby she found a brand new place to go
My baby she found a brand new place to go
She hangs across town at the Monte Carlo.

She likes my money, tells me she goin' to the picture
 show

She likes my money, tells me she goin' to the picture
　　show
But that girl's been throwin' my money away at the
　　Monte Carlo.

(From *Monte Carlo Blues* by Roosevelt Sykes)

Classic blues was entertainment and country blues, folk-
lore. The blues and blues-oriented jazz of the new city dwell-
ers was harder, crueler, and perhaps even more stoical and
hopeless than the earlier forms. It took its life from the raw-
ness and poverty of the grim adventure of "big city livin'."
It was a slicker, more sophisticated music, but the people,
too, could fit these descriptions. The tenements, organized
slums, gin mills, and back-breaking labors in mills, factories,
or on the docks had to get into the music somehow.

To most Negroes, urban living was a completely strange
idea. They had come from all over the South, from back-
woods farms as sharecroppers who had never even been to
the moderately large cities of the South, into the fantastic
metropolises of the North. It must have been almost as
strange as that initial trip their ancestors made centuries be-
fore into the New World. Now the Negroes had not even
the land to walk across. Everywhere were cement, buildings,
and streets filled up with automobiles. Whole families
jammed up in tiny, unbelievably dirty flats or rooming
houses. But the sole idea was "to move," to split from the
incredible fabric of guilt and servitude identified so graphi-
cally within the Negro consciousness as the white South.
However, there was a paradox, even in the emotionalism of
this reasoning. The South was *home*. It was the place that
Negroes knew, and given the natural attachment of man
to land, even loved. The North was to be beaten, there was
room for attack. No such room had been possible in the
South, but it was still what could be called home. The emi-
grants sang, "I'm a poor ol' boy, a long ways from home," or
"I rather drink muddy water and sleep in a hollow log/Than

go up to New York City and be treated like a dirty dog."

Still after a time, the newly arrived Negroes from the South were the brunt of the Northern Negro's jibes. Nothing was quite as disparaging as to be called "a country boy." It was an epithet delivered with almost as much scorn as when the religious people might call some backslider a "heathen." To the new city dwellers, the "country boy" was someone who still bore the mark, continued the customs, of a presumably discarded Southern past. But the displaced persons made quick movements toward the accomplishment of the local sophistication and in a few months could even join in to taunt a new arrival with greetings like, "Hey, Cornbread!"

> My home's in Texas, what am I doin' up here?
> My home's in Texas, what am I doin' up here?
> Yes, my good corn whisky, baby, and women brought
> me here.

The local sophistication for the newly arrived Negroes was swift acclimatization to the conflicts and strangeness of the city. And acclimatization could mean so many things. The "rent party" was a form of acclimatization, the relief check, another. The early twentieth century was a very significant time for the Negro in the United States. In the city there was a wider psychological space for everybody. Things spread out in the cities, dispersed as was never possible in the South. The hand of the paternalistic society was subtler, and that subtlety enabled the Negroes to *improvise* a little more in their approach to it. There was even the simple fact that people could make their living now, when they did, in a greater variety of ways. You could work for Ford or run an elevator, be a pimp or (soon) a postman, etc.— but the idea was to "get in," to "make it" as best one could. This acclimatization had to occur in all facets of the urban Negro's life. But the "new people" brought with them the older customs and the older attitudes, and even though

they rushed with all speed (in relation to their economic, hence *social*, status) into the cool waters of American culture, they brought with them at least, their songs.

I used to have a woman that lived up on a hill,
I used to have a woman that lived up on a hill,
She was crazy 'bout me, ooh well, well, 'cause I worked
 at the Chicago mill.

You can hear the women hollerin' when the Chicago
 Mill whistle blows,
You can hear the women hollerin' when the Chicago
 Mill whistle blows,
Cryin', "Turn loose my man, ooh well, well, please and
 let him go."

If you want to have plenty women why not work at the
 Chicago Mill?
If you want to have plenty women why not work at the
 Chicago Mill?
You don't have to give them nothin', oooh well, jest tell
 them that you will.

(From *Chicago Mill Blues* by Peatie Wheatstraw)

The "balance" that the constant, northward flow of Southern Negro culture provided for Negroes in the North manifested itself in innumerable ways. Tom Davin's interviews with James P. Johnson, one of the masters of what came to be known as "New York stride piano" mentions the phenomena of "acclimatization" and "balance":

"One night a week, I played for Drake's Dancing Class on 62nd Street, which we called 'The Jungles Casino.' It was officially a dancing school, since it was very hard for Negroes to get a dance-hall license. But you could get a license to open a dancing school very cheap.

"The Jungles Casino was just a cellar, too, without fixings. The furnace, coal, and ashes were still there behind a parti-

tion. The coal bin was handy for guests to stash their liquor in case the cops dropped in.

"There were dancing classes all right, but there were no teachers. The 'pupils' danced sets, two-steps, waltzes, schottisches, and 'The Metropolitan Glide,' a new step.

"I played for these regulation dances, but instead of playing straight, I'd break into a rag in certain places. The older ones didn't care too much for this, but the younger ones would scream when I got good to them with a bit of rag in the dance music now and then.

". . . The dances they did at The Jungles were wild and comical—the more pose and the more breaks, the better. These Charleston people and the other southerners had just come to New York. They were country people and they felt homesick. When they got tired of two-steps and schottisches (which they danced with a lot of spieling) they'd yell: 'Let's go back home!' . . . 'Let's do a set!' . . . or 'Now, put us in the alley!' I did my *Mule Walk* or *Gut Stomp* for these country dances.

"Breakdown music was the best for such sets, the more solid and groovy the better. They'd dance, hollering and screaming until they were cooked. The dances ran from fifteen to thirty minutes, but they kept up all night long or until their shoes wore out—most of them after a heavy day's work on the docks." [6]

The Southerners brought the blues north with them, and it was the fusion of the older traditions with "the new learning" that produced the urban blues, though the earlier blues forms still persisted. But for most Negroes who were raised in the North, blues was something quite *new*. The Northern Negro, *i.e.*, the one raised in the North, had from the outset of his life been exposed to the kind of *centerless* culture to which the new Northerners were just now adjust-

[6] "Conversations with James P. Johnson," *Jazz Review* (July, 1959), pp. 11-12.

ing. The young Negro who had always lived in the North was never aware of a "purer" Negro culture than the consciously diluted model that existed there. Before the great movements north, many Northern Negroes were quite purposely resisting what could be called their cultural heritage in an attempt to set up a completely "acceptable" route into what they had come to think of as the broadness of American society. Blatant references to "the South," and all the frightening associations that word produced, were not tolerated. But with the coming of the black hordes, it was no longer possible to completely suppress these references and their associations. Whereas the older Northern Negroes might have forbidden their children the blues or simply refused to expose them to it, with the coming of the new citizens whole areas of "Southern Negro" culture were thrust upon these innocent youths.

The Negro musician in the North, before what are called the "jazz years," was usually well within the tradition of white "show" music (and brass-band style), if he played "popular" music, or else he was a "serious" musician. Just as the New Orleans Creoles had learned European music on European instruments from European teachers, so had the Northern Negro been trained. In an interview by Nat Hentoff, Garvin Bushell, a clarinetist with some of the pre-blues "Northern" Negro groups, placed the situation in its proper perspective.

"[The playing of] New York musicians of the time was different than the playing of men in Chicago, St. Louis, Texas and New Orleans. New York 'jazz' then was nearer the ragtime style and had less blues. There wasn't an Eastern performer who could really play the blues. We later absorbed how from the Southern musicians we heard, but it wasn't original with us. We didn't put that quarter-tone pitch in the music the way the Southerners did. Up North we learned the ragtime conception—a lot of notes.

The City / • • • • /109

"On Sundays I rehearsed with a band from Florida. The way they played reminded me of my uncle's work in the circus band. They played real blues.

"Gradually, the New York cabarets began to hear more of the real pure jazz and blues by musicians from Florida, South Carolina, Georgia, Louisiana, etc. What they played was more expressive than had been heard in New York to that time.

.

"You could only hear the blues and real jazz in the gutbucket cabarets where the lower class went. The term 'gutbucket' came from the chitterlings bucket. Chitterlings are the guts of a hog and the practice used to be to take a bucket to the slaughterhouse and get a bucket of guts. Therefore, anything real low down was called gutbucket." [7]

Again, the marvelous paradox created by ghetto reasoning and the social predicates out of which it issued. The Northern musicians who wouldn't play blues or "jass" were quite happy playing American and European popular music, including light opera—anything within the shadowy world of semiclassical music—but all was played in the raggy style of the day, which, of course, had been the result of white dilutions of Negro ragtime styles. And even though the Negro musicians who imitated "popular" ragtime styles were merely trying to reflect the dominant tastes of the day, they still managed to bring a separate cultural knowledge (maintained by the "blue" tones of the Negro church) to their "syncopated music," as it was called then.

Northern Negro pre-jazz music was almost like the picture within a picture within a picture, and so on, on the cereal package. Ragtime was a Negro music, resulting from the Negro's appropriation of white piano techniques used in show music. Popularized ragtime, which flooded the coun-

[7] "Garvin Bushell and New York Jazz in the 1920's," *Jazz Review* (January, 1959), p. 12.

try with songsheets in the first decade of this century, was a dilution of the Negro style. And finally, the show and "society" music the Negroes in the pre-blues North made was a kind of bouncy, essentially vapid appropriation of the popularized imitations of Negro imitations of white minstrel music, which, as I mentioned earlier, came from white parodies of Negro life and music. And then we can go back even further to the initial "steal" American Negro music is based on, that is, those initial uses Euro-American music was put to by the Afro-American. The hopelessly interwoven fabric of American life where blacks and whites pass so quickly as to become only grays!

Typical of the kind of black orchestras that thrived in the North at the beginning of the century were James Reese Europe's various Clef Club and Tempo Club orchestras. As accompanist for Vernon and Irene Castle, it was Europe who with his Europe's Society Orchestra was largely responsible for introducing the Castle Walk and Fox Trot to America. Europe had concerts at Carnegie Hall where he played such music as *Indian Summer, Concert Waltz,* and other semi-classical, mildly ragged items, and at one concert the orchestration of his 100-piece orchestra included ten pianos and forty-seven mandolins! Needless to say, Europe's orchestra was the first Negro "dance band" to be recorded.

The invasion of the North by Southern musicians was augmented by the closing of New Orleans' red light district, Storyville, in 1917. This threw a great many Negro and Creole musicians out of work, and they joined the trek northward. The larger Northern dance bands began to hire some of the Southern musicians because at the time the "dada strain" of the blues-oriented instrumentalists was thought to be an added "novelty" feature that could increase an orchestra's commercial value. But usually the Northern Negro musician came under the influence of these Southern musicians with their "hot" or bluesy intonations. And by the time the phonograph record became popular, this "hot" style

was spread to an even broader Northern audience, black and white alike.

World War I was an extremely significant phenomenon insofar as it related to the movement of the Negroes into the mainstream of American life. The rudeness with which "the great war" dragged America and most of the Western world into the twentieth century served also to produce the "modern" American Negro. The war proposed to the great masses of Negroes that the world was indeed much more than America. The idea of Europe as a place where other people lived who had a consistent social definition as "white people" just like American white people was to most Negroes a major revelation. And when Negroes went into the services in their special black units, even though they were designed to utilize black bodies while continuously avoiding any recognition of these bodies as belonging to other human beings, there was still a sense of actual *participation* in the affairs and fortunes of the country that was heightened by the recognition these black troops received in various parts of Europe, France notably. After the war, the returning soldiers with their tales of Europe and its white people so like but so very unlike the American whites caused a great deal of open resentment among Negroes about the racially restrictive social mores of American life.

In Richard Wright's novel *Black Boy*, there is a passage that in part describes the white man's reaction to this newly acquired "international" sense World War I produced in many Negroes, North or South: "Among the topics that southern white man did not like to discuss with Negroes were the following: American white women; The Ku Klux Klan; France, and how Negro soldiers fared while there; French women; Jack Johnson; the entire northern part of the United States; the civil war, Abraham Lincoln; U. S. Grant; General Sherman; Catholics; the Pope; Jews; the Republican Party; Slavery; Social Equality; Communism; Socialism; the

13th, 14th, and 15th Amendments to the Constitution; or any topic calling for positive knowledge or manly self-assertion on the part of the Negro." [8] (Nor, I suppose, could many Negroes before the northward movement or World War I discuss these things. They simply did not exist.)

For the first time, Negroes began to feel the singularity of their plight as American black men. And there have never been so many race riots in this country as during and immediately after World War I. Race relations, as our peculiar mode of mutual mistrust between blacks and whites is termed, reached a terrifying nadir, manifested by such bloody episodes of violence as the East St. Louis race riots of 1917. It was the war also that was responsible in many ways for swelling the numbers of Negroes leaving the South. As I mentioned before, the wartime economy of this country created a great many factory jobs in the North that were open to Negroes. Also, after the war was over, a great many younger Negroes who had been in the army could no longer be satisfied with "the mind of the South." The tradition of silent acceptance had become much too stifling. It is significant that World War II produced a similar social crisis in this country.

World War I not only pointed up the social inequities of American life as being peculiar to America, but also, because of this delineation, these social inequities suffered by the black man could for the first time be looked at somewhat objectively by Negroes as an *evil*, and not merely as their eternal *lot*. It was during these times that the first widespread organized resistance by Negroes against these evils began to form. The race riots were one manifestation of this tendency, also the appearance of groups like Marcus Garvey's black nationalist organization, which advocated that Negroes return to Africa. (The NAACP, which had been formed some years earlier in 1909, enjoyed during the first years after the war its greatest support from poorer

[8] *Black Boy* (New York, Harper Bros., 1937), p. 202.

The City / • • • • /113

Negroes, a support it has since lost in favor of the support of white liberal philanthropists and the Negro bourgeoisie.) The Garvey movement, even though ill-fated, enjoyed a great deal of popularity among poorer Negroes, and it is important to realize that even at the time of World War I and the years directly following, the Negro masses had not moved so far into the mainstream of American life that they could forget there was an Africa out of which their forebears had been taken and to which they themselves might yet have to return.

Another blues music to appear in the cities around this same time was what was called boogie woogie. Basically a piano music, boogie woogie rose to its greatest popularity in the rent parties and juke joints of the North, even though, characteristically enough, it had its origins in the primitive blues of the Southern country Negro. It seemed to be a fusion of vocal blues and the earlier guitar techniques of the country singers, adapted for the piano. The old blues singers called it "Western" piano, meaning that the music had originated in the mining and lumber camps of the West and Midwest. In some ways boogie bears strong resemblance to ragtime piano style, although the repeated "rolling" (*ostinato*) figure used in boogie piano identifies it immediately. Ragtime was the first appropriation of white pianistic techniques by Negro musicians, boogie woogie was the second appropriation of a "pianistic" approach to the instrument, but in such a blatantly percussive and blueslike manner as to separate it immediately from any more Europeanized music. In keeping with the traditional styles of Negro music, boogie woogie also was predominantly a music of rhythmic contrasts rather than melodic or harmonic variations.

Most of the great boogie pianists came north in the general exodus during the first three decades of the century (although a few of them, like Jimmy Yancey and Albert Ammons, were born in Chicago, the city where boogie re-

ceived its first popularity). The boogie pianist achieved a special social status, playing at the various Chittlin' Struts, Gumbo Suppers, Fish Fries, Egg Nog Parties. His services were much sought after, and he could gain entrance to all these "pay-parties" without being expected to pay. "If you could play piano good, you went from one party to another and everybody made a fuss about you and fed you ice cream, cake, food and drinks. In fact, some of the biggest men in the profession were known as the biggest eaters we had. At an all-night party, you started at 1 A.M., had another meal at 4 A.M. Many of us suffered later because of eating and drinking habits started in our younger socializing days." [9]

> I don't mind playin' anytime y'all can get me drunk,
> But Mr. Pinetop is sober now.
> I been playing the piano round here all night long
> And y'all ain't bought the first drink somehow.
>
> (From *I'm Sober Now* by Clarence "Pine Top" Smith)

One reason perhaps why boogie woogie remained predominantly a piano music (until its eventual dilution and commercialization) was because of the general environment that served as catalyst for its development. Although ragtime was also a piano music, the very fact that it was a "composed" music (and sheet music could be issued so quickly on a large scale) meant that it could be performed by any number of pieces and in almost any environment. It took much longer for boogie sheet music to arrive, because boogie woogie was still a largely improvised music.

Small, very amateurishly lettered signs would appear in the local stores and restaurants, advertising the larger parties. (The number of grocery stores and restaurants offering "Southern Specialties" had increased tenfold throughout the North, and in any Negro neighborhood it was possible to find the hogmaws, chitterlin's, collards, pig knuckles, tails,

[9] "Conversations with James P. Johnson," p. 10.

feet, snouts, that were so integral to Southern Negro cuisine. This was one of the first organized industries Negroes in the North got into, packaging and selling their traditional foods. Today, some of these same foods are packaged and sold by large white companies for Negro consumption, but foods like yams and collard greens have also found their way into a great many non-Negro kitchens.) On the weekends, after a hard week of work, hundreds of dancers would crowd into the "blue light" parties to "grind" or "slow-drag" or "belly-rub." There would usually be four or five pianists at any really popular affair, and each would take his turn at the "box." The parties could last all weekend, and for some intrepid souls, well into the week. The Third Ward of Newark once boasted for several months, until the law moved in, a rent party promoted by two blues singers which was called "The Function" and which advertised that one could "Grind Till You Lose Your Mind." It was at these kinds of parties that boogie woogie developed.

> I want you to pull up on your blouse, let down on your
> skirt,
> Get down so low you think you're in the dirt . . .
> Now when I say "Boogie!" I want you to boogie;
> When I say "Stop!" I want you to stop right still . . .
>
> (From *Pinetop's Boogie Woogie* by Clarence "Pine Top" Smith)

The success of race recordings soon led the companies to record not only the classic blues singers but also a few boogie-woogie pianists and country singers as well. The larger record companies began setting up permanent Southern offices for the discovery of new talent, and some really ambitious companies like Columbia even had a mobile unit that roamed the South, recording people like Barbecue Bob, Peg Leg Howell, Blind Willie Johnson, Lillian Glinn, Pink Anderson, Blind Willie McTell (recording then under the name "Blind Sammie"), Bobby Cadillac, Aaron T-Bone

Walker, and many other singers who sang what was essentially folk material. But, for the most part, the rent-party pianists, with exceptions like Clarence "Pine Top" Smith, Eurreal Montgomery, Hersal Thomas, remained unrecorded. The music, boogie woogie, still remained so extremely functional that it could be considered by its exponents as strictly an avocation, rather than a way to make a living. Most of the better boogie-woogie pianists had other jobs, just like the earlier blues singers, and their boogie was something they created for themselves within the environment of those "new" black cities of the North.

In October, 1929, the worst economic disaster this country has ever experienced shattered its relative prosperity. The war years, for Negroes especially, had been a time when jobs were relatively easy to find, and a great many people had some money to spend. But with the coming of the Depression, factories and offices closed, and by 1932, almost 14 million people were unemployed. Negroes were hardest hit. All the ex-farmhands who'd come north to accept Mr. Ford's offer now stood in long lines waiting for something to eat. Many of these Negroes became disillusioned and returned to the South, but most stayed. The suddenness of the Depression proved a dramatic ending for the era of the classic blues singer. Not only did most night clubs and cabarets begin to close or lay off their performers, but the recording industry was ruined almost overnight. And predictably, it was the race records that were first to go. Negroes simply could not spend money on phonograph records; most were barely able to get enough to eat. There were no recordings issued by Negro performers for almost three years.

Aside from the deadly effects the Depression had on the music business and the general unemployment, especially in the new Negro communities of the North, that resulted because of this economic crisis, there is a further significance that should be appreciated regarding the *psychological* ef-

fect the Depression had on Negroes. The Depression, or the Great Depression, as it is called by some economists to differentiate it from the other less crippling "panics" and "recessions" that preceded it (there were depressions in America of varying degrees of severity in 1819, 1837, 1873-77, 1893-98, 1913-14, this latter actually proving a prelude to the crushing chaos of 1929), was especially significant in the development of a political image in and for the modern American Negro. Negroes before the Depression were traditionally and understandably Republican, when they voted at all, in honor of the "Party of Lincoln." (Even in the forties I remember my grandmother telling me she was voting for Dewey and Wilkie instead of my childhood hero F.D.R., for just that reason.) But with the Depression and Roosevelt's New Deal and its W.P.A. projects that provided work for a great many impoverished Negroes as well as the extension of relief and welfare payments to these same poor who could not work in the various Federal projects, the Negro's allegiance swung radically and quickly toward the Democratic Party.

Perhaps the three events that helped shape presentday America as it now exists can be seen as World War I, the Great Depression, and World War II, and these events helped equally to shape the presentday American Negro. World War I proposed, as I said, an international sense of the world that was never developed in the minds of most Negroes before. The Depression was the first real economic crisis—an economic crisis experienced by the Negro, based on the *general* fortunes of the entire society. Before the Depression, it is quite easy to see how in the paternalized stratum of American society inhabited by Negroes an economic crisis would be of no great importance. The movement by Negroes into the mainstream of American society had also placed them in the path of an economic uncertainty that they had never known before. But we must add to those

Blues People / • • • • / *118*

three events that shaped the modern Negro the Emancipation and the move to the cities because they were, of course, the only occurrences that could make the next three historical imperatives of the "American Experience" at all meaningful to the Negro in America.

During the Depression, even though the commercial aggrandizement of the blues had been halted, blues naturally enough continued. Classic blues suffered irreparably because to a certain extent its popularity was based on an *economic* principle, as is all popular theater. Not that Bessie Smith or the others sang *strictly* to make money, but their immense popularity was the result of their *ability* to make money. And the purest fabric of the blues, that part of blues that is the purest expression of Negro life in America, was connected to the idea of professionalism at the time of the classic singers rather gratuitously. Suffice it to say that when the artificial catalyst of the commercial theater was temporarily destroyed, the classic singers were no longer "popular," and the legitimate blues of the next period— urban blues and boogie woogie—emerged and continued to grow with a vitality that could only be diluted by the twin menaces of acceptance by the general public and loss of contact with the most honestly *contemporary* expression of the Negro soul.

The house-rent parties and chitterlin' drags continued through the Depression, and the blues that issued from these legitimate connections with Negro life also continued. Thus it was that the first recordings to be issued when the recording companies began to function again were records by urban blues singers like LeRoy Carr, who enjoyed a tremendous popularity with his soft, sophisticated, yet plaintive blues.

How long, how long, has that evening train been gone?
How long, how long, baby, how long?

Standing at the station, watch my baby leaving town.
Feeling disgusted, nowhere could she be found.
How long, how long, baby, how long.

But the house-party pianists and boogie-woogie men also began to enjoy the fattened popularity of the phonograph record, although their real "elevation" into the popular culture of the country did not come until the late thirties. Jimmy Yancey, Cripple Clarence Lofton, Meade "Lux" Lewis, Cow Cow Davenport, Montana Taylor, Albert Ammons, Pete Johnson, Charlie Spand, and others, began to be heard in earnest when the recording companies got back on their feet. Also, urban performers like Big Maceo Merriweather, Roosevelt Sykes, Tampa Red, Sonny Boy Williamson, Big Bill Broonzy (who later returned to a more "country" way of making blues), Memphis Slim, Lonnie Johnson, began to come into their own.

I walked all night long, with my 32-20 in my hand
I walked all night long, with my 32-20 in my hand
Lookin' for my woman, well, I found her with another man.

But even though the blues continued to change, thereby exhibiting the most contemporary reflection of the Negro experience in America, the older forms did not just disappear. There were still country people and country singers arriving each day in the various black cities to provide the cultural balance, singing of earlier, less complicated reactions to American life. There were still singers in the theater who maintained the grand tradition of classic blues, even though by the end of the 1930's, Ma Rainey had ceased to perform and Bessie Smith was dead. And the phonograph record provided a vital artifact as reference to the America

they sang of and the black consciousness that had reacted to that America.

Also, the social and cultural separation of blacks and whites caused what is known as a *lag* between the groups, so that even when the most contemporary manifestation of blues had been altered by Negroes within their own group, there was likely to be an agitated echo of some earlier style within the white group. (Hence the popularity of boogie woogie in the forties, when it finally reached Carnegie Hall and oblivion.) But the separation was not as rigid in many ways. There was more commerce with the former masters, more of a surface agreement to respond to each other, at least formally, in some mildly humanistic manner. In the South, even some time after slavery (including the present time) Negroes continued to live in pretty similar circumstances. But the exodus produced not only a huge disparity between large groups of Negroes but opened up a space for even larger disparities to develop. There was now the Northern Negro and the Southern Negro, and the "space" that the city provided was not only horizontal; it could make strata, and disparities grew within the group itself. The Northern industrial city had given new form to the Negro's music; it had also, equally, proposed new reactions for him psychologically which would soon produce new sociological reactions.

9 / *Enter the Middle Class*

. . . the race
does not advance, it is only
better preserved

(CHARLES OLSON)

At the rent parties, barbecues, "hot bed" apartments (places where several families crowded in together to live), and after-hours places, there must have been some Negroes absent—as there had been in the South when religious members of the slave community absented themselves from the "sinful" activities of the more secularly inclined. However, just as the "Jordan" had changed in the minds of a great many Negroes to something immediate and material, so these rent parties were no longer "sinful," but "vulgar," or at least "wasteful." (I can see my grandfather now making such a pronouncement.)

Instead of the fabled existential, happy, carefree Negroes, there were now some black people who were interested in what was around them and how to get to it. (The people who wanted the white man's God had made these same separations in the old society—"I am bound for the Promised Land"—but they had long been losing ground, in

the new cities.) Negroes appeared whose Promised Land was where they were now, if only they could "save a little money, send the kids to school, get a decent place to live. . . ." The further "movement" *into* America. And this movement, this growing feeling that developed among Negroes, was led and fattened by a growing black middle class.

The migration north was, of course, the main reason for the rise of a black middle class in America, since there was in the North that space that the increasing subtlety of the paternalistic society allowed. There was greater room for *progress.*

But even in the slave society there had been the beginnings of a "privileged" class of Negroes. The house servants were extended privileges that were never enjoyed by the majority of "field niggers." The "house nigger" not only assimilated "massa's" ideas and attitudes at a more rapid rate, but his children were sometimes allowed to learn trades and become artisans and craftsmen. These artisans and craftsmen made up the bulk of the 500,000 black freedmen at the beginning of the Civil War.

These house servants, as I have mentioned, were the first to accept the master's religion, and were the first black ministers and proselytizers for the new God. The Christian Church in slave times represented not only a limited way into America, but as it came to be the center of most of the slaves' limited social activities, it also produced a new ruling class among the slaves: the officials of the church.

The church officials, the house servants, and the freedmen were the beginnings of the black middle class, which represented (and represents) not only an economic condition, but, as is true with any stratum of any society, a definite way of looking at the society in which it exists. The black middle class, from its inception (possibly ten seconds after the first Africans were herded off the boat) has formed almost exclusively around the proposition that it is better not to be black in a country where being black is

Enter the Middle Class / • • • • / *123*

a liability. All the main roads into America have always been fashioned by the members of the black middle class (not as products of a separate culture, but as vague, featureless Americans). I pointed out earlier why Negroes in North America were able to adopt the customs and habits of the masters so much more quickly than their brothers throughout the rest of the Americas. But still another factor was that from the very beginning of Afro-American culture in North America, there have always been Negroes who thought that the best way for the black man to survive was to cease being black. First, it was the stench of Africa these aspirant *Americans* wanted to erase; then, the early history of the Negro in America.

The African gods were thrown into disrepute first, and that was easy since they were banned by the whites anyway. As always, the masses of black men adapted, rather than completely assimilated; appropriated, rather than traded, one god or one culture for another. (The Freedman's Bureau published none of the secular songs of the Negro, but only the "religious" songs—and then those that were quite readily recognizable as pickups from pale white Protestant hymns.)

It was the growing black middle class who believed that the best way to survive in America would be to *disappear* completely, leaving no trace at all that there had ever been an Africa, or a slavery, or even, finally, a black man. This was the only way, they thought, to be *citizens*. For the Creoles and mulattoes of the South, this was easier—there *was* a quickly discernible difference between themselves and their darker brother since it was the closeness of their fathers (and mothers) to the masters that had produced them in the first place. Many of the freedmen were mulattoes, and many of the mulatto freedmen and *gens de couleur* even had black slaves themselves. But the darker members of the fledgling bourgeoisie had to work out their salvations under much more difficult circumstances. The real *black*

bourgeoisie was always lashed irrevocably to the burden of color. Hence, the hopelessness and futility of "erasing" all connections to the black society when it was always impossible to erase the most significant connection of all.

Many freedmen had moved north even during slavery: they made up the majority of the Northern black middle class even after the Emancipation. The movement north brought not only the "impoverished masses" but also many members of the middle class: some because they thought to make an even deeper entry into America, some, like the church people, because they had to follow their flocks or they would be out of luck.

Whole churches moved north, and the first thing many of the poor Negroes did when they reached that Promised Land was to pool their meager resources and set up their church again, and get their preacher a good place to live. The storefront church was a Northern phenomenon simply because in the cities these country people found it was impossible to just buy some wood and build a church, as they had done in the South. And many churches, such as the one my parents went to, progressed, as their members moved up the economic ladder in the industrial North, from storefront or apartment to huge, albeit quixotic, structures.

The middle-class churches were always pushing for the complete assimilation of the Negro into white America. Middle-class Baptist and Methodist churches strove with all their might to do away with any of the black appropriations of Christianity that rural Southern Negroes had affected. A white Christianity was, after all, the reason for existence of these churches, and their directors always kept this in their minds. Many churches "split" once they moved north because of conflicts that arose among the members as to whether they wanted the church "black" or "white." Many of the new emigrants had to set up churches of their own because they were not welcome in the black middle-class

churches of the North. In the 1920's, in Beaver Falls, Pennsylvania, where my grandfather and his flock moved from Alabama, they had to build their own (the Tabernacle Baptist Church) when they found that they were unwelcome in the established black Baptist church because they were *Southerners.* The black residents of Beaver Falls wanted nothing to do with the South and its terrible memories of slavery. They would cut off their own people to have a go at America.

The "morality" of the black middle class was not completely the result of a "spontaneous" reaction to white America, it was also carefully nurtured and cultivated by certain elements of white America. Behind a great many manifestations of the temperament of the black middle class sits the carefully washed "wisdom" of the early Protestant missionaries, who not only *founded* the black Christian churches but also quite consciously instilled the post-Renaissance religious dogmas into their new black congregations. The educational philanthropies were also attended and shaped in their beginnings by these same missionary elements, who sought to show the savage heathens how through "thrift, prayer, and work" they might somehow enter into the kingdom of heaven (even though it might be through the back door). The paradox, and perhaps the cruelest psychological and cultural imposition of all, was the inculcation of this Puritan ethos on a people whose most elegant traditions were the complete antithesis of it. Of course, the poor and the unlettered were the last to respond to this gift, but the strivers after America, the neophytes of the black middle class, responded as quickly as they could. In effect, the way to Puritan Protestant heaven only existed for the black man who could pretend he was also a Protestant and a Puritan.

When the supernatural goal of the society (black and white) yielded to the more practical, positivistic ideals of industrialized twentieth-century America, salvation be-

longed to those who realized that the worth of man was his ability to make money. The black middle class responded to this call, as it would to any call that would insure it respectability and prestige and their concomitant privilege. But religious or positivist, the adjustment necessary for the black man to enter completely into a "white" American society was a complete disavowal that he or *his part of the culture* had ever been anything else but American. (The cruel penalty for this kind of situation is the socio-cultural temperament of America today, where the very things that have served to erect a distinctive culture on this continent are most feared and misunderstood by the majority of Americans!) But the fact was that by the time of the move north (and precipitated in part because of it), the oppression the Negro knew America capable of—his indestructible bond with this country—and the space and light he saw it capable of producing sat dictating the narrow path most Negroes could travel on their way toward *citizenship*. For Negroes, the oppression was an historical imperative informing each response they could make to whatever situation the society proposed; but their ever-widening knowledge of the country and its most profound emotional characteristics made any withdrawal impossible. Even the poorer Negro had moved to the point where he thought perhaps he might one day live in this country as a person of certain economic capability, with almost complete disregard of the color of his skin. (This is a brilliant, yet desperately conceived hypothesis, but its validity has yet to be demonstrated.) However, the moral-religious tradition of the black middle class is a weird mixture of cultural opportunism and fear. It is a tradition that is capable of reducing any human conceit or natural dignity to the barest form of social outrage.

It is uncomfortably symbolic that there were some Negroes "absent" from the rent and barbecue parties, just as it is analogous of the social microcosm that at twelve o'clock in

the old Tin Type Hall in New Orleans, around the turn of the century, "when the ball was getting right, the more respectable Negroes who did attend went home. Then Bolden played a number called *Don't Go Away Nobody*, and the dancing got rough. When the orchestra settled down to the slow blues, the music was mean and dirty, as Tin Type roared full blast."[1] It was not only the Creoles' purely political (made social) response to a Negro music but the feeling of the black people themselves that there were things much more important than the natural expression of a vital culture.

In the North, before the migration that hurled all the deepest blacks of Southern Negro culture into America at large, the Northern Negroes had to a great extent secured themselves a leaky boat of security from these reminders of the slave culture. "Most of the Negro population in New York then [around 1921] had either been born there or had been in the city so long, they were fully acclimated. They were trying to forget the traditions of the South; they were trying to emulate the whites. You couldn't deliver a package to a Negro's front door. You had to go down to the cellar door. And Negroes dressed to go to work. They changed into work clothes when they got there. You usually weren't allowed to play blues and boogie woogie in the average Negro middle-class home. That music supposedly suggested a low element. And the big bands with the violins, flutes, piccolos, didn't play them either."[2]

One of the funniest and most cruelly absurd situations to develop because of the growth and influence of a definable black middle class in America is the case of Black Swan Records. Black Swan was founded and run by a Negro, Harry Pace, during the early twenties. It was the first Negro-owned record company in the country, and it quickly

[1] F. Ramsey and C. Smith, eds., *Jazzmen* (New York, Harcourt, Brace, 1939), pp. 12-13.
[2] Garvin Bushell, "Garvin Bushell and New York Jazz in the 1920's," *Jazz Review* (January, 1959), p. 12.

grew into a money-maker, its success based to a large extent on the popularity of its star performer, a young girl named Ethel Waters. Black Swan also recorded numerous other blues performers, and advertised its products as: "The Only Genuine Colored Record. Others Are Only Passing for Colored." (A wild turnabout!) But many Negroes, especially those in business, brought pressure on Pace to change his position, since they thought that the job of a Negro recording company would be to show how dignified Negroes really were . . . and, of course, blues were not dignified. Pace tried to use all kinds of other material that was not strictly blues (for this reason Ethel Waters with her torchy, "pop" style was a godsend), but the popularity of the company waned because the audience to which the records were largely aimed did not care as much about the *dignity* of its musical tastes as the Negro business community. Finally, Black Swan was sold to Paramount, a white company, which had no qualms about recording the rougher, less dignified, blues performers.

The *space* the city provided grew quickly vertical. The idea of *society*, or at least divisions within a social milieu, grew more common among Negroes. The earlier "mulatto-freedmen-house servant-field servant" division that became so fixed within the slave society was, of course, broken down, but the new strata forming within the "free" black societies proved to be equally as rigid. The new society based its divisions almost completely upon *acquisition*, reflecting and reacting to the changed psyche of twentieth-century America. In the black society, the change was effected almost exclusively by the mass movement north and the "openness" of the new industrial culture. The older, stricter divisions of black society, based on certain mythological characteristics of color-caste and the importance of less menial positions within the slave culture, were broken down because many "field niggers" and "monkey men" (dark-skinned African-looking Negroes) could go into

Mr. Ford's factories and "make $5 a day just like a white man." The white society's need for Negro laborers and the resulting scramble into the great Northern cities "smeared" the caste lines of an older black society and began to form a sprawling bourgeoisie based on the pay check—an almost exact duplication of the way in which the earlier caste system of white America was "debased." But the white society still had some semblance of caste—its "first" families, intact (although frequently as heads or "captains" of industry). Negroes could not become "captains" of industry and could never have belonged to any first families (except, perhaps, as family retainers), so it was the professional men—doctors, lawyers, ministers—who were the heads of the new black society. And these people wanted more than anything in life to become *citizens*. They were not ever satisfied with being freedmen, or former slaves. They wanted no connection with that "stain on America's past"; and what is more, they wanted the right (which they thought they could earn by moving sufficiently away from the blacker culture) to look on that "stain" as objectively as possible, when they had to, and to refer to it from the safety of the bastions of the white middle class. They did not even want to be "accepted" as *themselves,* they wanted any self which the mainstream dictated, and the mainstream *always* dictated. And this black middle class, in turn, tried always to dictate that self, or this image of a whiter Negro, to the poorer, blacker Negroes.

The effects of these attempts by the black middle class to whiten the black culture of this country are central to my further discussions on the sociological significance of the changes in Negro music, but I think it might be useful here to consider also the effects this "whitening" had in other cultural areas. I think it is not fantastic to say that only in music has there been any significant Negro contribution to a *formal* American culture. For the most part, most of the other

contributions made by black Americans in the areas of painting, drama, and literature have been essentially undistinguished. The reasons for this tragic void are easy to understand if one realizes one important idea about the existence of any black culture in this country. The only Negroes who found themselves in a *position* to pursue some art, especially the art of literature, have been members of the Negro middle class. Only Negro music, because, perhaps, it drew its strength and beauty out of the depths of the black man's soul, and because to a large extent its traditions could be carried on by the "lowest classes" of Negroes, has been able to survive the constant and willful dilutions of the black middle class and the persistent calls to oblivion made by the mainstream of the society. Of course, that mainstream wrought very definite and very constant changes upon the *form* of the American Negro's music, but the emotional significance and vitality at its core remain, to this day, unaltered. It was the one vector out of African culture impossible to eradicate. It signified the existence of an Afro-American, and the existence of an Afro-American culture. And in the evolution of form in Negro music it is possible to see not only the evolution of the Negro as a cultural and social element of American culture but also the evolution of that culture itself.

The "coon shout" proposed one version of the American Negro and of America; Bessie Smith proposed another. (Swing and bebop, as I shall attempt to point out, propose still another.) But the point is that both these versions are accurate and informed with a legitimacy of emotional concern nowhere available in, say, what is called "Negro literature." The reason is as terrifying as it is simple. The middle-class black man, whether he wanted to be a writer, or a painter, or a doctor, developed an emotional allegiance to the middle-class (middle-brow) culture of America that obscured, or actually made hideous, any influences or psychological awareness that seemed to come from outside

what was generally acceptable to a middle-class white man, especially if those influences were identifiable as coming from the most despised group in the country. The black middle class wanted no subculture, nothing that could connect them with the poor black man or the slave.

Literature, for most Negro writers, for instance, was always an example of "culture," in the narrow sense of "cultivation" or "sophistication" in an individual within their own group. The Negro artist, because of his middle-class background, carried an artificial social burden as the "best and most intelligent" of Negroes, and usually entered into the "serious" arts to exhibit his social graces—as a method, or means, of displaying his participation in the serious aspects of Western culture. To be a writer was to be "cultivated," in the stunted bourgeois sense of the word. It was also to be a "quality" black man, not merely an "ordinary nigger."

Early Negro novelists such as Charles Chesnutt, Otis Shackleford, Sutton Griggs (even though he was more militant), Pauline Hopkins, produced works that were potboilers for the growing Negro middle class. The books were also full of the same prejudices and conceits that could be found in the novels of their models, the white middle class. The contempt for the "lower-classed Negroes" found in these novels by black novelists is amazing and quite blatant. And, as Robert A. Bone points out: "It must be understood at once that the early [Negro] novelists believed substantially in the myth of Anglo-Saxon superiority. Pauline Hopkins writes: 'Surely the Negro race must be productive of some valuable specimens, if only from the infusion which amalgamation with a superior race must eventually bring.'" Chesnutt's and Griggs's "heroes" were usually "refined Afro-Americans"; as Bone shows further: "In several of the early novels there is a stock situation in which a 'refined Afro-American' is forced to share a Jim Crow car with dirty, boisterous, and drunken Negroes."

The idea of the "separation," the strata, had developed within the group. The thin division of field hand from house servant had widened, and the legacy of the house servant was given voice constantly in the work of the early Negro writers. As Bone says, "When all the sound and fury of these novels has evaporated, what remains is an appeal for an alliance between 'the better class of colored people' and the 'quality white folks.' " [3] And an "amen" could be heard to that sentiment throughout the rising black churches of the North. Of course, the Negro novelist ceased to be so blatantly patronizing and disparaging of "most Negroes" when the social climate in the country itself became more "liberal." No longer would a member of the Negro middle class be idiotic enough to write, as Shackleford once did in his novel *Lillian Simmons:* "She could understand why Jim Crow cars and all other forms of segregation in the South were necessary, but she could not feel that it was fair to treat all colored people alike, because all were not alike." [4]

By the twenties, spurred again by the movement of Negroes to the North and the change that had made of a basically agricultural country an industrial giant, thereby transforming the core of the Negro population from farm workers into a kind of urban proletariat, a great change also took place among Negro artists and intellectuals. Even though they were still fundamentally the products of the Negro middle class and still maintained rather firmly many emotional and intellectual ties with it, the Negro novelists of the twenties at least began to realize that the earlier attitudes of the black middle class were the most agonizing remnants of the "slave mentality." It was now that the middle class demanded, through its spokesmen the novelists and the more intrepid educators, "at least equality." It was the beginning of what was called the "Negro Renaissance," and the emergence of what Alain Locke called the "New Ne-

[3] *Op. cit.,* p. 19.
[4] *Ibid.,* p. 18.

gro." But if now the more cultivated members of the black middle class began to realize that the old stance of "whiter Negroes" could not effect an entrance into the mainstream of American society (these writers, in fact, rebelled against the entire concept of a slavish disparagement of the Negro by Negroes as a prerequisite for such privilege), this "rebellion" still took form within the confines of the American middle-class mind, even if those confines had been somewhat broadened by the internationalism imposed upon the country by World War I. Even the term *New Negro,* for all its optimistic and rebellious sound, still assumes that it is a different kind of Negro who is asking for equality—not old Rastus the slave. There is still, for all the "race pride" and "race consciousness" that these spokesmen for the Negro Renaissance claimed, the smell of the dry rot of the middle-class Negro mind: the idea that, somehow, Negroes must *deserve* equality.

The spirit of this "Renaissance" was divided as an emotional entity into three separate and easily identifiable reactions, corresponding to the cultural stratum of the particular Negroes who had to interpret it. The rising middle class-spawned intelligentsia invented the term *New Negro* and the idea of the Negro Renaissance to convey *to the white world* that there had been a change of tactics as to how to climb onto the bandwagon of mainstream American life. The point here is that this *was* to be conveyed to white America; it was another conscious reaction to that white America and another adaptation of the middle-class Negro's self-conscious performance for his ever appreciative white audience. There was a loud, sudden, but understandably strained, appreciation for things black by this intelligentsia. The "Harlem School" of writers attempted to glorify the lives of the black masses, but only succeeded in making their lives seem *exotic* as literary themes. It produced a generation and a tradition of Lafcadio Hearns. The reproduction of a black America as real as the white America these writers

seemed to sense as "the norm" was never realized. A white man, Carl Van Vechten, mechanized and finally strait-jacketed a good part of the Negro Renaissance when he wrote the novel *Nigger Heaven*, which many Negro writers have never ceased to imitate.

For poorer Negroes, as I have mentioned before, Marcus Garvey's "Back to Africa Movement" represented the renewed sense of "race pride" the concept of the New Negro represented for the middle-class intelligentsia. Garvey thought, and persuaded a great body of the Negro masses, that equality could never be achieved in the United States, and the Negro should seek to embrace his older, "truer," African traditions and eventually set up an independent black state in Africa. Although Garvey ultimately failed, his call to "Mother Africa" inspired thousands of Negroes, though, of course, the middle class would have nothing to do with him. Not only because it did not want to be associated with a movement that involved the poorer Negro but also because any mention of Africa only conjured up frightening visions of undigested Tarzan movies.

The middle class reacted to the growing "nationalism" among poorer Negroes and the intelligentsia by adopting a milder kind of nationalism themselves. And even though most were startled at first by the kind of radicalism that the Niagara Movement, which led to the eventual establishment of the NAACP, and people like W. E. B. DuBois represented, they did begin to protest in earnest about "Jim Crow," and "the brotherhood of man." They eventually took over such organizations as the NAACP, aided by the dependence of such organizations on the philanthropies of white liberals, and molded them to their own purposes. But from the beginning, when the black middle class began to *realign* itself toward an America from which they could ask "equality" instead of privilege, they had oriented themselves as would-be *citizens*, rather than freedmen, or ex-slaves. And this is the fundamental difference, perhaps even the single

line of demarcation, separating the black middle class from the rest of the Negroes living in the United States. The middle class accepts the space, the openness and/or "liberalism" of twentieth-century America as the essential factor of its existence in this country as citizens. But when the recognized barriers to such "citizenship" are reached, when all their claims to equality with the rest of America, on the one hand, and superiority, on the other, to their own black brothers seem a useless and not wholly idealistic delusion because in the end they are still regarded by this society as "only Negroes," they are content with the name "second-class citizens." This at least shows them with a foot in the door, if somehow still having to battle to get the rest of themselves in; always in, behind the calm façade of white middle-class America. For the black intelligentsia, the term *second-class citizen* was a meaningless hoax, and the poorer Negro never even considered the idea of citizenship as something that could be extended in this country to a person with a black skin. The poor Negro always remembered himself as an ex-slave and used this as the basis of any dealing with the mainstream of American society. The middle-class black man bases his whole existence on the hopeless hypothesis that no one is supposed to remember that for almost three centuries there was slavery in America, that the white man was the master and the black man the slave. This knowledge, however, is at the root of the legitimate black culture of this country. It is this knowledge, with its attendant muses of self-division, self-hatred, stoicism, and finally quixotic optimism, that informs the most meaningful of Afro-American music.

My burden's so heavy, I can't hardly see,
Seems like everybody is down on me,
An' that's all right, I don't worry, oh, there will be a
 better day.

The most expressive Negro music of any given period will be an exact reflection of what the Negro himself is. It will be a portrait of the Negro in America at that particular time. Who he thinks he is, what he thinks America or the world to be, given the circumstances, prejudices, and delights of that particular America. Negro music and Negro life in America were always the result of a reaction to, and an adaptation of, whatever America Negroes were given or could secure for themselves. The idea of ever becoming "Americans" in the complete social sense of that word would never have been understood by Negro slaves. Even after the Emancipation, such a concept would have seemed like an unamusing fantasy to most Negroes since many times the very term *America* must have meant for them "a place they don't want you." America, for Negroes, was always divided into black and white, master and slave, and as such, could not simply be called "America." And so there have been, since slavery, two Americas: A white America and a black America, both responsible to and for the other. One oppressed, the other the oppressor. But an even more profound difference between these two Americas has been their awareness of each other, or the degree to which the one America is aware of the other. The white America has never had more than a cursory knowledge of black America (even during the days of the Negro Renaissance, as I have pointed out, the knowledge of black America obtained by white America, for all the talk to the contrary, was never more than superficial). But the black American has always *had to* know what was on the white man's mind, even if as a slave, he had no full knowledge of what America really was. The Negro's adaptation to American life has been based since the Emancipation on his growing knowledge of America and his increasing acquaintance with the workings of the white man's mind. The Negro American had always sought to *adapt* himself to the other America and to exist

as a casual product of this adaptation; but this central concept of Afro-American culture was discarded by the middle class. After the move north and the sophistication that that provided, it was *assimilation* the middle class desired: not only to *disappear* within the confines of a completely white America but to erase forever any aspect of a black America that had ever existed.

The separation I spoke of between the freedman and the citizen is basic to any understanding of the evolution of black America. From a relatively homogenous social, cultural, and geographical unit, existing strictly apart from white America, Negroes became a group of diverse "Americans" forming a psychological chain that begins with a complete awareness of and dependence on what is now called a "folk culture" and moves to a completely antithetical extreme—to those Negroes who are completely dependent upon the culture of mainstream America. It is a psychological chain much like a spectrum that begins at deepest black and moves easily into American gray. There was a period of transition, however, when for the majority of Negroes, the chain did not stretch completely into gray America. But the separation, the cleavage, within black America was beginning to be quite apparent.

The beginning of this cleavage within black America was demonstrated in microcosm in New Orleans, even before the mass exodus of Negroes northward. New Orleans, with its co-existing complex of social, cultural, and racial influences, predated the modern, post-World-War-I, Northern city in many ways. French, Spanish, English, African, and Caribbean cultures existed simultaneously within New Orleans and all were thriving. Within what could be called the black society there was already the extreme cleavage I have mentioned, based for the most part on socio-ethnic considerations, most easily verified by color.

The Creoles, *gens de couleur,* and mulattoes existed both

socially and economically as the more generalized black middle class was to do in later years. They encouraged the separation between themselves and their darker, usually poorer half-brothers. And they emphasized this separation as formally as they could by trying to emulate as much as possible the white French culture of New Orleans.

The Downtown people acquired most of the European instrumental techniques and disparaged the vocal blues style that raged Uptown in the black belt. But the repressive segregation laws passed at the turn of the century forced the "light people" into closer social and economic relationships with the blacker culture. And it was the connections engendered by this forced merger that produced a primitive jazz. The black rhythmic and vocal tradition was translated into an instrumental music which utilized some of the formal techniques of European dance and march music.

Later the merging of the Southern blues tradition with the musical traditions of the Northern Negro produced an instrumental music similar in intent to the early jazz of New Orleans. And when the instrumental innovators themselves began to be heard in the North, the music, jazz, had already developed further, aided by the architectonic and technical ideas of ragtime, into a more completely autonomous music. The important idea here, though, is that the first jazzmen were from both sides of the fence—from the darker blues tradition and a certain fixed socio-cultural, and most of the time economic, stratum, and also from the "white" Creole tradition and its worship of what were certainly the ideals of a Franco-American middle class. Also, the Negroes who hired the blues men into their dance and society bands in the North were ofttimes by-products of the desire of Negroes to set up a black middle class. So were many of the musicians who were influenced by the "dirty" way of playing. This meant that as jazz developed after the early twenties in this country, it could only be a music that would reflect the socio-cultural continuum that had developed

Enter the Middle Class / • • • • / *139*

within Negro America from blackest black to whitest white. The jazz player could come from any part of that socio-cultural spectrum, but if he were to play a really moving kind of jazz, he had to reflect almost all of the musical spectrum, or at least combine sufficiently the older autonomous blues tradition with the musical traditions of the Creoles or the ragtime orchestras of the North. And thus, jazz could not help but reflect the entire black society. (Such a thing as a *middle-class blues singer* is almost unheard of. It is, it seems to me, even a contradiction of terms.)

Jazz, as it emerged and as it developed, was based on this new widening of Afro-American culture. In the best of jazz, the *freedman-citizen* conflict is most nearly resolved, because it makes use of that middle ground, the space that exists as the result of any cleavage, where both emotional penchants can exist as *ideas* of perhaps undetermined validity, and not necessarily as "ways of life."

First there was, after the Emancipation, an America. Then there was a North. And after World War I, even places and sets of ideas that were not American. That was, in one sense, as far as the blues would go as a completely *autonomous* music. The blues as a fully integrated American experience was what was called "classic" blues. Publicly, as American performers, the great lady blues singers of the twenties brought blues to a social and cultural significance that it never has had before or since. The jazz people took over from there.

Blues in its most significant form again returned underground, into the house parties and black cabarets that existed in the new black communities of the North, with all the wild "un-American" abandon which was supposed to typify the pre-middle-class Negro society. Without the jazz players, blues would have existed as an American music, *i.e.*, considered as such by the mainstream, only during the

time of the classic singers. Before their time and after it, autonomous blues was the product of a subculture.

Given the necessary social involvement with American culture, Negroes themselves would have drifted away from blues since it no longer was an exact reflection of their lives in America. For the developing black middle class, it was simply the mark of Cain, and just another facet of Negroness which they wished to be rid of. But jazz, even with its weight of blues, could make itself available as an emotional expression to the changing psyche of the "modern" Negro, just as in less expressive ways, it made itself available to the modern American white man.

During the twenties, when jazz was first beginning to be heard in the North and in whatever diverse presentations, throughout America, it was still in a period of transition. The older blues people were still coming into the Northern cities, the classic singers were at their peaks; and the newer city blues was also developing (as the expression of a *new* subculture) as well as the spontaneous piano music, boogie woogie (or the Eastern "stride" piano style), that was concomitant with it. But the jazz players were also coming into these towns, and a whole new generation of Negroes was born into this transitional culture—the first generation with a preponderance of *citizens* rather than ex-slaves. These were the people who had to decide what was to be done with blues and what weight it would have in their lives. At the same time there were still a great many Negroes who had known slavery personally, or knew it as the emotional idea on which any experience of America had to be based. All these Negroes existed as black America; the extremes were the rent-party people at the one end of black society and the various levels of parvenu middle class at the other. Jazz represented, perhaps, the link connecting the two, if they were to be connected. The verticality of the city began to create two separate *secularities,* and the blues had to be divided among them if it was going to survive at all.

Enter the Middle Class / • • • • */ 141*

The blues was conceived by freedmen and ex-slaves—if not as the result of a personal or intellectual experience, at least as an emotional confirmation of, and reaction to, the way in which most Negroes were still forced to exist in the United States. The blues impulse was a psychological correlative that obscured the most extreme ideas of *assimilation* for most Negroes, and made any notion of the complete abandonment of the traditional black culture an unrealizable possibility. In a sense, the middle-class spirit could not take root among most Negroes because they sensed the final fantasy involved. Besides, the pay check, which was the aspect of American society that created a modern black middle class, was, as I mentioned before, also available to what some of my mother's friends would refer to as "low-type coons." And these "coons" would always be unavailable both socially and culturally to any talk of assimilation from white man or black. The Negro middle class, always an exaggeration of its white model, could include the professional men and educators, but after the move north it also included men who worked in factories and as an added dig, "sportsmen," *i.e.*, gamblers and numbers people. The idea of Negro "society," as E. Franklin Frazier pointed out, is based only

on acquisition, which, as it turns out, makes the formation of a completely parochial meta-society impossible. Numbers bankers often make as much money as doctors and thereby are part of Negro "society." And even if the more formal ("socially responsible") Negro middle class wanted to become simply white Americans, they were during the late twenties and thirties merely a swelling minority.

The two secularities I spoke of are simply the ways in which the blues was beginning to be redistributed in black America through these years. The people who were beginning to move toward what they could think of as citizenship also moved away from the older blues. The unregenerate Northerners already had a music, the thin-willed "society" bands of Jim Europe, and the circus as well as white rag had influenced the "non-blues" bands of Will Marion Cook and Wilbur Sweatman that existed before the migration. But the huge impact the Southerners made upon the North changed that. When the city blues began to be powerful, the larger Negro dance bands hired some of the emigrants as soloists, and to some degree the blues began to be heard in most of the black cabarets, "dance schools," and theaters. The true jazz sound had moved north, and even the blackest blues could be heard in the house parties of Chicago and New York. But for most of America by the twenties, jazz (or *jass*, the noun, not the verb) meant the Original Dixieland Jazz Band (to the hip) and Paul Whiteman (to the square). Whiteman got rich; the O.D.J.B. never did.

The O.D.J.B. was a group of young white men who had been deeply influenced by the King Oliver band in New Orleans; they moved north, and became the first jazz band to record. They had a profound influence upon America, and because they, rather than the actual black innovators, were heard by the great majority of Americans *first*, the cultural lag had won again.

A Negro jazz band, Freddie Keppard's Original Creoles, turned down an invitation to record a few months before

the O.D.J.B.; Keppard (myth says) didn't accept the offer because he thought such a project would merely invite imitation of his style! That is probably true, but it is doubtful that Keppard's band would have caught as much national attention as the smoother O.D.J.B. anyway, for the same reason the O.D.J.B. could never have made as much money as Whiteman.

It is significant that by 1924, when Bessie Smith was still causing riots in Chicago and when young Louis Armstrong was on his way to New York to join the Fletcher Henderson band—and by so doing, to create the first really swinging *big* jazz band, the biggest names in "jazz" were Whiteman and the Mound City Blue Blowers, another white group. Radio had come into its own by 1920, and the irony is that most Negroes probably thought of jazz, based on what they had heard, as being a white dilution of older blues forms! It was only after there had been a few recordings sufficiently distributed through the black Northern and urban Southern neighborhoods, made by Negro bands like King Oliver's (Oliver was then in Chicago with his historic Creole Jazz Band, which featured Louis Armstrong, second cornet), Fletcher Henderson's, and two Kansas City bands—Bennie Moten's and Clarence Williams', that the masses of Negroes became familiar with jazz. At Chicago's Lincoln Gardens Cafe, Oliver first set the Northern Negro neighborhoods on fire, and then bands like Moten's and Williams' in the various clubs around Kansas City; but Henderson reached his Negro audience mostly via records because even when he got his best band together (with Coleman Hawkins, Louis Armstrong, Don Redman, etc.), he was still playing at Roseland, which was a white club.

The earliest jazz bands, like Buddy Bolden's, were usually small groups. Bolden's instrumentation was supposed to have been cornet, clarinet, trombone, violin, guitar, bass

(which was one of the first instrumental innovations for that particular group since most bands of that period and well after used the tuba) and drums. These groups were usually made up of musicians who had other jobs (like pre-classic blues singers) since there was really no steady work for them. And they played most of the music of the time: quadrilles, schottisches, polkas, ragtime tunes, like many of the other "cleaner" groups around New Orleans. But the difference with the Bolden band was the blues quality, the Uptown flavor, of all their music. But this music still had the flavor of the brass marching bands. Most of the musicians of that period had come through those bands; in fact, probably still marched with them when there was a significant funeral. Another quality that must have distinguished the Bolden band was the improvisational character of a good deal of their music. Charles Edward Smith remarks that "The art of group improvisation—like the blues, the life blood of jazz—was associated with this uptown section of New Orleans in particular. As in folk music, two creative forces were involved, that of the group and that of the gifted individual." [1]

Most of the Uptown bands were noted for their "sloppy ensemble styles." The Bolden band and the other early jazz groups must have sounded even sloppier. The music was a raw mixture of march, dance, blues, and early rag rhythm, with all the players improvising simultaneously. It is a wonderful concept, taking the unison tradition of European march music, but infesting it with teeming improvisations, catcalls, hollers, and the murky rhythms of the ex-slaves. The Creoles must have hated that music more than anything in life.

But by the time the music came upriver along with the fleeing masses, it had changed a great deal. Oliver's Creole Band, the first really influential Negro jazz band in the

[1] "New Orleans and Traditions in Jazz," in *Jazz*, p. 39.

North, had a much smoother ensemble style than the Bolden band: the guitar and violin had disappeared, and a piano had been added. In New Orleans, pianists had been largely soloists in the various bawdy houses and brothels of Storyville. In fact, pianists were the only Negro musicians who worked steadily and needed no other jobs. But the early New Orleans jazz groups usually did not have pianos. Jelly Roll Morton, one of the first jazz pianists, was heavily influenced by the ragtime style, though his own rags were even more heavily influenced by blues and that rougher rag style called "barrelhouse." As Bunk Johnson is quoted as saying, Jelly played music "the whores liked." And played in a whorehouse, it is easy to understand how functional that music must have been. But the piano as part of a jazz ensemble was something not indigenous to earlier New Orleans music. The smoother and more clearly polyphonic style of Oliver's band, as opposed to what must have been a veritable heterophony of earlier bands like Bolden's —Kid Ory's Sunshine Orchestra, the first black jazz band to record (Los Angeles, 1921), gives us some indication— showed a discipline and formality that must certainly have been imposed to a large degree by ragtime and the more precise pianistic techniques that went with it.

Oliver's band caused a sensation with audiences and musicians alike and brought the authentic accent of jazz into the North. Garvin Bushell remembers: "We went on the road with Mamie Smith in 1921. When we got to Chicago, Bubber Miley and I went to hearing Oliver at the Dreamland every night. [This was before Armstrong joined the band and they moved to Lincoln Gardens.] It was the first time I'd heard New Orleans jazz to any advantage and I studied them every night for the entire week we were in town. I was very much impressed with their blues and their sound. The trumpets and clarinets in the East had a better 'legitimate' quality, but their [Oliver's band's] sound touched you more. It was less cultivated but more expressive

of how the people felt. Bubber and I sat there with our mouths open." [2]

Louis Armstrong's arrival at twenty-two with Oliver's band had an even more electrifying effect on these Northern audiences, which many times included white jazz musicians. Hoagy Carmichael went to the Lincoln Gardens with Bix Beiderbecke in 1923 to hear that band:

"The King featured two trumpets, a piano, a bass fiddle and a clarinet . . . a big black fellow . . . slashed into *Bugle Call Rag*.

"I dropped my cigarette and gulped my drink. Bix was on his feet, his eyes popping. For taking the first chorus was that second trumpet, Louis Armstrong.

"Louis was taking it fast. Bob Gillette slid off his chair and under the table . . . Every note Louis hit was perfection." [3]

This might seem amusing if it is noted that the first and deepest influences of most white Northern and Midwestern jazz musicians were necessarily the recordings of the O.D.J.B., who were imitating the earlier New Orleans styles, and Oliver, who had brought that style to its apex. Thus, this first hearing of the genuine article by these white musicians must have been much like tasting real eggs after having been brought up on the powdered variety. (Though, to be sure, there's no certainty that a person will like the original if he has developed a taste for the other. So it is that Carmichael can write that he still preferred Beiderbecke to Armstrong, saying, "Bix's breaks were not as wild as Armstrong's but they were hot and he selected each note with musical care." [4]

Blues as an autonomous music had been in a sense inviolable. There was no clear way into it, *i.e.*, its production, not

[2] "Garvin Bushell and New York Jazz in the 1920's," *Jazz Review* (February, 1959), p. 9.
[3] *The Stardust Road* (New York, Rinehart, 1946), p. 53.
[4] As quoted in *The Story of Jazz*, p. 128.

its appreciation, except as concomitant with what seems to me to be the peculiar social, cultural, economic, and emotional experience of a black man in America. The idea of a white blues singer seems an even more violent contradiction of terms than the idea of a middle-class blues singer. The materials of blues were not available to the white American, even though some strange circumstance might prompt him to look for them. It was as if these materials were secret and obscure, and blues a kind of ethno-historic rite as basic as blood.

The classic singers brought this music as close to white America as it could ever get and still survive. W. C. Handy, with the publication of his various "blues compositions," *invented* it for a great many Americans and also showed that there was some money to be made from it. Whiteman, Wilbur Sweatman, Jim Europe, all played Handy's compositions with success. There was even what could be called a "blues craze" (of which Handy's compositions were an important part) just after the ragtime craze went on the skids. But the music that resulted from this craze had little, if anything, to do with legitimate blues. That could not be got to, except as the casual expression of a whole culture. And for this reason, blues remained, and remains in its most moving manifestations, obscure to the mainstream of American culture.

Jazz made it possible for the first time for something of the legitimate feeling of Afro-American music to be imitated successfully. (Ragtime had moved so quickly away from any pure reflection of Negro life that by the time it became popular, there was no more original source to imitate. It was, in a sense, a premature attempt at the socio-cultural merger that later produced jazz.) Or rather, jazz enabled separate and *valid* emotional expressions to be made that were based on older traditions of Afro-American music that were clearly not a part of it. The Negro middle class would not have a music if it were not for jazz. The white

man would have no access to blues. It was a music capable of reflecting not only the Negro and a black America but a white America as well.

During the twenties, serious young white musicians were quick to pick up more or less authentic jazz accents as soon as they had some contact with the music. The O.D.J.B., who came out of a parallel tradition of white New Orleans marching bands, whizzed off to Chicago and stunned white musicians everywhere as well as many Negro musicians in the North who had not heard the new music before. Young white boys, like Beiderbecke, in the North and Midwest were already forming styles of their own based on the O.D.J.B.'s records and the playing of another white group, the New Orleans Rhythm Kings, before Joe Oliver's band got to Chicago. And the music these boys were making, or trying to make, had very little to do with Paul Whiteman. They had caught the accent, understood the more generalized emotional statements, and genuinely moved, set out to involve themselves in this music as completely as possible. They hung around the Negro clubs, listening to the newly employed New Orleans musicians, and went home and tried to play their tunes.

The result of this cultural "breakdown" was not always mere imitation. As I have said, jazz had a broadness of emotional meaning that allowed of many separate ways into it, not all of them dependent on the "blood ritual" of blues. Bix Beiderbecke, as a mature musician, was even an innovator. But the real point of this breakdown was that it reflected not so much the white American's increased understanding of the Negro, but rather the fact that the Negro had created a music that offered such a profound reflection of America that it could attract white Americans to want to play it or listen to it for exactly that reason. The white jazz musician was even a new *class* of white American. Unlike the earlier blackface acts and the minstrels who sought to burlesque

Swing—From Verb to Noun / • • • • / *149*

certain facets of Negro life (and, superficially, the music associated with it), there were now growing ranks of white jazz musicians who wanted to play the music because they thought it emotionally and intellectually fulfilling. It made a common cultural ground where black and white America seemed only day and night in the same city and at their most disparate, proved only to result in different *styles*, a phenomenon I have always taken to be the whole point (and value) of divergent cultures.

It is interesting that most of these young white musicians who emerged during the early twenties were from the middle class and from the Middle West. Beiderbecke was born in Davenport, Iowa; that town, however, at the turn of the century was a river port, and many of the riverboats docked there—riverboats whose staffs sometimes included bands like Fate Marable's, Dewey Jackson's, and Albert Wynn's, and musicians like Jelly Roll Morton and Louis Armstrong. Beiderbecke's first group, the Wolverines, played almost exclusively at roadhouses and colleges in the Midwest, most notably at Indiana University.

A few years after the Wolverines had made their reputation as what George Hoefer calls "the first white band to play the genuine Negro style of jazz," another group of young white musicians began to play jazz "their own way." They were also from the Midwest, but from Chicago. Eddie Condon, Jimmy McPartland, Bud Freeman, PeeWee Russell, Dave Tough, and some others, all went to Austin High School and became associated with a style of playing known as "Chicago jazz," which took its impetus from the records of the O.D.J.B. and the New Orleans Rhythm Kings dates on the North Side of Chicago.

Chicago and nearby parts of the Midwest were logically the first places where jazz could take root in the North (although there were some parallel developments in New York). In a sense Chicago was, and to a certain extent is now, a kind of frontier town. It sits at the end of the river-

boat runs, and it was the kind of industrial city that the first black emigrants were drawn to. It had many of the heavy industries that would employ Negroes, whereas New York's heaviest industry is paperwork. And in Chicago, during what was called the "Jazz Age," there was an easiness of communication on some levels between black and white that was not duplicated in New York until some time later. Chicago at this time was something like the musical capital of America, encompassing within it black emigrants, white emigrants, country blues people, classic stylists, city house-party grinders, New Orleans musicians, and young Negro musicians and younger white musicians listening and reacting to this crush of cultures that so clearly typified America's rush into the twentieth century.

The reaction of young white musicians to jazz was not always connected directly to any "*understanding* of the Negro." In many cases, the most profound influence on young white musicians was the music of other white musicians. Certainly this is true with people like Beiderbecke and most of the Chicago-style players. But the entrance of the white man into jazz at this level of sincerity and emotional legitimacy did at least bring him, by implication, much closer to the Negro; that is, even if a white trumpet player were to learn to play "jazz" by listening to Nick LaRocca and had his style set (as was Beiderbecke's case) *before* he ever heard black musicians, surely the musical debt to Negro music (and to the black culture from which it issued) had to be understood. As in the case of LaRocca's style, it is certainly an appropriation of black New Orleans brass style, most notably King Oliver's; though the legitimacy of its deviation can in no way be questioned, the fact that it is a deviation must be acknowledged. The serious white musician was in a position to do this. And this acknowledgment, whether overt or tacit, served to place the Negro's culture and Negro society in a position of intelligent regard it had never enjoyed before.

This acknowledgment of a developed and empirical profundity to the Negro's culture (and as the result of its separation from the mainstream of American culture) also caused the people who had to make it to be separated from this mainstream themselves. Any blackness admitted within the mainstream existed only as it could be shaped by the grimness of American sociological (and political) thought. There was no life to Negroes in America that could be understood by America, except negatively or with the hopeless idealism of impossible causes. During the Black Renaissance the white liberal and sensual dilettante "understood" the Negro. During the Depression, so did the Communist Party. The young white jazz musicians at least had to face the black American head-on and with only a very literal drum to beat. And they could not help but do this with some sense of rebellion or separateness from the rest of white America, since white America could have no understanding of what they were doing, except perhaps in the terms that Whiteman and the others succeeded in doing it, which was not at all—that is, explaining a bird by comparing it with an airplane.

"Unlike New Orleans style, the style of these musicians —often and confusingly labeled 'Chicago'—sacrificed ease and relaxation for tension and drive, perhaps because they were mastering a new idiom in a more hectic environment. They had read some of the literature of the 20's—drummer, Dave Tough, loved Mencken and the *American Mercury*— and their revolt against their own middle-class background tended to be conscious. The role of the improvising—and usually non-reading—musician became almost heroic." [5]

Music, as paradoxical as it might seem, is the result of thought. It is the result of thought perfected at its most empirical, *i.e.*, as *attitude*, or *stance*. Thought is largely conditioned by reference; it is the result of consideration or speculation against reference, which is largely arbitrary.

[5] *The Story of Jazz*, p. 129.

There is no *one* way of thinking, since reference (hence value) is as scattered and dissimilar as men themselves. If Negro music can be seen to be the result of certain attitudes, certain specific ways of thinking about the world (and only ultimately about the *ways* in which music can be made), then the basic hypothesis of this book is understood. The Negro's music changed as he changed, reflecting shifting attitudes or (and this is equally important) *consistent attitudes within changed contexts*. And it is *why* the music changed that seems most important to me.

When jazz first began to appear during the twenties on the American scene, in one form or another, it was introduced in a great many instances into that scene by white Americans. Jazz as it was originally conceived and in most instances of its most vital development was the result of certain attitudes, or empirical ideas, attributable to the Afro-American culture. Jazz as played by white musicians was not the same as that played by black musicians, nor was there any reason for it to be. The music of the white jazz musician did not issue from the same cultural circumstance; it was, at its most profound instance, a learned art. The blues, for example, which I take to be an autonomous black music, had very little weight at all in pre-jazz white American culture. But blues is an extremely important part of jazz. However, the way in which jazz utilizes the blues "attitude" provided a musical analogy the white musician could understand and thus utilize in his music to arrive at a style of jazz music. The white musician understood the blues first as music, but seldom as an attitude, since the attitude, or world-view, the white musician was responsible to was necessarily quite a different one. And in many cases, this attitude, or world-view, was one that was not consistent with the making of jazz.

There should be no cause for wonder that the trumpets of Bix Beiderbecke and Louis Armstrong were so dissimilar. The white middle-class boy from Iowa was the product of a

culture which could *place* Louis Armstrong, but could never understand him. Beiderbecke was also the product of a sub-culture that most nearly emulates the "official" or formal culture of North America. He was an instinctive intellectual who had a musical taste that included Stravinsky, Schoenberg, and Debussy, and had an emotional life that, as it turned out, was based on his conscious or unconscious disapproval of most of the sacraments of his culture. On the other hand, Armstrong was, in terms of emotional archetypes, an honored priest of his culture—one of the most impressive products of his society. Armstrong was not *rebelling* against anything with his music. In fact, his music was one of the most beautiful refinements of Afro-American musical tradition, and it was immediately recognized as such by those Negroes who were not busy trying to pretend that they had issued from Beiderbecke's culture. The incredible irony of the situation was that both stood in similar places in the superstructure of American society: Beiderbecke, because of the isolation any deviation from mass culture imposed upon its bearer; and Armstrong, because of the socio-historical estrangement of the Negro from the rest of America. Nevertheless, the music the two made was as dissimilar as is possible within jazz. Beiderbecke's slight, reflective tone and impressionistic lyricism was the most impressive example of "the artifact given expression" in jazz. He played "white jazz" in the sense I am trying to convey, that is, as a music that is the product of attitudes expressive of a peculiar culture. Armstrong, of course, played jazz that was securely within the traditions of Afro-American music. His tone was brassy, broad, and aggressively dramatic. He also relied heavily on the vocal blues tradition in his playing to amplify the expressiveness of his instrumental technique.

I am using these two men as examples because they were two early masters of a developing *American* music, though they expressed almost antithetical versions of it. The point

is that Afro-American music did not become a completely American expression until the white man could play it! Bix Beiderbecke, more than any of the early white jazzmen, signified this development because he was the first white jazz musician, the first white musician who brought to the jazz he created any of the *ultimate concern* Negro musicians brought to it as a casual attitude of their culture. This development signified also that jazz would someday have to contend with the idea of its being an art (since that *was* the white man's only way into it). The emergence of the white player meant that Afro-American culture had already become the expression of a particular kind of American experience, and what is most important, that this experience was available intellectually, that it could be learned.

Louis Armstrong's departure from the Oliver Creole Jazz Band is more than an historical event; given further consideration, it may be seen as a musical and socio-cultural event of the highest significance. First, Armstrong's departure from Chicago (as well as Beiderbecke's three years later, in 1927, to join the Goldkette band and then Paul Whiteman's enterprise) was, in a sense, symbolic of the fact that the most fertile period for jazz in Chicago was finished and that the jazz capital was moving to New York. It also meant that Louis felt mature enough musically to venture out on his own without the presence of his mentor Joe Oliver. But most important, Armstrong in his tenure with Fletcher Henderson's Roseland band was not only responsible to a great degree for giving impetus to the first big jazz band, but in his capacity as one of the hot soloists in a big dance (later, jazz) band, he moved jazz into another era: the ascendancy of the soloist began.

Primitive jazz, like most Afro-American music that preceded it, was a communal, collective music. The famous primitive ensemble styles of earlier jazz allowed only of

"breaks," or small solo-like statements by individual players, but the form and intent of these breaks were still dominated by the form and intent of the ensemble. They were usually just quasi-melodic punctuations at the end of the ensemble chorus. Jazz, even at the time of Oliver's Creole Band, was still a matter of *collective improvisation,* though the Creole Band did bring a smoother and more complex polyphonic technique to the ensemble style. As Larry Gushee remarked in a review of a recent LP of the Creole Band (Riverside 12-122) ". . . the Creole Jazz Band . . . sets the standard (possibly, who knows, only because of an historical accident) for all kinds of jazz that do not base their excellence on individual expressiveness, but on form and *shape* achieved through control and balance." [6]

The emergence of this "individual expressiveness" in jazz was signaled impressively by Armstrong's recordings with a small group known as the Hot Five. The musicians on these recordings, made in 1925 and 1926, were Kid Ory, trombone; Johnny Dodds, clarinet and *alto saxophone;* Lil Hardin, now Mrs. Armstrong, piano; and Johnny St. Cyr, banjo. On these sides, Armstrong clearly dominates the group, not so much because he is the superior instrumentalist, but because rhythmically and harmonically the rest of the musicians followed where Louis led, sometimes without a really clear knowledge of where that would be. The music made by the Hot Five is Louis Armstrong music: it has little to do with collective improvisation.

"The 1926 Hot Five's playing is much less purely collective than King Oliver's. In a sense, the improvised ensembles are cornet solos accompanied by *impromptu countermelodies* [my italics], rather than true collective improvisation. This judgment is based on the very essence of the works, and not merely on the cornet's closeness to the microphone. Listen to them carefully. Isn't it obvious that Armstrong's personality absorbs the others? Isn't your attention sponta-

[6] *Jazz Review* (November, 1958), p. 37.

neously concentrated on Louis? With King Oliver, you listen to the *band*, here, you listen first to *Louis*." [7]

The development of the soloist is probably connected to the fact that about this time in the development of jazz, many of the "hot" musicians had to seek employment with larger dance bands of usually dubious quality. The communal, collective improvisatory style of early jazz was impossible in this context, though later the important big jazz bands and big "blues bands" of the Southwest solved this problem by "uniting on a higher level the individual contribution with the entire group." [8]

The isolation that had nurtured Afro-American musical tradition before the coming of jazz had largely disappeared by the mid-twenties, and many foreign, even debilitating, elements drifted into this broader instrumental music. The instrumentation of the Henderson Roseland band was not chosen initially for its jazz possibilities, but in order to imitate the popular white dance bands of the day. The Henderson band became a jazz band because of the collective personality of the individual instrumentalists in the band, who were stronger than any superficial forms that might be imposed upon them. The saxophone trio, which was a clichéed novelty in the large white dance bands, became something of remarkable beauty when transformed by Henderson's three reeds, Buster Bailey, Don Redman, and Coleman Hawkins. And just as earlier those singular hollers must have pierced lonely Southern nights after the communal aspect of the slave society had broken down and had been replaced by a pseudoautonomous existence on many tiny Southern plots (which represented, however absurd it might seem, the widest breadth of this country for those Negroes, and their most exalted position in it), so the changed society in which the large Negro dance bands existed represented, in

[7] André Hodeir, *Jazz: Its Evolution and Essence* (New York, Grove Press, 1956), pp. 50-51.
[8] *Jazz, A People's Music*, p. 206.

a sense, another post-communal black society. The move north, for instance, had broken down the old communities (the house parties were one manifestation of a regrouping of the newer communities: the Harlems and South Chicagos). Classic blues, the public face of a changed Afro-American culture, was the solo. The blues that developed at the house parties was the collective, communal music. So the jam sessions of the late twenties and thirties became the musicians' collective communal expression, and the solo in the large dance bands, that expression as it had to exist to remain vital outside its communal origins. The dance bands or society orchestras of the North replaced the plot of land, for they were the musician's only means of existence, and the solo, like the holler, was the only link with an earlier, more intense sense of the self in its most vital relationship to the world. The solo spoke singly of a collective music, and because of the emergence of the great soloists (Armstrong, Hawkins, Hines, Harrison), even forced the great bands (Henderson's, Ellington's, and later Basie's) into wonderfully extended versions of that communal expression.

The transformation of the large dance bands into jazz bands was in good measure the work of the Fletcher Henderson orchestra, aided largely by the arrangements of Don Redman, especially his writing for the reed section which gave the saxophones in the Henderson band a fluency that was never heard before. The reeds became the fiery harmonic and melodic imagination of the big jazz bands. And it was the growing prominence of the saxophone in the big band and the later elevation of that instrument to its fullest expressiveness by Coleman Hawkins that planted the seed for the kind of jazz that is played even today. However, it was not until the emergence of Lester Young that jazz became a saxophone or reed music, as opposed to the brass music it had been since the early half-march, half-blues bands of New Orleans.

Louis Armstrong had brought *brass jazz* to its fullest

flowering and influenced every major innovation in jazz right up until the forties, and bebop. Earl Hines, whose innovations as a pianist began a new, single-note line approach to the jazz piano, was merely utilizing Armstrong's trumpet style on a different instrument, thereby breaking out of the ragtime-boogie-stride approach to piano that had been predominant since that instrument was first used in jazz bands. Coleman Hawkins' saxophone style is still close to the Armstrong-perfected brass style, and of course, all Hawkins' imitators reflect that style as well. Jimmy Harrison, the greatest innovator on the trombone, was also profoundly influenced by Armstrong's brass style.

With the emergence of many good "hot" musicians from all over the country during the mid-twenties, the big jazz bands continued to develop. By the late twenties there were quite a few very good jazz bands all over the country. And competent musicians "appeared from everywhere, from 1920 on: by 1930 every city outside the Deep South with a Negro population (1920 census) above sixty thousand except Philadelphia had produced an important band: Washington, Duke Ellington; Baltimore, Chick Webb; Memphis, Jimmie Lunceford; St. Louis, the Missourians; Chicago, Luis Russell and Armstrong; New York, Henderson, Charlie Johnson, and half a dozen more." [9]

So an important evolution in Afro-American musical form had occurred again and in much the same manner that characterized the many other changes within the tradition of Negro music. The form can be called basically a Euro-American one—the large (sweet) dance band, changed by the contact with Afro-American musical tradition into another vehicle for that tradition. Just as the Euro-American religious song and ballad had been used, so with the transformation of the large dance band into the jazz band and the adaptation of the thirty-two-bar popular song to jazz purposes, the music itself was broadened and extended even

[9] Hsio Wen Shih, "The Spread of Jazz and the Big Bands," in *Jazz*, p. 161.

further, and even more complex expressions of older musical traditions were made possible.

By the late twenties a great many more Negroes were going to high school and college, and the experience of an American "liberal" education was bound to leave traces. The most expressive big bands of the late twenties and thirties were largely middle-class Negro enterprises. The world of the professional man had opened up, and many scions of the new Negro middle class who had not gotten through professional school went into jazz "to make money." Men like Fletcher Henderson (who had a chemistry degree), Benny Carter, Duke Ellington, Coleman Hawkins, Jimmie Lunceford, Sy Oliver, and Don Redman, for example, all went to college: "They were a remarkable group of men. Between 1925 and 1935 they created, in competition, a musical tradition that required fine technique and musicianship (several of them were among the earliest virtuosi in jazz); they began to change the basis of the jazz repertory from blues to the wider harmonic possibilities of the thirty-two-bar popular song; they created and perfected the new ensemble-style big-band jazz; they kept their groups together for years, working until they achieved a real unity. They showed that jazz could absorb new, foreign elements without losing its identity, that it was in fact capable of evolution." [10]

These men were all "citizens," and they had all, to a great extent, moved away from the older *lowdown* forms of blues. Blues was not so *direct* to them, it had to be utilized in other contexts. Big show-band jazz was a music of their own, a music that still relied on older Afro-American musical tradition, but one that had begun to utilize still greater amounts of popular American music as well as certain formal European traditions. Also, the concept of making music as a means of making a living that had developed with the

[10] *Ibid.*, p. 164.

coming of classic blues singers was now thoroughly a part of the constantly evolving Afro-American culture. One did not expect to hear Bessie Smith at a rent party, one went to the theater to hear her. She was, at all levels, a *performer*. The young middle-class Negroes who came into jazz during the development of the show bands and dance bands all thought of themselves as performers as well. No matter how deeply the music they played was felt, they still thought of it as a public expression.

"If so many musicians came to jazz after training in one of the professions, it was because jazz was both more profitable and safer for a Negro in the 1920's; it was a survival of this attitude that decided Ellington to keep his son out of M.I.T. and aeronautical engineering in the 1930's." [11]

Just as Bessie Smith perfected vocal blues style almost as a Western artifact, and Louis Armstrong perfected the blues-influenced brass style in jazz (which was a great influence on all kinds of instrumental jazz for more than two decades), so Duke Ellington perfected the big jazz band, transforming it into a highly expressive instrument. Ellington, after the Depression had killed off the big theater-band "show-biz" style of the large jazz bands, began to create a personal style of jazz expression as impressive as Armstrong's innovation as a soloist (if not more so). Ellington replaced a "spontaneous collective music by a worked-out orchestral language." [12]

Ellington's music (even the "jungle" bits of his twenties show-band period, which were utilized in those uptown "black and tan" clubs that catered largely to sensual white liberals) was a thoroughly American music. It was the product of a native American mind, but more than that, it was a music that *could* for the first time exist within the formal boundaries of American culture. A freedman could not have created it, just as Duke could never have played like Peatie Wheatstraw. Ellington began in much the same

[11] *Ibid.*, p. 164.
[12] *Jazz: Its Evolution and Essence*, p. 33.

way as a great many of the significant Northern Negro musicians of the era had begun, by playing in the ragtime, show-business style that was so prevalent. But under the influence of the Southern styles of jazz and with the growth of Duke as an orchestra leader, composer, and musician, the music he came to make was as "moving" in terms of the older Afro-American musical tradition as it was a completely American expression. Duke's sophistication was to a great extent the very quality that enabled him to integrate so perfectly the older blues traditions with the "whiter" styles of big-band music. But Ellington was a "citizen," and his music, as Vic Bellerby has suggested, was "the detached impressionism of a sophisticated Negro city dweller."

Even though many of Ellington's compositions were "hailed as uninhibited jungle music," the very fact that the music was so much an American music made it cause the stir it did: "Ellington used musical materials that were familiar to concert-trained ears, making jazz music more listenable to them. These, however, do not account for his real quality. . . . In his work all the elements of the old music may be found, but each completely changed because it had to be changed. . . . Ellington's accomplishment was to solve the problem of form and content for the large band. He did it not by trying to play pure New Orleans blues and stomp music rearranged for large bands, as Henderson did, but by re-creating all the elements of New Orleans music in new instrumental and harmonic terms. What emerged was a music that could be traced back to the old roots and yet sounded fresh and new." [13]

For these reasons, by the thirties the "race" category could be dropped from Ellington's records. Though he would quite often go into his jungle things, faking the resurrection of "African music," the extreme irony here is that Ellington was making "African sounds," but as a sophisticated American. The "African" music he made had much

[13] *Jazz: A People's Music,* p. 192.

less to do with Africa than his best music, which, in the sense I have used throughout this book, can be seen as a truly Afro-American music, though understandable only in the context of a completely American experience. This music could, and did, find a place within the main culture. Jazz became more "popular" than ever. The big colored dance bands of the thirties were a national entertainment and played in many white night clubs as well as the black clubs that had been set up especially for white Americans. These bands were also the strongest influence on American popular music and entertainment for twenty years.

The path of jazz and the further development of the Afro-American musical tradition paradoxically had been taken over at this level to a remarkable degree by elements of the Negro middle class. Jazz was their remaining connection with blues; a connection they could make, at many points, within the mainstream of American life.

The music had moved so far into the mainstream, that soon white "swing" bands developed that could play with some of the authentic accent of the great Negro bands, though the deciding factor here was the fact that there were never enough good white jazz musicians to go around in those big bands, and most of the bands then were packed with a great many studio and section men, and perhaps one or two "hot" soloists. By the thirties quite a few white bands had mastered the swing idiom of big-band jazz with varying degrees of authenticity. One of the most successful of these bands, the Benny Goodman orchestra, even began to buy arrangements from Negro arrangers so that it would have more of an authentic tone. The arranger became one of the most important men in big-band jazz, demonstrating how far jazz had gotten from earlier Afro-American musical tradition. (Fletcher Henderson, however, was paid only $37.50 per arrangement by Goodman before Goodman actually hired him as the band's chief arranger.)

The prominence of radio had also created a new medium

Swing—From Verb to Noun / • • • • / *163*

for this new music, and the growing numbers of white swing bands automatically qualified for these fairly well-paying jobs: "The studio work was monopolized by a small group of musicians who turn up on hundreds of records by orchestras of every kind. One of the least admirable characteristics of the entire arrangement was that it was almost completely restricted to white musicians and it was the men from the white orchestras who were getting the work. The Negro musicians complained bitterly about the discrimination, but the white musicians never attempted to help them, and the contractors hired the men they wanted. At the Nest Club, or the Lenox Club the musicians were on close terms, but the relationship ended when the white musicians went back to their Times Square hotels. A few of them, notably Goodman, were to use a few of the Harlem musicians, but in the first Depression years the studio orchestras were white." [14]

So the widespread development of the swing style produced yet another irony—when the "obscurity" of the Negro's music was lessened with the coming of arranged big-band jazz, and the music, in effect, did pass into the mainstream of American culture, in fact, could be seen as an integral part of that culture, it not only ceased to have meaning for a great many Negroes but also those Negroes who were most closely involved with the music were not even allowed to play it at the highest salaries that could be gotten. The spectacle of Benny Goodman hiring Teddy Wilson and later Lionel Hampton, Charlie Christian, and Cootie Williams into his outrageously popular bands and thereby making them "big names" in the swing world seems to me as fantastically amusing as the fact that in the jazz polls during the late thirties and early forties run by popular jazz magazines, almost no Negro musicians won. Swing music, which was the result

[14] Samuel Charters and Leonard Kunstadt, *Jazz, A History of the New York Scene* (New York, Doubleday, 1962), p. 262.

of arranged big-band jazz, as it developed to a music that had almost nothing to do with blues, had very little to do with black America, though that is certainly where it had come from. But there were now more and more Negroes like that, too.

By the time the large dance and show bands started to develop into jazz bands, the more autonomous blues forms had gone largely undergound, had returned, as it were, to be enjoyed by the *subculture* in which they were most functional as a collective expression. At house parties and all-black cabarets and clubs, the blues was almost always still in evidence. And not only the newer city, or urban, blues held complete sway, although it was the most contemporary expression for a great many Negroes in the "colored sections" of the North and Midwest, but the older country blues was heard wherever there were people who knew and loved it best. Even during the Depression (and into the late thirties) there were still many black emigrants headed north from the most isolated rural areas of the South. They continued to bring the older traditions with them and moved into the older neighborhoods of the North, from which an emergent middle and lower-middle class had swept out into less grim environments, running the Italians out of one section, the Irish or Polish or Ukranians out of others—or being run out themselves by their less sophisticated "country" brothers.

Although the Depression had smashed the "race" record business to a large degree, new recordings of urban and

country blues were still being made. Many of the country blues singers who came up north or into Kansas City or St. Louis began to change their styles, either consciously (as in the case of Big Bill Broonzy) or unconsciously to fit the chaotic harshness of the new world. Some blues singers even managed to get into the entertainment world of white America, and many times no more real blues ever left their lips.

The city blues singers at first used guitar or boogie piano accompaniment. But the classic singers had left another legacy, and that was the use of larger instrumental accompaniment. Bessie Smith, Ma Rainey, and the others all had recorded with small bands and sometimes made their public appearances with the larger theater bands. This theatrical tradition left its mark; many of the urban singers began to use larger and larger instrumental accompaniment, usually bass, drums, and a couple of horns. Some of the dance bands even employed blues singers at Negro theaters and cabarets, and these singers began to utilize a different kind of approach to blues-singing.

The great Southwestern bands out of Kansas City, Oklahoma, St. Louis, all used vocalists, some of whom were marvelous blues singers. These large bands had developed very much differently than the big Northeastern bands like Henderson's and Ellington's. They had always remained much closer to the older blues tradition, and even after they began to master some of the instrumental techniques of the Eastern bands, they still played a music that relied heavily on blues. Bands like Bennie Moten's from Kansas City, Walter Page (and his Blue Devils) from Oklahoma City, Charlie Creath from St. Louis, and Troy Floyd from Texas had "books" that were jammed with blues numbers, and all were bands that developed in relative isolation from the whiter orchestral styles. Negroes in the Southwest still wanted a great part of their music to be blues-oriented, even if it was played by a large dance band. And the music of these great Southwestern orchestras continued to be hard and swinging, even when a

great many large Negro bands in other areas of the country had become relatively effete. It is said that when Ellington's and Henderson's bands traveled through the Southwest, the musicians there were impressed most by their musicianship and elegance, but they did not want to sound as "thin" as that.

The "shouting" blues singers like Joe Turner and Jimmy Rushing first were heard literally screaming over the crashing rhythm sections and blaring brass sections that were so characteristic of the Southwestern bands. Kansas City, a wide open town that featured gambling and as many night clubs as possible, became the headquarters of these big blues bands and their shouting vocalists. There was plenty of work for the bands there until the late thirties, when some measure of respectability finally came to Kansas City and many of the best musicians in the area left to go to Chicago or New York.

> I left my baby
> standin' in the back door cryin'
> Yes, I left my baby
> standin' in the back door cryin'.
> She said, baby, you got a home
> just as long as I got mine.

These Southwestern "shouters" and big blues bands had a large influence on Negro music everywhere. The shouter gave impetus to a kind of blues that developed around the cities in the late thirties called "rhythm & blues," which was largely huge rhythm units smashing away behind screaming blues singers. The singers and their groups identified completely with "performance," but they still had very legitimate connections with older blues forms.

> Well, this'll make you laugh
> Though it's not funny to me.
> Yes, this'll make you laugh
> Though it's not funny to me.

I'm in love with a married woman,
She's in love with me.

(From *Married Woman Blues,* words and music by Joe
Turner and White Keys Jackson)

All these blues forms existed together in the cities; the
phonograph record and later the radio helped push this
blues continuum into all parts of the country. By the for-
ties, after the war had completely wiped out the remaining
"race" record categories, the radio became the biggest dis-
seminator of blues music. By that time the shouters had
really taken over, yet this tradition, though largely commer-
cialized, was still *obscure* enough to escape the bloodless
commercialism of the white American entertainment world.
Cecil Gant, a young Negro war veteran, startled the record-
ing industry and, in a sense, revitalized it by making some
recordings as a boogie piano player and semi-shouting blues
singer that sold a great many copies. The companies, of
course, set about immediately to resuscitate their race fields,
only to find that a great many Negroes resented this kind of
label being put on their music. But under the title "rhythm
& blues" the records sold almost as well as race records had
before the Depression.

My father was no jockey
 but he sure taught me how to ride
I say, my father was no jockey
 but he sure taught me how to ride
He said first in the middle,
 then you sway from side to side.

Rhythm & blues was still an *exclusive* music. It was per-
formed almost exclusively for, and had to satisfy, a Negro au-
dience. For this reason, it could not suffer the ultimate steril-
ity that would have resulted from total immersion in the
mainstream of American culture. It, too, was a music that
was hated by the middle-class Negro and not even under-
stood by the white man. Nor was the white man given a

The Blues Continuum / • • • • / *169*

chance, during the forties, to understand it. Most white men believed that "The biggest contribution to American music the Negro had made by this time was to swing." And the "King of Swing" was a white man, Benny Goodman, whose only real connection to Afro-American musical tradition was the fact that he hired a Negro arranger and later a few Negro musicians.

But the radio beamed the shouting blues all over America to city and country Negroes alike. Even when issued from the most blatantly commercial Negro minds, the music made a hit—the slickest Northern shouters were soon imitated in the most rural black areas of the South. Singers with gold lamé jackets and orangeish pants were canonized along with the older types who still sang of the solitary isolation of the Negro's lot in soft plaintive voices that could never have been heard above the electric guitars, harmonicas, and blasting rhythm sections of the young shouters. The constant use of the riff, heavy drumming, and unison-screaming saxophones behind the singers was all a legacy of the blues-oriented Southwestern bands. Men like Wynonie Harris, Jimmy Witherspoon, Bullmoose Jackson, B. B. King, were among the best and the most sophisticated of the shouters; the more "primitive" school of shouters like Muddy Waters, T-Bone Walker, BoDiddley, Smokey Hogg, seemed to bring a deeper knowledge of older blues forms into their music. And it was all sent over the airwaves into the various black communities: a kind of blues continuum wherein almost all blues styles were made available to Negroes since they existed side by side on records, and the performers still lived in the same ghettoes as the audience.

Another very interesting development during the growth of rhythm & blues was the fact that after the disappearance of the race records the larger white companies lost control over the recording of the new music, which would account even more for its relative obscurity outside black communities: "The large record companies, within two or three years

after the war, had completely lost control of the blues record business. There were hundreds of companies recording blues, many of them Negro-owned and many of them in the South. The Chess Record Company in Chicago and Savoy Records in New York have recorded some of the best of the post-war blues, with Atlantic Records, in New York, not far behind. Few of the singers signed exclusive contracts; so a singer like Lowell Fulson or Smokey Hogg was often recording simultaneously for half a dozen companies." [1]

Also, most of the major record companies were making plenty of money from swing, and they probably did not feel the need to go back into the "race" business. (But companies like Savoy and Atlantic developed later into large and influential businesses and went into the recording of modern jazz as well.)

Rhythm & blues not only reflected that stream of music that had been city blues and was a further development of the growing urban tradition, it also reflected a great deal about the America it came out of and the Negroes who sang or listened to it. Certainly the war years had brought about profound changes in the cultural consciousness of Negroes, as they had done to the superstructure of American culture as a whole. There was a kind of frenzy and extra-local vulgarity to rhythm & blues that had never been present in older blues forms. Suddenly it was as if a great deal of the Euro-American humanist façade Afro-American music had taken on had been washed away by the war. Rhythm & blues singers literally had to shout to be heard above the clanging and strumming of the various electrified instruments and the churning rhythm sections. And somehow the louder the instrumental accompaniment and the more harshly screamed the singing, the more expressive the music was. Blues had always been a vocal music, and it must be said that the instrumental accompaniment for rhythm & blues singers was still very much in the vocal tradition, but

[1] *The Country Blues*, p. 234.

now the human voice itself had to struggle, to scream, to be heard.

Equally interesting are the uncommonly weird sounds that were made to come out of the instruments. The screaming saxophone is the most characteristic. In fact, during the heyday of rhythm & blues, blues-oriented instrumentalists, usually saxophone players, would vie to see who could screech, or moan, or shout the loudest and longest on their instruments. Men like Eddie "Lockjaw" Davis, Illinois Jacquet, Willis "Gatortail" Jackson, Big Jay McNeeley, Lynn Hope, and many others would have "honking" contests and try to outshout and outstomp any other saxophonist who would dare challenge them. Finally, when most of the "honkers," as they were called, had reached a similar competence, the contests got more athletic. Jay McNeeley used to lie on his back and kick his feet in the air while honking one loud screeching note or a series of identical riffs. The riff itself was the basis for this kind of playing, the saxophonist repeating the riff much past any useful musical context, continuing it until he and the crowd were thoroughly exhausted physically and emotionally. The point, it seemed, was to spend oneself with as much attention as possible, and also to make the instruments sound as unmusical, or as *non-Western*, as possible. It was almost as if the blues people were reacting against the softness and "legitimacy" that had crept into black instrumental music with the advent of swing. In a way, this is what had happened, and for this reason, rhythm & blues sat as completely outside the mainstream as earlier blues forms, though without that mainstream this form of music might have been impossible. Rhythm & blues also became more of an anathema to the Negro middle class, perhaps, than the earlier blues forms, which by now they might have forgotten, because it was contemporary and existed as a legitimate expression of a great many Negroes and as a gaudy reminder of the real origins of Negro music. To my own mind, however, it seems a less personal music than the older blues forms,

if only because the constant hammering of the overwhelming rhythm sections often subverts the verse, the lyrics, and lyric content of the blues. And too, rhythm & blues, it seems, is more easily *faked*, and only a few of the shouters seemed to be able to vary the mood or mode of their performance, or for that matter, to alter their public image as *performers*. One gets the idea that a man who falls down on his back screaming is doing so, even though he might be genuinely moved to do so, more from a sense of performance than from any unalterable emotional requirement. But again, the opposite idea also seems true—that for the Negro who found his most complete statement in rhythm & blues, the dramatic or *burlesqued* part of the performance might be as integral a part of the expression as the blues itself, since it made the departure, the separation, from the social implications of the white popular song complete.

> My papa told me, my mother sat down and cried
> She say, "You're too young a man, to have that
> many women you got."
> I looked at my mother dear and I didn't even
> crack a smile.
> I said, "If the women kill me, I don' mind dyin'."

For one *class* of Negroes, as the developing strata of the city emphasized, the blues could extend in a kind of continuum from rhythm & blues all the way back to country blues. In the cities all these forms sat side by side in whatever new confusions urban life offered, and the radio made them all equally of the moment. Although at this point rhythm & blues was the most constantly played blues music heard throughout the country, it also created a revived demand for the older forms—to be played on those same radio circuits.

> I'm a real young boy, just sixteen years old
> I'm a real young boy, just sixteen years old
> I need a funky black woman to satisfy my soul.

The Blues Continuum / • • • • / *173*

For another class of Negroes, the blues had to get to them via the big dance bands the rest of the country was listening to. They were committed to the "popular" form socially, and, as it turned out, emotionally as well. But the paradox of the black man's participation in American life could be pushed further: "The increasing popularity of swing arrangements on the Henderson model led to a general similarity of style in all the big bands, Negro and white. Goodman, Shaw, the Dorseys, Barnet, Hines, Calloway, Teddy Hill, Webb, were all approaching the same standards of proficiency. There is a terrifying record, an anthology called *The Great Swing Bands*, on which most of these bands are represented. If they are played without consulting notes or labels, *it is impossible to distinguish one from the other*." [2]

So, many of the new citizens had got their wish. At that particular point in the development of big-band jazz, the Afro-American musical tradition seemed indistinguishable from the commercial shallowness of American dance music. With rhythm & blues, blues as an autonomous music had retreated to the safety of isolation. But the good jazzmen never wanted to get rid of the blues. They knew instinctively how they wanted to use it, *e.g.*, Ellington. The harder kinds of blues stayed in the old neighborhoods with the freedmen when the citizens moved out. Rhythm & blues was a popularization, in a very limited sense, of the older blues forms, and in many cases merely a commercialization, but it was still an emotionally sound music. Its very vulgarity assured its meaningful emotional connection with people's lives. It still intimated the existence of what I think to be a superior music: city, classic, or country blues. Its roots were still evident and functional. It held the blues line in the cities, and the radios gave it to the rural Negro as well.

[2] Hsio Wen Shih, *loc. cit.*, p. 72.

12 / *The Modern Scene*

*It is for want of a conscious critical sense and the intel-
lectual powers of comparison and classification that the
Negro has failed to create one of the great cultures of
the world, and not from any lack of the creative impulse,
nor from lack of the most exquisite sensibility and the
finest taste.*

(ROGER FRY, *Negro Sculpture*)

*The blues occurs when the Negro is sad, when he is far
from his home, his mother, or his sweetheart. Then he
thinks of a motif or a preferred rhythm and takes his
trombone, or his violin, or his banjo, or his clarinet, or
his drum, or else he sings, or simply dances. And on the
chosen motif, he plumbs the depths of his imagination.
This makes his sadness pass away—it is the Blues.*

(ERNEST ANSERMET, 1918)

When the swing style had run its course and most big-band
jazz, except the blues-oriented bands in the Southwest and
the Ellington organization (and the "traditional" or New Or-
leans jazz people still around), had become watered-down,
slick "white" commercializations of Fletcher Henderson, the

"modern" people came on the scene. Thereby a more dreadful *separation* was instigated.

The blues people (as Ralph Ellison put it, "those who accepted and lived close to their folk experience") had their continuum, but the middle-class Negroes had gotten "free" of all the blues tradition, except as it was caricatured in white swing style, or the pitiful spectacle of Carnegie Hall boogie woogie, or Hazel Scott playing Grieg's *Concerto in A Minor* at Café Society. Assimilation, the social process they felt they must accept, always proposed that the enforced social scale of a people in American, or Western, society determined the value of that people's culture. Afro-American musical tradition could hardly be considered a social (or economic) asset in American society. Autonomous blues could not reflect the mind of the middle-class Negro, even if he chose not to deny his folk origins.

Jazz demonstrated how the blues impulse, and thus Afro-American musical tradition, could be retained in a broader musical expression. Big-band jazz showed that this music could exist as a peculiarly American expression (and also that there was a commercial use for it), which included, of course, the broadened social perspective of the post-Depression, urban Negro. But as a true expression of an America which could be celebrated, as Whitman said, "in a spirit kindred to itself," jazz could not be understood by a nation which had finally *lost* the Civil War by "placing private property above other values"—the result being such denials of human dignity as the legislation of inhumanity and oppression all over the South. As a folk expression of a traditionally oppressed people, the most meaningful of Negro music was usually "secret," and as separate as that people themselves were forced to be. ("The old blues reminds me of slavery," is the way many middle-class Negroes put it. And they could only think of slavery with the sense of shame their longing for acceptance constantly provided. Their Utopia could have no slaves nor sons of slaves.) But as the secret-

ness and separation of Negroes in America was increasingly broken down, Negro music had to reflect the growing openness of communication with white America. The ease with which big-band jazz was subverted suggests how open an expression Negro music could become. And *no* Negro need feel ashamed of a rich Jewish clarinetist.

By the forties the most contemporary expression of Afro-American musical tradition was an urban one, arrived at in the context of Negro life in the large industrial cities of America. And just as World War I and the Great Depression served to produce the "modern" Negro, so World War II produced even more radical changes within the psyche of the American black man. The Negro's participation in World War II was much less limited than in World War I. Even though Negroes were still largely confined to "Negro units" of the Armed Forces, many of these units fought side by side with white units. There was even a fighter squadron composed exclusively of black pilots. The Negro's role in this war could not be minimized as in World War I. World War II was an all out struggle, and the United States had to use all its resources. For this reason, more Negroes than ever were utilized in important positions or positions of authority. (According to NAACP figures, there were 404,348 Negroes as Army enlisted men in World War I, and 1,353 commissioned officers. In World War II, there were 905,000 Negroes as Army enlisted men and 8,000 officers. While the number of Negroes more than doubled, the number of commissioned officers increased almost *eight* times.) The sense of participation in the mainstream of the society was strengthened among all Negroes, not only the middle class. Dorie Miller, one of the first Negroes to die in the war, at Pearl Harbor, was almost canonized by Negroes all over the country. At my parents' church in Newark, New Jersey, "Remember Dorie Miller" buttons which the church had purchased were passed out.

The sense of a world outside of America, first revealed to

Negroes by World War I, was reinforced by the even more international aspects of World War II. There were even blues sung about the war by the older singers or by "sophisticated" blues singers like Josh White. There was the song *Are You Ready?*, very popular in Negro communities, which extolled the virtue of heroism (by Negroes) in the war: "When the captain says, 'Attack'/There'll be no turning back/Are you ready? Are you ready to go?" There is also one portion of the song that has the prospective hero saying, "I'll batter that ratter till his head gets flatter." (It is interesting to note that the expression "Are you ready" was also being used a great deal among Negroes around that time to mean "Are you ready—to enter into white America?" The term of disparagement being, "He's not ready." For instance, "loud" or "vulgar" Negroes were termed by many self-appointed black guardians of white social propriety as "unready.")

The sense of participation and responsibility in so major a phenomenon as the World War was heightened for Negroes by the relatively high salaries they got for working in the various defense plants throughout the country. (The Picka-tinny Arsenal in New Jersey was spoken of in reverent tones by Negroes in the area as a place where a black man could make "good money.") But this only served to increase the sense of resentment Negroes felt at the social inequities American life continued to impose upon them. This was especially true of the young men who returned from the war after having risked their lives for this country, only to find that they were still treated like subhumans, that it was only "their country" so long as they remained in "their places." Negroes who held good wartime jobs as civilians and whose incomes were much higher than ever before were infuriated to find that their increased economic status still couldn't buy them a way out of the huge Negro ghettoes of the cities. Resentment and disgust with the *status quo* many times found expression in incidents of racial violence. As had happened during and after World War I, bloody riots broke out all over

the United States. The largest was probably the Harlem riot of 1943, when Negroes broke the windows of white business establishments in the area and menaced white policemen. Some of the riots, like the one in Cicero, Illinois, a suburb of Chicago, began because the Negroes with their good money wanted to get homes as well. As thirty years before, there had been great migrations northward to the industrial centers. There were similar riots in Detroit, Chicago, and Newark. There were also social movements among Negroes which resulted in the formation of organizations to combat inequality, just as there had been around the time of World War I. One of the most effective of these was the 1941 March-On-Washington movement in which Negroes threatened to march on the capital if they were not included in the defense program. It was specifically because of this movement that President Roosevelt signed the executive order that was supposed to forbid discrimination by Government contractors. The committee that started the March-On-Washington movement later saw to it that the Fair Employment Practices Committee was set up. During the war, the Negro "secured more jobs at better wages and in a more diversified occupational and industrial pattern than ever before." [1]

Between the thirties and the end of World War II, there was perhaps as radical a change in the psychological perspective of the Negro American toward America as there was between the Emancipation and 1930. In many respects the bridge into the mainstream of American society had been widened by the war and the resultant increase in general living standards of the black American. The Negro middle class had grown, and the percentage of Negroes completing high school and attending college had risen sharply. Many of the Negro veterans took advantage of the educational benefits offered under the G.I. Bill. In the South alone, for instance, "for the year 1933-34 only 19 per cent of the Negro children

[1] Robert C. Weaver, *Negro Labor* (New York, Harcourt, Brace, 1946), p. 306.

of high school age were in high schools." [2] But by 1940, only six years later, the figure had risen to 35 per cent. And this was in the South; Frazier also points out that in 1940, "About twice the proportion of adult Negroes in the northern cities as in the southern cities have completed one to three years or four years of high school education." [3]

In general, the war years and the period immediately after saw a marked resumption of the attacks by Negroes on legalized social and economic inequity in America. The period of economic chaos during the Depression thirties was cruelest for Negroes, and some of the fervor of anti-oppression feelings subsided among them, or at least was diverted, in their scramble to stay alive. But by the mid-forties that fervor had returned, and was reinforced by the Negro's realization that he was in many ways an integral part of American society. What once could be excused, even by Negroes, as the result of dubious custom now came into focus more clearly as simple oppression. If the fruits of the society went to the "best qualified," then all the Negro demanded was an equality of means. Given this equality politically and economically, there was only one America. And that was an America any citizen could aspire to. This was the psychological hypothesis which informed the Negro's attitude toward America during the mid-forties. The middle class, as always, was more optimistic that such a hypothesis would be understood by white America. "Go to college or learn a trade"—these were the building blocks for the single society, and again because the black middle class confused legitimate political and economic desires with their shame at not already having attained these goals, they thought this meant they had to abandon history and the accreted cultural significance of the black man's three hundred years in America. For the poor,

[2] E. F. Frazier, *The Negro in the United States* (New York, Macmillan, 1957), p. 436
[3] *Ibid.*, p. 445.

however, "culture" is simply how one lives, and is connected to history by habit.

Swing had no meaning for blues people, nor was it expressive of the emotional life of most young Negroes after the war. Nevertheless, by the forties it had submerged all the most impressive acquisitions from Afro-American musical tradition beneath a mass of "popular" commercialism. And most of America took the music to heart. There were swing radio programs throughout the country, the most popular swing musicians had their own radio shows and were almost as well known as movie stars. Big-band jazz, for all practical purposes, had passed completely into the mainstream and served now, in its performance, simply as a stylized reflection of a culturally feeble environment. Spontaneous impulse had been replaced by the arranger, and the human element of the music was confined to whatever difficulties individual performers might have reading a score. Philosophically, swing sought to involve the black culture in a platonic social blandness that would erase it forever, replacing it with the socio-cultural compromise of the "jazzed-up" popular song: a compromise whose most significant stance was finally catatonia and noncommunication. The psychological stresses of World War II and the unrealized weight of America's promise in history could only be answered "popularly" with such moral sterility as would produce *Hut-Sut-Ralston, Chicory-Chic,* or *Marezy Doats.* As I said, catatonia and non-communication. The Negro's conditional separation from the mainstream spared him.

When the moderns, the *beboppers,* showed up to restore jazz, in some sense, to its original separateness, to drag it outside the mainstream of American culture again, most middle-class Negroes (as most Americans) were stuck; they had passed, for the most part, completely into the Platonic citizenship. The willfully harsh, *anti-assimilationist* sound of

bebop fell on deaf or horrified ears, just as it did in white America. My father called me a "bebopper" in much the same way as some people say "beatnik" now. But the Negro middle class had wandered completely away from the blues tradition, becoming trapped in the sinister vapidity of mainline American culture.

Of the blues-oriented big bands of the thirties and early forties which I mentioned before as having resisted the commercialization and sterility of most big-band jazz, Count Basie's had the most profound effect on the young musicians of the forties who would soon be called "boppers." The Basie band was in the hard-swinging Southwestern blues tradition and was certainly less polished than the beautiful Ellington groups of the late thirties and early forties. But Basie's music offered a fresh, open method for contemporary reinterpretation of the Afro-American musical tradition— one that drew its strength from blues tradition, which automatically made it the antithesis of the florid vacuousness of the swing style.

". . . Basie . . . brought to jazz a style and body of music less varied than Ellington's, but one deeply rooted in folk art, powerful in its influence on jazz up to and including bebop.

"His [Basie's] forms used the riff, and its solo reply or obbligato, in a manner based on old choral spirituals. The 'jump' rhythm, as he used it, also comes from a spirituals background, and in his hands it always has the human elasticity which it lacks in a manneristic treatment." [4]

Another important facet of Basie's music that had a great deal of influence on young musicians was the solo room the riff-solo structure provided. Basie's soloists, and especially the tenor saxophonists, could develop long melodically conceived solos based on the chords the riffs suggested. These solos seemed autonomous and possessed of a musical life of their own, even though at their most perfectly realized, their

[4] *Jazz, A People's Music*, p. 206.

relationship to what the rest of the band was playing was unmistakable. In a sense the riff-solo structure was a perfect adaptation of the old African antiphonal vocal music as well as the Afro-American work song and spiritual. Tenor saxophonist Lester Young brought this kind of riff-solo relationship to its most profound form. He was also the first saxophonist to develop the saxophone as an autonomous instrument capable of making its own characteristic music. As I mentioned before, Coleman Hawkins' saxophone work, as impressive as it was, was really just an extension of the Armstrong style to another instrument. Hawkins was a saxophone virtuoso, but Young was an innovator. Young got the instrument away from the on-the-beat, eighth-note pattern that Hawkins utilized, and demonstrated with his light, flowing, gauzy tone how subtly beautiful the instrument could be. Also, as Ross Russell pointed out in an article on Lester Young and his relationship to the boppers, "Lester's insistence on the rhythmic priorities of jazz came as a tonic to a music which was drifting away from the drive of early New Orleans music. Lester did more than reaffirm these priorities. He replenished the stream polluted by the arrangers and thus made possible the even more complex rhythmic development of the bebop style." [5]

Since Lester Young, jazz has become, for the most part, a saxophone music. Hawkins played trumpet music and brought it to magnificent perfection on his own horn, but it was Lester Young who first committed jazz to using the saxophone as its most inspired instrument. The most important innovators since Young have been saxophonists; just as from Armstrong back into jazz history, the most important innovators were trumpet players.

Basie's music saved the big band as an honest musical form, and his uses of the small group provided a form for the young musicians of the forties. He initiated a kind of small

[5] Ross Russell, "The Parent Style and Lester Young," in *The Art of Jazz*, p. 210.

group music that utilized all the most important harmonic and rhythmic discoveries the big band provided, but with the added flexibility and necessary solo virtuosity of the small band:

"Basie's own piano style indicates the base for this music. It employs the full piano, but uses rich chords and full sounds sparingly, to punctuate and support the solo melodic lines. His large-band music also has this character, the full band often heard in many performances only for punctuation. . . . It was easy to move from this kind of music to an actual small-band music. A single trumpet, trombone and sax, if used together with a good knowledge of harmony, could sound chords as solid as a full-band choir. A single instrument, such as Basie's piano or Young's tenor, could riff as effectively as, and even more subtly than, a full band or full choir." [6]

It is pretty obvious why the small band form was so attractive to the young jazz musicians of the forties. The tasteless commercialism of most of the swing bands had rendered them virtually incapable of serving as vehicles for any serious musical expression. The expanded sense of the communal expression so characteristic of Afro-American musical tradition which was found in the best large bands, certainly Basie's and Ellington's, had completely vanished in the swing period. Individual expression within this framework was also impossible. The autonomy, even anarchy, of the small band was not only an instinctive return to the older forms of jazz, but it must certainly have been a conscious attempt by these young musicians to secure some measure of isolation from what they had come to realize by now was merely cultural vapidity—the criterion of "equality of means" also provides for an objective evaluation of those means. It was the generation of the forties which, I think, began to consciously analyze and evaluate American society in many of that society's own terms (and Lester Young's life, in this

[6] *Jazz, A People's Music*, p. 213.

respect, was reason enough for the boppers to canonize him). And even further, this generation also began to understand the *worth* of the country, the society, which it was supposed to call its own. To understand that you are black in a society where black is an extreme liability is one thing, but to understand that it is the society that is lacking and is impossibly deformed because of this lack, *and not yourself*, isolates you even more from that society. Fools or crazy men are easier to walk away from than people who are merely mistaken.

The cultural breakdown attendant upon living in the large urban centers of the North and Midwest contributed importantly to the sense of objective cynicism which had evolved as a dominant attitude toward America among young Negroes in the forties—a sense that certainly provoked the question, "How come they didn't drop that bomb on the Germans?" in many black neighborhoods. A culture whose rich sense of ironic metaphor produced the humor of "If you white, you all right/If you brown, hang around/But if you black, get back," could now with equal irony propose as unofficial lyrics to one of the popular bebop originals during the forties, *Buzzy*, "You better get yourself a white girl/A colored girl ain't no good." Again, it was a change of perspective based on the assumption that all the terms of "successful adjustment" to the society had been at least understood by Negroes, and that the only barrier to complete assimilation into that society was the conditional parochialism that assimilation would demand. The "understanding" then only served to reinforce the cynicism. It was not that a Negro was uneducated or vulgar or unfit for the society which determined why he was not accepted into it, it was the mere fact that he *was* a Negro. No amount of education, taste, or compromise would alter that fact. Education, etc., was finally superfluous, given the basic term of "successful adjustment," which was that you be a white man. The sociologists' dogma of "progressive integration" into the society, based on successful application to the accomplishment of the fundamen-

tal prerequisites of worth in the society, becomes meaning less once those prerequisites are understood and desired, then possessed, and still the term of separation exists. This was one of the reasons so many college men from the black middle class went back into jazz during the thirties. They had met the superfluous requirements for acceptance into the successful elements of the society, but that acceptance was still withheld. Many of those musicians began to look upon jazz as "the Negro's business," but they overlooked the simple validity of Gresham's Law and the coming of the swing era.

The musicians of the forties, however, understood the frustration American society proposed for the Negro, *i.e.*, that the only assimilation that society provided was toward the disappearance of the most important things the black man possessed, without even the political and economic reimbursement afforded the white American. Swing demonstrates this again—that even at the expense of the most beautiful elements of Afro-American musical tradition, to be a successful (rich) swing musician, one had to be white. Benny Goodman was the "King of Swing," not Fletcher Henderson, or Duke Ellington, or Count Basie. There was, indeed, no way into the society on one's own terms; that is, that an individual be allowed to come into the society as an individual, or a group as an individual group, with whatever richness the value of local (social or ethnic) cultural reference could produce. The individuality of local cultural reference only reinforced separation from the society. Understanding this, the young musicians of the forties sought to make that separation meaningful, as their fathers had done before them, but with the added commitment that their conscious evaluation of the society would demand.

The cultural breakdown I have referred to was accomplished in most cases by the physical integration of Negroes and whites in many of the large cities of the North and Midwest. During the twenties and thirties, schools, movies, sport-

ing events, and to a certain extent, employment, all became areas where there could be an expanded social commerce between black and white America, and thus the various musical and entertainment fads that had originally come into existence as facets of Afro-American culture found popularity in mainstream American society. (To some extent, there has been this cross-fertilization of cultures since the time of the African slaves, but with the anonymity the social hierarchy enforced.) Even such a phenomenon as the Black Renaissance of the twenties depended upon a degree of social *leveling*, a leveling that enabled white Americans to understand what such a "Renaissance" was supposed to imply, and what is more important, that would allow the Negroes involved to explain what they meant by this "Renaissance." In the days of the slave society, for instance, a white man might have picked up a Negro song or dance or some unconscious element of speech, but it would have been absurd to suppose that he as master would be willing to listen to some slave explain why he was a "New Negro." The breakdown, or leveling, of the forties was even more extreme—if one can imagine the irony of white youth imitating a certain kind of Negro dress (the "zoot suit," which attained so much popularity during that decade, came "straight off Lenox Avenue"). Or even more ironic, the assumption by a great many young white Americans of many elements of a kind of Negro speech. "Bop talk" and in my own generation, "Hip talk" are certainly manifestations of this kind of social egalitarianism. But this leveling has implications more profound than egalitarianism.

Certainly a white man wearing a zoot suit or talking bop talk cannot enter into the mainstream of American society. More important, that white man does not desire to enter the mainstream (because all he would have to do is change clothes and start "talking right," and he would be easily reinstated). His behavior is indicative on most levels of a conscious nonconformity to important requirements of the

society (though the poor white boy in a really integrated neighborhood might pick up these elements of Negro culture simply as social graces within his immediate group). The white beboppers of the forties were as removed from the society as Negroes, but as a matter of choice. The important idea here is that the white musicians and other young whites who associated themselves with this Negro music identified the Negro with this separation, this nonconformity, though, of course, the Negro himself had no choice. But the young Negro musician of the forties began to realize that merely by being a Negro in America, one *was* a nonconformist.

The Negro music that developed in the forties had more than an accidental implication of social upheaval associated with it. To a certain extent, this music resulted from conscious attempts to remove it from the danger of mainstream dilution or even understanding. For one thing, the young musicians began to think of themselves as *serious* musicians, even artists, and not performers. And that attitude erased immediately the protective and parochial atmosphere of "the folk expression" from jazz. Musicians like Charlie Parker, Thelonius Monk, and Dizzy Gillespie were all quoted at various times as saying, "I don't care if you listen to my music or not." This attitude certainly must have mystified the speakeasy-Charleston-Cotton-Club set of white Americans, who had identified jazz only with liberation from the social responsibilities of full citizenship. It also mystified many of the hobbyists, who were the self-styled arbiters of what Afro-American music should be. Most of the jazz critics and writers on jazz (almost all of whom, for obvious reasons, were white) descended on the new music with a fanatical fury. The young musicians were called "crazy" (which stuck in the new vernacular), "dishonest frauds," or in that slick, noble, patronizing tone that marks the liberal mind: "merely misguided." Critics like the Frenchman Hugues Panassie talked knowingly about "the heresy of bebop," saying that it simply wasn't jazz. Roger Pryor Dodge, one of the pioneer

jazz critics and historians, wrote in the pages of *The Record Changer:* "To sum up Bop and its derivatives, let us say that in spite of their own complicated development they function in essence as a music on a much lower level of musical significance than either early Dixieland or New Orleans. . . . In fact, let us say flatly that there is no future in preparation for jazz through Bop, or through any of those developments known as Cool and Progressive." [7]

For the first time critics and commentators on jazz, as well as critics in other fields, attacked a whole mode of Afro-American music (with the understanding that this attack was made on the music as music, and not merely because it was the product of the black American). The point is that because of the lifting of the protective "folk expression" veil from a Negro music, the liberal commentators *could* criticize it as a pure musical expression. And most of them thought it hideous. Even the intellectual attacked the music as "anti-humanistic"; poet and critic of popular culture Weldon Kees said of bebop: "I have found this music uniformly thin, at once dilapidated and overblown and exhibiting a poverty of thematic development and a richness of affectation, not only, apparently, intentional, but enormously self-satisfied." Kees then goes on to say, "In Paris, where Erskine Caldwell, Steinbeck, Henry Miller, are best-sellers and 'nobody reads Proust any more,' where the post-Picasso painters have sunk into torpor and repetition, and where intellectuals are more cynically Stalinized than in any other city in the world, bebop is vastly admired." [8] A wild piece of sophistry!

But the characteristic criticism of bebop (and jazz fan magazines like *Downbeat* were so guilty in this regard, they have recently had to *re-review* classic bebop records by Charlie Parker, Thelonius Monk, etc., and give them wild acclaim because their first reviews were so wrong-headed)

[7] "Jazz: Its Rise and Decline," *The Record Changer*, Vol. 14, No. 3, p. 9.
[8] "Muskrat Ramble: Popular and Unpopular Music," *Partisan Review* (May, 1948), p. 622.

was voiced by art and jazz critic Rudi Blesh in the *Herald Tribune:* ". . . the irrelevant parts of bebop are exactly what they seem; they add up to no . . . unity . . . A capricious and neurotically rhapsodic sequence of effects for their own sake, [bebop] comes perilously close to complete nonsense as a musical expression . . . Far from a culmination of jazz, bebop is not jazz at all, but an ultimately degenerated form of swing, exploiting the most fantastic rhythms and unrelated harmonies that it would seem possible to conceive."

It seems to me an even more fantastic kind of sophistry that would permit a white man to give opinions on how he thinks a black man should express himself musically or any other way, given the context of the liberal social organism, but under the canons of "art criticism," this kind of criticism is obligatory. So then, if only by implication, bebop led jazz into the arena of *art*, one of the most despised terms in the American language. But, as art, or at least, as separated from the vertiginous patronization of the parochial term *folk art* (which often resulted in the lugubrious quotes with which I prefaced this chapter), the Negro music of the forties had pushed its way into a position of serious (if controversial) regard.

Socially, even the term bebop, which began merely as an onomatopoeic way of characterizing a rhythmic element of the music, came to denote some kind of social nonconformity attributable to the *general* American scene, and not merely to the Negro. Bebopper jokes were as popular during the forties as the recent beatnik jokes, and usually when these jokes were repeated in the mainstream American society, they referred to *white nonconformists* (or musicians, who were necessarily nonconformists) and not to Negroes. The bebop "costume," which became the rage for "hip" or "hep" (then) young America, was merely an adaptation of the dress Dizzy Gillespie, one of the pioneers of bebop, wore. (And Dizzy's dress was merely a personal version of a kind of fashionable Negro city dress.) Horn-rimmed glasses, a

beret, a goatee, and sometimes ridiculously draped suits in the manner of the zoot suit were standard equipment for the young bopper. (It may be not entirely irrelevant to note that nowadays the word *bop* is used by teen-agers to mean *fight*, or more specifically, a *gang fight*. The irony here, however, is that the term is used in this connection more by white teen-agers, Negro gangs preferring the word *rumble*.)

What seem most in need of emphasis here are the *double* forms of assimilation or synthesis taking place between black and white American cultures. On one hand, the largely artificial "upward" social move, demanded by the white mainstream of all minorities, and the psychological address to that demand made by the black bourgeoisie, whereby all consideration of local culture is abandoned for the social and psychological security of the "main." On the other hand, the *lateral* (exchanging) form of synthesis, whereby difference is used to enrich and broaden, and the value of any form lies in its eventual use. It is this latter form of synthesis (certainly available and actual, to varying degrees, since the first black man came into America) that became so important after World War II, and even more magnified after the Korean War. The point is that where one form of synthesis, which was actually assimilation, tended to wipe out one culture and make the other even less vital, the other kind of synthesis gave a local form to a general kind of nonconformity that began to exist in American (Western) society after World War II—a consideration I will come back to.

It is not strange that bebop should have met with such disapproval from older musicians, many of whom were still adjusting to the idea of "four even beats," which characterized the best music of the swing era and delineated it from the accented off-beat (two-beat) music of earlier jazz. And even more alien were the rather "radical" social attitudes the younger players began to express. Parker, Monk, and the others seemed to welcome the musical isolation that historical

social isolation certainly should have predicated. They were called "cultists" by almost everyone who did not like the music, equating the bop dress with a specific form of quasi-religious indulgence; though if these same people had seen just an "average" Negro in New Jersey wearing a draped coat (of course *sans* the sophisticated "camp" of the beret, called "tam," and the window-pane glasses—used to assume an intellectual demeanor said, for three hundred years, to be missing from black Americans), they would have thought nothing of it. Socially, it was the young white man's emulation of certain of these Negro mores that made them significant in the mainstream of the society, since, as yet, the mainstream had no knowledge of bop as a music developed from older Negro music.

"By borrowing the principle of a two- and four-beat bar first from hymns and then from polkas and military marches, the American Negro made a sharp break with his African ancestors. However, his sense of rhythm was not completely at home in this rigid framework. An opposition arose between the container and the thing contained. Half a century after the birth of jazz, this opposition has not been smoothed away, and it probably never will be. The Negro has accepted 2/4 and 4/4 bars only as a framework into which he could slip the successive designs of his own conceptions . . . he has experimented with different ways of accommodating himself to the space between measure bars." [9]

Musically, the Negro's address to the West has always been in the most impressive instances lateral and exchanging. But the mode or attitude characterizing the exchange has always been constantly changing, determined, as I have tried to make clear, by the sum of the most valid social and psychological currents available to him. Given this hypothesis, the *contemporaneity* of the Negro's music in the context of Western cultural expression can be seen as necessary. Bebop, if anything, made this necessarily contemporaneous

[9] *Jazz: Its Evolution and Essence,* p. 210.

quality of Afro-American music definite and uncompromising, not because of any formal manifestoes (even the first recordings of the music were much behind the actual inception, due to the normal cultural lag as well as the recording ban of 1942-44 and the shortage of recording materials caused by the war), but because of a now more or less conscious attitude among these young jazzmen that what they were doing was different from what jazz players before them had done, and *separate* from the most popular jazzlike music of the day, which they frankly thought of as sterile and ugly. But the leaders of the changed jazz could still be looked at and placed, if one had the time, in terms of jazz tradition —and as logical, if not predictable, developers of that tradition. Gillespie has acknowledged his musical indebtedness to swing trumpeter Roy Eldridge (and, of course, to Armstrong) many times over. Charlie Parker is easily seen as an innovator whose dynamic and uninhibited comprehension of Lester Young's music made his own work possible. And Parker's modern placement of blues is as classic as any Negro's and at least as expressive as Bessie Smith's. What had changed was the address, the stance, the attitude.

"Bebop rhythm differs formally from swing rhythm, because it is more complex and places greater emphasis upon polyrhythmics. It differs emotionally from swing rhythm, creating greater tension, thereby reflecting more accurately the spirit and temper of contemporary emotions." [10]

There has been much talk about the influence of contemporary Western classical music on the Negro jazz musicians of the forties. It is already admitted, with this hypothesis, that jazz by the forties had had its influence on contemporary classical music as well. Composers like Stravinsky, Milhaud, and many lesser men produced works in which the influence of jazz or African rhythms was quite readily apparent. But I think that the influence of European and Euro-American classical music during the forties was indirect, and

[10] Ross Russell, "Bebop," quoted in *The Art of Jazz*, p. 189.

not consciously utilized in the music of the boppers, though by the fifties (especially in the work of certain white jazzmen) and in our own time, many of these influences are conscious, sometimes affected. What seems to me most important about the music of the forties was its reassertion of many "non-Western" concepts of music. Certainly the re-establishment of the hegemony of polyrhythms and the actual subjugation of melody to these rhythms are much closer to a purely African way of making music, than they are to any Western concepts (except, as I mentioned, in the conscious attempts of certain contemporary classical composers like Stravinsky to make use of non-Western musical ideas).

Bebop also re-established blues as the most important Afro-American form in Negro music by its astonishingly contemporary restatement of the basic blues impulse. The boppers returned to this basic form, reacting against the all but stifling advance artificial melody had made into jazz during the swing era. Bop melodies in one sense were merely more fluent extensions of the rhythmic portions of the music. Many times it was as if the rhythmic portions of the music were inserted directly into the melodic line, and these lines were almost rhythmic patterns in themselves. In bop melodies there seemed to be an endless changing of direction, stops and starts, variations of impetus, a jaggedness that reached out of the rhythmic *bases* of the music. The boppers seemed to have a constant need for deliberate and agitated rhythmical contrast.

Concomitant with the development of these severely diverse rhythms, changes also were made in the basic functions of the traditionally non-solo instruments of the jazz group. Perhaps the biggest innovation was the changed role of the drummer. The steadiness of the beat was usually maintained in pre-bop jazz groups by the bass drum (either two or four beats to the bar). Then the bebop drummer began to use his top cymbals to maintain the beat, and used the bass drum for occasional accents or thundering emphases. The

top cymbal was hit so that the whirring, shimmering cymbal sound underscored the music with a *legato* implication of the desired 4/4 beat. This practice also made it necessary for the string bass to carry the constant 4/4 underpinning of the music as well, and gave the instrument a much more important function in the jazz rhythm section than it had ever had before. Above the steadiness and almost perfect *legato* implied by the cymbals' beat and augmented by the bass fiddle, the other instruments would vary their attack on the melodic line, thereby displacing accents in such a way as to imply a polyrhythmic effect. The good bop drummer could also, while maintaining the steady 4/4 with the cymbal, use his left hand and high-hat cymbal and bass drum to set up a still more complex polyrhythmic effect.

There is a perfect analogy here to African music, where over one rhythm, many other rhythms and a rhythmically derived "melody" are all juxtaposed. One recording of Belgian Congo music[11] features as its rhythmic foundation and impetus an instrument called the *boyeke*, which is actually a notched palm rib about four feet long which is scraped with a flexible stick to produce a steady rhythmic accompaniment. It is amazing how closely the use of this native African instrument corresponds to the use of the top cymbal in bebop. Even the sounds of the instruments are fantastically similar, as is the use of diverse polyrhythms above the basic beat. The function of the *drone* in many non-Western musics is also quite similar. But as Wilder Hobson pointed out, ". . . the blues may originally have consisted merely in the singing, over a steady, percussive rhythm, of lines of variable length, the length being determined by what phrase the singer had in mind, with equally variable pauses (the accompanying rhythm continuing) determined by how long it took the singer to think up another phrase." [12] And I think this consideration, while certainly pertinent to all Negro music, is an

[11] *Ekonda, tribal music of the Belgian Congo* (Riverside RLP 4006).
[12] *American Jazz Music* (New York, W. W. Norton, 1939), p. 36.

especially valuable idea when analyzing recent developments in the jazz of the sixties, which depends so much on the innovations and re-evaluations of bebop.

Although it would seem now that bop's rhythmic conceptions were its most complete innovations, during the forties many people who were unimpressed or disgusted with the "new" music seemed to be mystified most by its harmonic ideas. Actually the most "daring" harmonic re-evaluations in jazz are the ones that are going on at the present time, although to be sure, bebop provided a totally fresh way of thinking about jazz harmony. The boppers began to abandon the traditional practice of improvising or providing variations on a melodic theme. Instead, they began to play their variations on the chords on which the melody was based, usually creating entirely new melodies, or sometimes they merely used the original melody as the bass notes for a new set of chords, and improvised a countermelody. For these reasons many bop "originals" were really rephrased versions of popular songs like *Indiana, I Got Rhythm, Honeysuckle Rose, Cherokee,* etc.

". . . the origin of the harmonic variation which has gradually dominated jazz is [not] difficult to trace within the music; like the rhythmic changes . . . it comes from the blues. Longer ago than we know (and probably ever shall know), playing the blues could mean freely improvising in an harmonic frame. And this is true whether the soloist is aware of an implicit harmonic frame or not, whether he uses one chord per chorus (or just one thump), two, three, or whatever, and whether he limits himself to 'regular' eight-, twelve-, or sixteen-bar choruses or lets inspiration dictate chorus length. It was evident that a man could take this conception and apply it to any chord and chorus structure —whether it came from his grandfather or the radio." [13]

The pianist's function in bebop was changed almost as

[13] Martin Williams, "Extended Improvisation and Form: Some Solutions," *Jazz Review* (December, 1948), p. 15.

radically as the drummer's. Because of the increased domi-
nance of the cymbal and the string bass as maintainers of
the steady rhythm (especially the latter), the bop pianist
could refrain from supplying strict rhythm lines with his
left hand and develop a much more complex and flowing
right-hand line. The pianist also could "feed" the soloist
chords, solidifying the bop group harmonically. This practice
was, in effect, much like the role Count Basie as pianist had
assumed with most of his groups. (Basie's efforts helped
move jazz piano away from the older "stride" style with its
heavy insistence on an almost guitar-like left hand. Later
Earl Hines was able to develop a piano style utilizing the
long, fluent "horn" line, which was developed even further
by pianists like Teddy Wilson and Art Tatum, all preparing
the way for Bud Powell and the rest of the bebop pianists.)

I have already discussed some of the reasons *why* bebop
developed, but *how* it developed, in some kind of social and
historical sense, might also be interesting, though, I am
convinced, it is not nearly as important as the first con-
sideration. It is only about twenty years since the first news
of a "new" kind of jazz literally turned the jazz world
around. And even though the innovators like Parker, Gil-
lespie, Monk, were unknown to large audiences while their
music was developing, their influence on musicians, even in
the early forties, was enormous. How the music developed
and how the musicians who were eventually associated with
it came together have been the subjects of many disputes
for almost as long as the music itself has existed. In just
twenty years, facts have become obfuscated by legend and
opinion, and there is no clear account of how the various
heroes of bebop did come together. Perhaps the most familiar
and stereotyped version is the one André Hodeir repeated:

"Around 1942, after classical jazz had made its conquests,
a small group used to get together every night in a Harlem
night club called Minton's Playhouse. It was made up of
several young colored boys who, unlike their fellow musicians

no longer felt at home in the atmosphere of 'swing music.' It was becoming urgent to get a little air in a richly decked-out palace that was soon going to be a prison. That was the aim of trumpeter Dizzy Gillespie, pianist Thelonius Monk, guitarist Charlie Christian (who died before the group's efforts bore fruit), drummer Kenny Clarke, and saxophonist Charlie Parker. Except for Christian, they were poor, unknown, and unprepossessing; but Monk stimulated his partners by the boldness of his harmonies, Clarke created a new style of drum playing, and Gillespie and Parker took choruses that seemed crazy to the people who came to listen to them. The bebop style was in the process of being born." [14]

It sounds almost like the beginnings of modern American writing among the emigrés of Paris. But this is the legend which filled most of my adolescence. However, as one of the innovators himself has put it: "It's true modern jazz probably began to get popular there [Minton's], but some of these histories and articles put what happened over the course of ten years into one year. They put people all together in one time in one place. I've seen practically everybody at Minton's, but they were just there playing. They weren't giving any lectures." [15]

At any rate, Parker came to New York from Kansas City, where he had last been playing with the Jay McShann band, one of the blues-oriented Southwestern bands in the early forties. He had already been through the city earlier with the McShann band, and it was then that he started playing around a few Harlem clubs, principally Monroe's Uptown Club. But in 1942, "Bird" went with the great Earl Hines band as a tenor man. This band during those years included at one time or another Dizzy Gillespie and Benny Harris on trumpets; Budd Johnson and Wardell Gray, tenors; Sarah Vaughan as a second pianist and vocalist; along with Billy

[14] *Op. cit.*, pp. 99-100.
[15] Thelonious Monk, as quoted by Nat Hentoff, *The Jazz Life* (New York, Dial, 1961), p. 195.

Eckstine, Benny Green, trombonist, and Shadow Wilson on drums. It was one of the first large bands to have a legitimately "boppish" accent. But the first real bop orchestra was the big band organized by Billy Eckstine in 1944, which included at one time or another Dizzy Gillespie, Fats Navarro, Miles Davis, Kenny Dorham, trumpets; Gene Ammons, Dexter Gordon, Lucky Thompson, tenor saxophones; Charlie Parker, alto; Leo Parker, baritone; John Malachi, piano; Art Blakey, drums; Tommy Potter, bass; arrangements by Budd Johnson, Tadd Dameron, Jerry Valentine; Sarah Vaughan and Billy Eckstine, vocals. Eckstine also played valve trombone. Almost all of these musicians played important roles in the development and popularization of bebop. And the Eckstine band demonstrated quite indelibly that bop could be scored, and scored for a large orchestra, and that the music was not merely a faddish affectation, but a serious and important musical language.

If bebop was an extreme, it was the only kind of idea that could have restored any amount of excitement and beauty to contemporary jazz. But what it perpetrated might make one shudder. Bebop was the *coup de grâce*, the idea that abruptly lifted jazz completely out of the middle-class Negro's life (though as I have pointed out, the roots of this separation were as old as the appointment of the first black house servant). He was no longer concerned with it. It was for him, as it was for any average American, "deep" or "weird." It had nothing whatsoever to do with his newer Jordans. And as I mentioned, the music by the mid-forties had also begun to get tagged with that famous disparagement *art* (meaning superfluous, rather than something that makes it seem important that you are a human being). It had no "function." "You can't dance to it," was the constant harassment—which is, no matter the irrelevancy, a lie. My friends and I as youths used only to emphasize the pronoun more, saying, "*You* can't dance to it," and whispered, "or

anything else, for that matter." It might not be totally irrelevant, however, to point out that the melody of one of Charlie Parker's bebop originals, *Now's the Time,* was used by blues people as the tune of an inordinately popular rhythm & blues number called *The Hucklebuck,* which people danced to every night while it was popular until they dropped. No function, except an emotional or aesthetic one—as no Negro music had had a "function" since the work song. I am certain *Ornithology,* a popular bebop original of the forties, would not be used to make a dance out of picking cotton, but the Negroes who made the music would not, under any circumstances, be willing to pick cotton. The boogie woogies that grew, and were "functional" in the house parties of the new black North were no more *useful* in any purely mechanical sense than bebop. But any music is functional, as any art is, if it can be put to use by its listeners or creators. A man might be right in thinking that bebop was useless to help one clear the west 40 (though I cannot see why, except in terms of one's emotional proclivities); nor was it really good to wear dark glasses and berets if one wanted to work in the post office or go to medical school. But the music was a feast to the rhythm-starved young white intellectuals as well as to those young Negroes, uncommitted to the dubious virtues of the white middle class, who were still capable of accepting emotion that came from outside the shoddy cornucopia of popular American culture.

In a sense the term *cultists* for the adherents of early modern jazz was correct. The music, bebop, defined the term of a deeply felt nonconformity among many young Americans, black and white. And for many young Negroes the irony of being thought "weird" or "deep" by white Americans was as satisfying as it was amusing. It also put on a more intellectually and psychologically satisfying level the traditional separation and isolation of the black man from America. It was a cult of protection as well as rebellion.

The "romantic" ornamentation of common forties urban Negro dress by many of the boppers (and here I mean the young followers of the music, and not necessarily the musicians), they thought, served to identify them as being neither house niggers nor field niggers. Granted, it was in a sense the same need for exoticism that drove many young Negroes into exile in Europe during these same years, but it was also to a great extent a deep emotional recognition by many of these same Negroes of the rudimentary sterility of the culture they had all their lives been taught to covet. They sought to erect a meta-culture as isolated as their grandparents', but issuing from the evolved sensibility of a modern urban black American who had by now achieved a fluency with the socio-cultural symbols of Western thinking. The goatee, beret, and window-pane glasses were no accidents; they were, in the oblique significance that social history demands, as usefully symbolic as had been the Hebrew nomenclature in the spirituals. That is, they pointed toward a way of thinking, an emotional and psychological resolution of some not so obscure social need or attitude. It was the beginning of the Negro's fluency with some of the canons of formal Western nonconformity, which was an easy emotional analogy to the three hundred years of unintentional nonconformity his color constantly reaffirmed.

The overemphasized, but still widespread, use of narcotics, not only among musicians and those similarly influenced but among poorer Negroes as well, should thus become understandable. Narcotics users, especially those addicted to heroin, isolate themselves and are an isolated group within the society. They are also the most securely self-assured in-group extant in the society, with the possible exception of homosexuals. Heroin is the most popular addictive drug used by Negroes because, it seems to me, the drug itself transforms the Negro's normal separation from the mainstream of the society into an advantage (which, I have been saying, I think it is anyway). It is one-upmanship of the

The Modern Scene / • • • • / *201*

highest order. Many heroin addicts believe that no one can be knowledgeable or "hip" unless he is an addict. The terms of value change radically, and no one can tell the "nodding junkie" that employment or success are of any value at all. The most successful man in the addict's estimation is the man who has no trouble procuring his "shit." For these reasons, much of the "hip talk" comes directly from the addict's jargon as well as from the musician's. The "secret" bopper's and (later) hipster's language was the essential part of a cult of redefinition, in terms closest to the initiated. The purpose was to isolate even more definitely a cult of protection and rebellion. Though as the bare symbols of the isolated group became more widely spread, some of the language drifted easily into the language of the mainstream, most of the times diluted and misunderstood. (There is a bug killer on the market now called "Hep.")

The social and musical implications of bebop were extremely profound, and it was only natural that there should be equally profound reactions. One of these reactions, and one I have never ceased to consider as socially liable as it was, and is, musically, was the advent and surge to popularity of the "revivalists."

"At about the same time that the first little bop bands were causing a sensation on Fifty-Second Street, New York suddenly became conscious of New Orleans music and found itself in the middle of a 'New Orleans revival.' In doing research for the first historical study of jazz, *Jazzmen*, published by Harcourt, Brace and Company in 1939, the editors, Frederic Ramsey, Jr., and Charles Edward Smith, with the help of jazz enthusiast William Russell, had found an elderly New Orleans trumpet player named Bunk Johnson working in a rice field outside of New Iberia, Louisiana. There had been a series of semiprivate recordings of Bunk with a New Orleans band and they finally decided to bring Bunk to New York. On September 28, 1945, a seven-piece

New Orleans band led by Johnson opened at the Stuyvesant Casino, on the Lower East Side of Manhattan. . . . If the writers and critics who were responsible for bringing him to New York had simply advertised that here was a New Orleans band which represented the jazz style of perhaps thirty years before, there would have been no trouble. . . . Instead the writers, not all of them, but a very clamorous group of them, said very openly that this was the last pure jazz band, the only one playing 'true jazz' and that newer styles were somehow a corruption of this older style." [16]

Bunk Johnson's "rediscovery" was only one development in the growth of the revivalist school. Lu Watters and his Yerba Buena Band, Bob Crosby and his Bobcats, and the many Eddie Condon bands in New York playing in residence at Condon's own club were already popular in the late thirties. By the forties the popularity of "Dixieland" bands was enormous at colleges throughout the country, or at any of the other places the young white middle class gathered. The "revived" Dixieland music was a music played by and for the young white middle class. It revived quite frankly, though perhaps less consciously, the still breathing corpse of minstrelsy and blackface. Young white college students trying to play like ancient colored men sounded, if one knew their intention, exactly like that, *i.e.*, like young white college students trying to play like ancient colored men.

". . . the Castle Band began to record Jelly Roll Morton's arrangements; the Frisco Jazz Band imitated Lu Watters; the early Bob Wilber band (associated with Scarsdale High School) copied King Oliver . . ." [17] The Tailgate Jazz Band even began to imitate the Yerba Band's imitations of the old Oliver Band. There were Dixieland revivalist groups all over the country, thriving like athletic antique dealers. A few of the old Negro musicians like Johnson and Kid Ory were re-recorded or rediscovered, but for the most part

[16] *Jazz: A History of the New York Scene*, pp. 219-20.
[17] *The Story of Jazz*, p. 153.

Dixieland was a kind of amateur "white jazz" that demonstrated more than anything the consistency of the cultural lag.

Whole bodies of criticism grew up around the senseless debate about "which was the real jazz." Jazz criticism had grown more respectable around the early forties; also, there had been a great deal more legitimate research into the origins and diverse developments of the music, though much of it was still in the "gee whiz" or hobby stage. Many of the men who wrote about jazz were middle-class white men who "collected hot" (the term for collecting jazz records), and there is no body of opinion quite as parochial as the hobbyist's. Quite a few "little magazines," devoted to "collecting hot" and dedicated to the proposition that no one under fifty could play "the real jazz," sprang up all over the country. Usually there were only two or three kinds of features in these magazines: articles castigating the "moderns" (which many times meant swing musicians); articles praising obscure Negroes who had once played second cornet for the Muskogee, Oklahoma, Masons; or discursive investigations of the "matrix numbers" of records issued by defunct record companies. Many of the critical writers in these magazines canonized the cultural lag by writing about jazz as if they were trying to discredit Picasso by reconstructing the Pyramids: "In a sense, the New Orleans revival demonstrated that a good portion of the white world had caught up with and was enjoying—frequently to the point of active participation—an imitation of the music that the American Negro had played twenty to thirty years earlier." [18]

By the forties the "mixed group" had become a not uncommon phenomenon. Jelly Roll Morton had recorded with the New Orleans Rhythm Kings in the twenties, and during the thirties Benny Goodman had various mixed groups,

[18] *Ibid.*, p. 154.

and a few of the other white swing bands had also hired single Negro musicians or arrangers. Also, perhaps, there were more informal sessions where both white and black musicians blew. In the forties, however, these sessions grew very numerous, especially in New York. And many of the small bop recording groups were mixed, not to mention the groups that played around Fifty-Second Street. In fact, by the time the recording ban was lifted, and more bebop records could be heard, a great many of the most significant releases featured mixed groups. To a certain extent these mixed groups reduced the cultural lag somewhat, and many white musicians by the mid-forties were fluent in the new jazz language.

By 1945, the first really bop-oriented big white band had formed under clarinetist Woody Herman, and by 1946, Herman had one of the best big bands in the country. The band was made up both of swing musicians, liberated swing musicians, and after its break-up and remodeling, many young white beboppers. Right up until the fifties many of the best young white musicians in the country had played in the various Herman "Herds." Men like Chubby Jackson, Neal Hefti, Ralph Burns, Bill Harris, Flip Phillips, Billy Bauer, Dave Tough (a swing retread), Stan Getz, Terry Gibbs, Urbie Green, Red Mitchell, Zoot Sims, Al Cohn, Jimmy Giuffre, all passed through these Herman bands, and they were among the white musicians who had grown impressed with, and then fluent in, bebop phrasing.

Herman's bands played a useful mixture of wide open swing style with varying amounts of solid boppish accents. They had good soloists and in Neal Hefti and Ralph Burns, better than competent, though sometimes overambitious, arrangers. However, there were two other large white bands coming into their own around this same period, whose music in some ways was much like the Herman band (some of the same musicians played in all three bands), though they later began to use arrangements and compositions that were

even more ambitious than anything the Herman band wanted to do. These two bands, Stan Kenton's and Boyd Raeburn's, were the central figures (though Kenton for much longer) in the ascendancy of a new reaction, *progressive jazz*. Again, this was a music created for the most part by young white musicians, many of whom had had a great deal of experience in the large white swing organizations of the forties. Unlike Dixieland, this music did not conjure up any memories of minstrelsy or blackface; in fact, quite the opposite, progressive jazz was probably the "whitest" music given the name *jazz* to appear up until recent times. It was a music that was at its best vaguely similar to what contemporary classical composers were doing. It was a self-consciously "intellectual" and intellectualized music, whose most authentic exponent was Stan Kenton, with compositions like Bob Graettinger's *Thermopylae, City of Glass,* and *House of Strings.* (Raeburn's music, for all his ambitions toward a "serious popular music," as titles like *Boyd Meets Stravinsky, Yerxa* or *Dalvatore Sally* would indicate, still sounded quite a bit like bucolic mood music; "Mickey Mouse music" is a musicians' term for it.)

Not so strangely, the term *progressive jazz,* as it became more used in America, came vaguely to denote almost any jazz after swing except Dixieland. That is, any jazz that Americans could call, if they had an opportunity, "weird" or "deep." In fact, even today there are many people who speak knowingly of the progressive jazz musician, to mean, I suppose, anyone who does not play swing, "traditional" jazz, or Dixieland. In an ironic sense, Kenton's ideas were not much different from Paul Whiteman's; even the term *progressive* carries much the same intention of showing how much "advance" jazz had made since its cruder days when only Negroes played it. (Also, any term that denotes progress or advance, even in the arts, can be used quite comfortably in the post-Renaissance West. Kenton was at least as smart as Whiteman.) So two very apparent reactions resulting

from the emergence of bebop, revivalist Dixieland and progressive jazz, both the inventions of white musicians, shot off violently in two extremely opposite directions. One, toward the reproduction of a vanished emotional field, whose validity was that it removed its participants from the realization of the sterility and nonproductiveness of their contemporary emotional alignments; the other, an attempt to involve unserious minds in a *Kitsch* of pseudo-serious artistic "experience." (Some of Raeburn's records were packaged in jackets with imitation "surrealistic" covers, with explanations of the "symbols" on the back of the jackets. The symbols were numbered for easy identification.) Both were essentially "college boy" musics, since it grows increasingly more difficult as one gets older to delude oneself about one's legitimate emotional proclivities. But the polarity and grim significance of these two "movements" is quite clear with only the advantage of twenty years' history. In either case, these twin reactions involved the white middle class; and the peculiar nature of each reaction seems as formal as would a political reaction caused by some similarly disrupting source (as bebop, and the social orientation concomitant with it). However, the *fact* of bebop and the attitudes that had engendered it could not be affected by white middle-class reactions to them. The Negroes these reactions could affect were just as outraged by the "meaningless" music of the forties as their white doubles. Stan Kenton was a big favorite at Howard University, though a young pre-medical student once told me how terribly hostile he thought Charlie Parker was.

What was called "cool jazz" cannot be placed simply as "reaction," that is, not as simply as progressive and Dixieland can be. In many ways cool was a legitimate style of jazz music, if the definition of the music can be widened a bit to include obvious innovators and masters who might not be ordinarily identified as members of the "cool school."

Cool was not the obvious reaction progressive and Dixie-land represented, but in its final use as a "public" music, it did serve to obscure the most precious advances Parker and the other boppers had made. Except for individuals like Miles Davis, who is always cited as the innovator of the post-bop cool approach, most of the musicians readily associated with the style were white musicians who abandoned (or didn't properly understand) Parker's rhythmic innovations, and put to dubious use his melodic and harmonic examples. The recordings that Davis made in 1949 and 1950 (*Israel, Boplicity, Jeru, Godchild, Move, Venus De Milo, Budo, Darn That Dream*) with two groups of nine musicians that included Kai Winding, Lee Konitz, Gerry Mulligan, Max Roach, J. J. Johnson, John Lewis, Kenny Clarke (only Davis, Mulligan, and Konitz played on both sessions), are generally looked upon as the beginning of the cool style. All of the men named, with the exception of the drummers Roach and Clarke, both of whom were bop innovators, went on as leaders in the cool movement to one degree or another. These recordings also gave popularity to a new term, *chamber jazz*, and made the cool sound ubiquitous in a couple of years.

Miles Davis played with Parker very often, and is featured on several of the best records Parker ever made. At that time, Davis was still trying to find his own voice, first of all by discovering that he wasn't Dizzy Gillespie. (An obvious analogy is Gillespie's finding out he wasn't Roy Eldridge before he found his own voice.) Davis' rhythmical freedom and phrasing mark him as a bopper, even though he was regarded as a sort of leader of the cool movement. But his splendid lyricism and almost solipsistic tone, played almost exclusively in the middle register, put him very close to the cool sound that identified the new style. Also, his penchant for playing popular ballads followed a practice the other cool instrumentalists were very fond of. But Davis always made his versions of any popular ballad exclusively

his own in terms of the emotional weight he would give them, while most of the other instrumentalists identified with the style would play the ballad straight, seeking to make only the improvised choruses sound completely extemporaneous.

Most of the reed men associated with the cool style owed more allegiance to Lester Young, having forgotten or not having been interested, it seemed, in what Charlie Parker had done. And in copying Young's melodic approach, they also went straight back to his rhythmic attack as well. What was prized most of all in Young was his completely relaxed, anti-frenetic approach, as well as the languid, evanescent, almost alto-like tone that made his tenor saxophone so singular during the thirties. The majority of the cool instrumentalists never sought to further define Young's melodic and rhythmic accomplishments. The uses they made of them, with the cautious abandon that some fluency with bop accents supplied, were generally overly predictable and flat.

The nucleus of arrangers (Gil Evans, Mulligan, Carisi) and musicians Davis used for the 1949-50 recording dates (and also in an ill-fated band that made a couple of club dates) were out of the Claude Thornhill band, a white dance band. In fact, Evans was one of the first arrangers to do big-band arrangements of any of Charlie Parker's compositions. And there is small doubt that Davis did, and does, have a deep admiration for the purple lushness of the Thornhill sound, as can be readily attested by many of his own records, especially those on which Evans is the arranger. But for Davis, his small vibratoless tone was only a means rather than an end. He had a deep connection to the basic blues impulse, and he could insinuate more blues with one note and a highly meaningful pause than most cool instrumentalists could throughout an entire composition.

Perhaps for the reasons I mentioned in Chapter III, the cool timbre was much more suitable for most white musicians, who favored a "purity of sound," an artifact, rather

than the rawer materials of dramatic expression. Davis, too, for all his deep commitment to the blues, often seems to predicate his playing on the fabrication of some almost discernible object. And in this he seems closer to Bix Beiderbecke than Louis Armstrong. There were other Negro musicians before Davis who seemed as deeply persuaded by the beauty of the "legitimate" artifact-like sound, rather than by the classic open stridency of most jazz instrumentalists. Lester Young comes to mind immediately, but men like Teddy Wilson, Benny Carter, Johnny Hodges, seem obvious examples, also the many Negro saxophonists influenced by Young in Davis' own generation. Davis himself became the most copied trumpet player of the fifties, and because of the apparent simplicity of his method, his style is even now one of the most ubiquitous in jazz.

The period that saw bebop develop, during and after World War II, was a very unstable time for most Americans. There was a need for radical readjustment to the demands of the postwar world. The riots throughout the country appear as directly related to the psychological tenor of that time as the emergence of the "new" music. Each response a man makes to his environment helps make a more complete picture of him, no matter what that response is. The great interest in the Muslim religion by Negro musicians in the forties (many of them actually changed their names to Muslim ones) adds to the image of the Negro in America at that time as much as our knowing how many more Negroes were able to buy homes in Scarsdale adds to that image. Knowing that a Negro musician felt like changing the name of a popular song from *Honeysuckle Rose* to *Scrapple From the Apple,* or that he would call one of his compositions *Klactoveedsedstene* helps clarify his attitudes and even further, the attitudes of a great many Negroes responsible to the same set of emotional alternatives.

The "harshness" and "asymmetry" of bebop was much closer to the traditional Afro-American concept of music

than most of its detractors ever stopped to realize. But it is easy to see that the "harshness and asymmetry" of the music (or ideas) of one period might seem relatively mild and regular in another, maybe only a few years later. If *Livery Stable Blues* seemed crude and unsophisticated to Paul Whiteman, it is relatively easy to see why Stan Kenton might think the same of most bebop and seek a similar solution. Though by Kenton's time and during the years when cool jazz came into vogue in America, the lateral exchange of cultural reference between black and white produced an intercultural fluency that might have made such a misunderstanding, or lack of feeling, on Mr. Kenton's part impossible. It was the Negro's fluency with the technical references of Western music that made bebop (and all jazz, for that matter) possible, and it was certainly a fluency with these same superficial references of Negro music that produced, with whatever validity, the white cool style (or any jazz that white musicians played). What was not always attained in the case of the white jazz musician was the fluency of attitude or stance. And as I have said before, Negro music is the result of certain more or less specific ways of thinking about the world. Given this consideration, all talk of technical application is certainly after the fact.

Cool jazz is not as clearly a "white style" as Dixieland or progressive if Lester Young and Miles Davis can be placed within the definition. Yet Lee Konitz, a leader of the cool school and one of the most gifted white musicians to play jazz, cannot be linked to Davis or Young, except in the most superficial ways. In the case of Davis and Konitz, even though they have played together on several occasions and are together responsible for some of the best cool music (the eight recordings made in 1948-49), their basic approaches are entirely dissimilar, despite the fact that they both, within the demands of each instrument, favor light, pure tones with almost no vibrato. There the resemblance ends. John Lewis, the pianist and leader of the Modern Jazz Quartet, and

pianist Lennie Tristano, a white leader of one of the most exciting branches of the cool style, are both considered to be equally involved with this style; however, it would be difficult to find two more dissimilar instrumentalists and composers. Even though both men have shown deep interest in extended forms and the use of contrapuntal techniques in jazz, their methods are very different. Lewis, for all his persistence in drenching his compositions with the formal dicta of European music, is one of the most moving blues pianists in jazz, while it is hard to think of Tristano playing a blues.

During the late forties and right up until the middle fifties, the cool style was very popular. Long-playing albums by many of the musicians associated with the cool style (or "West Coast jazz," as it came to be called, with the great popularity of musicians like Shorty Rogers, Gerry Mulligan, and Dave Brubeck on the Coast) sold fantastically all over the country. The soft, intimate sound and regular rhythms of such groups, along with their tendency to redo popular ballads like *Spring Is Here* or *My Funny Valentine* with just a vague bop accent, made them listened to everywhere by white and black college students and young-men-on-the-way-up who were too sophisticated to listen to Dixieland. Also, many of the cool stylists maintained a healthy attitude toward the innovations that progressive jazz was supposed to have made, *contrapuntal jazz* and *jazz fugue* became standard terms that could be applied to a music whose name had once been a transitive verb unutterable in polite society.

There are many important analogies that can be made between the cool style and big-band swing, even about the evolution of the terms. *Swing*, the verb, meant a simple reaction to the music (and as it developed in verb usage, a way of reacting to anything in life). As it was formalized, and the term and the music taken further out of context, *swing* became a noun that meant a commerical popular

music in cheap imitation of a kind of Afro-American music. The term *cool* in its original context meant a specific reaction to the world, a specific relationship to one's environment. It defined an attitude that actually existed. To be *cool* was, in its most accessible meaning, to be calm, even unimpressed, by what horror the world might daily propose. As a term used by Negroes, the horror, etc., might be simply the deadeningly predictable mind of white America. In a sense this calm, or stoical, repression of suffering is as old as the Negro's entrance into the slave society or the captured African's pragmatic acceptance of the gods of the captor. It is perhaps the flexibility of the Negro that has let him survive; his ability to "be cool"—to be calm, unimpressed, detached, perhaps to make failure as secret a phenomenon as possible. In a world that is basically irrational, the most legitimate relationship to it is nonparticipation. Given this term as a consistent attitude of the Negro, in varying degrees, throughout his life in America, certain stereotypes might suddenly be reversed. The "Steppin-fechit" rubric can perhaps be reversed if one but realizes that given his constant position at the bottom of the American social hierarchy, there was not one reason for any Negro, ever, to hurry.

The essential irony here is that, like *swing*, when the term *cool* could be applied generally to a vague body of music, that music seemed to represent almost exactly the opposite of what *cool* as a term of social philosophy had been given to mean. The term was never meant to connote the tepid new popular music of the white middle-brow middle class. On the contrary, it was exactly this America that one was supposed to "be cool" in the face of.

The cool style, like arranged big-band swing, inundated America and most Negro musicians (bop or swing) who did not master the cool approach. (Actually, it did finally have a narrower definition, since even Miles Davis went into a virtual eclipse of popularity during the high point of the

cool style's success. In part, this might have been caused by Davis' personal problems, but I read in print more than a few times during the early fifties that Davis was "a bad imitation" of a white West Coast trumpeter, Chet Baker. If anything, the opposite was true; but Baker fitted in more closely with the successful syndrome of the cool. His barely altered renditions of popular ballads in a cracked, precious middle register were the rage of the mid-fifties, and Baker sang as well.) Like commerical swing, the music created a term of success and fame for its best-known stylists, who were inevitably white, Miles Davis and John Lewis were not the "Kings of Cool," as Basie and Ellington were not the "Kings of Swing"; instead, quite predictably, the "kings" during the height of the cool rage were white musicians like Gerry Mulligan, Chet Baker, Dave Brubeck, or Paul Desmond. In fact, the Dave Brubeck Quartet, which featured Paul Desmond on alto saxophone, was perhaps the perfect fifties cool success story. Brubeck, a pianist, had studied (though quite briefly, I believe) with the contemporary French composer Darius Milhaud, and it was he who, to a large extent, popularized the idea of using fugues, rondoes, and other such consciously affected pickups from European music. This was a natural for college-bred audiences who liked a little culture with their popular music. (A student at the University of Oregon suggested in an article in the *Northwest Review*, quoted in the *Jazz Review*, that Brubeck also played the alma mater of any college he happened to be visiting, "when the audience is beginning to drag.") Finally, Brubeck and his music formally entered the American main-stream when his picture appeared on the cover of *Time* magazine. Jazz had at last made it up the river from New Orleans (with the help of Paul Whiteman, Benny Goodman, and Dave Brubeck), right into the waiting room of Henry Luce's office.

Perhaps the Korean War, like the other two "major" wars before it, helped bring about changes in jazz. I am almost

certain that the fifties took on their own peculiar foreboding shape because of the grim catalyst of the Korean War and the emotional chaos that went with it. The Negro could not help but be affected; neither could his music. Cool was not a style that could outlast the fifties, and as in the case of commerical swing, most Negro musicians were never committed to it anyway. But the Japanese soldier in the racially significant Hollywood film had been changed to a North Korean or Chinese soldier, and now he asked the Negro soldier in the integrated Armed Forces questions, too. One question in the movie *Steel Helmet* was, "Black boy, why you fight this war . . . you can't even sit in the front of the bus?" And soldier James Edwards' answer was pitifully inadequate.

Korea and what historians are calling "the legacy of the cold war" proposed even harsher realities for America than World War II. The greater part of these are just now, in the 1960's, beginning to be felt in something like their real measure. But even in the mid-fifties America was a changed place from what it had been only a decade and a half before. Two hot wars and wedged between them and coming after them, a cold one, plus the growing significance of the atomic bomb as a force that had suddenly transformed the world into a place that was "no longer a series of frontiers, [but] a community which would survive or perish by its own hand" were only the impersonal parts of an American's experience of the contemporary world that had changed him and his society perhaps radically in the fifteen or so short years since 1940. The heroic wars "to make the world safe for democracy" had dwindled grimly into "police actions," the nature of which many American soldiers did not find out until they were captured. Even the term *democracy* was blackened by some ambitious, but hideously limited, men who thought that it meant simply "anti-communism." These phenomena are all legacies of the cold war era; the fifties were their spawning ground, and the

generation who would have to be fully responsible for them was not yet fully grown. Perhaps they were in college, as I was, listening to Dave Brubeck.

The Supreme Court was trying to answer James Edwards' interrogator, with its 1954 decision, to integrate the schools "with all deliberate speed." Now in 1963, nine years later, integration has not been fully accomplished, and in a great many cases where it has been, there is mere token integration. But the internal strife in the United States between black and white has at least been formally acknowledged as a conflict that might conceivably be legislated out of existence, though again it is the sixties that must test the validity of this desperate hypothesis. The fifties was a period of transition, in many aspects, of beginnings and endings. For one thing, Charlie Parker died in February of 1955, at thirty-five.

Perhaps it is good to use that mid-point of the fifties as an arbitrary point where the counterreaction called "hard bop" began to be noticed. An analogy between this development and the ending of the swing era by the beginnings of bebop in the forties is obvious, though the situation was not as extreme as it had been in the forties.

Amidst the cellos, flutes, fugues, and warmed-over popular ballads of the cool, there was evident, mostly among Negro musicians, a conscious, and many times affected, "return to the roots," as it has been called so often: "It was Horace Silver as musical director of Art Blakey's Jazz Messengers who first announced it, of course, and obviously he and the rest had turned to church and gospel music and the blues as sources of renewed inspiration. If these men were reluctant to listen to King Oliver and Bessie Smith, they heard Ray Charles and Mahalia Jackson with a kind of reverence." [19]

The hard-bop reactions were loudest in the East, *i.e.*,

[19] Martin Williams, "The Funky-Hard Bop Regression," *The Art of Jazz*, p. 233.

New York, which led quite predictably to the new style's being called "East Coast Jazz," to place it within the immediate reach of the press agents and jazz critics. *Funky* (a word with as dubious a place in polite society as *jazz*) became the treasured adjective, where once *cool* had been, with *soul* (as a quality of expression, probably found only in Negroes wearing Italian suits) following closely behind. The harsher, rawer, more classic timbres of older jazz were restored. Most of the melodies in hard-bop tunes were very simple, however, founded usually on some basic riff, usually much less complex than the jagged lines of the classic bop melodies. Pianists like Silver played fewer chords than the bop pianists, though their style was impossible without the innovations of bop pianist Bud Powell. But the soloist's dependence on chords was, if anything, made greater. The hard boppers sought to revitalize jazz, but they did not go far enough. Somehow they lost sight of the important ideas to be learned from bebop and substituted largeness of timbre and quasi-gospel influences for actual rhythmic or melodic diversity and freshness. The hard bop groups utilized rhythms that are amazingly static and regular when compared to the music of the forties. (And merely calling tunes *Dis Heah* or dropping *g*'s from titles is not going to make the music more compelling.)

Hard bop has by now become little more than a style. The opportunities for complete expression within its hardening structure and narrowly consistent frame of emotional reference grow more limited each time some mediocre soloist repeats a well-chewed phrase or makes of the music a static insistence rather than an opening into freer artistic achievement. It has become a kind of "sophistication" that depends more on common, then banal, musical knowledge, instead of truth or meaning suddenly revealed. What results, more times than not, is a self-conscious celebration of cliché, and an actual debilitation of the most impressive ideas to come out of bebop. One has the feeling, when listening to

the most popular hard-bop groups of the day, of being confronted merely by *a style*, behind which there is no serious commitment to expression or emotional profundity.

But what is most important about hard bop and the shape it took as a reaction to the growing insipidities the cool style had pushed on jazz is the change of stance which had to occur in order for the Negro musician to be able to react as he did. Again, this change, becoming apparent in the mid-fifties, had further implications that are only just now beginning to be fully understood. "Soul" music, as the hard-bop style is often called, does certainly represent for the Negro musician a "return to the roots." Or not so much a return as a conscious re-evaluation of those roots. Many times this re-evaluation proved as affected and as emotionally arid as would a move in the opposite direction. The shabbiness, even embarrassment, of Hazel Scott playing "concert boogie woogie" before thousands of white middle-class music lovers, who all assumed that this music was Miss Scott's invention, is finally no more hideous than the spectacle of an urban, college-trained Negro musician pretending, perhaps in all sincerity, that he has the same field of emotional reference as his great-grandfather, the Mississippi slave. Each seems to me merely burlesque, or cruder, a kind of modern minstrelsy.

The direction, the initial response, which led to hard bop is more profound than its excesses. It is as much of a "move" within the black psyche as was the move north in the beginning of the century. The idea of the Negro's having "roots" and that they are a valuable possession, rather than the source of ineradicable shame, is perhaps the profoundest change within the Negro consciousness since the early part of the century. It is a re-evaluation that could only be made possible by the conclusions and redress of attitude that took place in the forties. The feelings of inferiority which most Negroes had and still have to a certain extent were brought to their lowest valence up until the present time in the

forties. The emergence then of a psychological stance based on the emotional concept of "equality of means" meant that finally all the "barriers" against useful existence within the American society could be looked at by Negroes as being only the inventions of white Americans. The form and content of Negro music in the forties re-created, or reinforced, the social and historical alienation of the Negro in America, but in the Negro's terms. The Negro jazz musician of the forties was *weird*. And the myth of this weirdness, this alienation, was sufficiently important to white America for it to re-create the myth in a term that connoted not merely Negroes as the aliens but a *general* alienation in which even white men could be included. By the fifties this alienation was seen by many Negro musicians not only as valuable, in the face of whatever ugliness the emptiness of the "general" culture served to emphasize, but as necessary. The step from *cool* to *soul* is a form of social aggression. It is an attempt to place upon a "meaningless" social order, an order which would give value to terms of existence that were once considered not only valueless but shameful. *Cool* meant nonparticipation; *soul* means a "new" establishment. It is an attempt to reverse the social roles within the society by redefining the canons of value. In the same way the "New Negroes" of the twenties began, though quite defensively, to canonize the attributes of their "Negro-ness," so the "soul brother" means to recast the social order in his own image. White is then not "right," as the old blues had it, but a liability, since the culture of white precludes the possession of the Negro "soul." Even the adjective *funky*, which once meant to many Negroes merely a stink (usually associated with sex), was used to qualify the music as meaningful (the word became fashionable and is now almost useless). The social implication, then, was that even the old stereotype of a distinctive Negro smell that white America subscribed to could be turned against white America. For this smell now, real or not, was made a valuable characteristic of

"Negro-ness." And "Negro-ness," by the fifties, for many Negroes (and whites) was the only strength left to American culture.

This form of cultural arrogance was certainly useful in defining the emergence of the Negro as an autonomous human factor within American society. But it could not sustain its weight as a means to artistic expression without an added profundity that would give it a fluency within the total aspect of the society. This strength had to be returned, as it were, to the culture that had given it shape. Its secrecy had been a form of protection and incubation; but for it to remain secret or exclusive at this point in American social history would make it as sterile as the culture from which it was estranged. Secrecy had been the strength of the Afro-American culture when it was dependent largely on folk sources for its vitality, but now it had to be reinterpreted in terms of the most profound influences in the open field of *all existing* cultures, or it would retreat to the conditional meaningfulness of the folk or the final meaninglessness of the popular. Hard bop did the latter.

The continuous re-emergence of strong Negro influences to revitalize American popular music should by now be pretty well understood. What usually happened, as I have pointed out, was that finally too much exposure to the debilitating qualities of popular expression tended to lessen the emotional validity of the Afro-American forms; then more or less violent reactions to this overexposure altered their overall shape. This was true as far back as the lateral and reciprocal influences Negro spirituals had on the white hymns they were superficially modeled upon. And these reactions almost always caused valid changes in the forms themselves. The result was a deliberately changing, constantly self-refining folk expression, the limbs of which grew so large that they extended into the wider emotional field to which all Western art wants constantly to address itself. The

Negro music of the thirties whose dilution resulted in commercial swing had already set its ends past that of a strict folk music. In fact, as jazz began to take on an autonomous shape and could define within this shape the native materials of its earlier forms as folk music (that is, jazz could do with the shout, the work song, the blues, what Bartok did with Hungarian gypsy music, but with the added advantage of a constant natural reference), it eliminated, at each reevaluation, elements which might *only* have use in folk music. The fact that popular ragtime, Dixieland, swing, etc., were not Negro musics is important. They were the debris, in a sense, of vanished emotional references. The most contemporary Negro music to result afterward had absolutely nothing to do with this debris, except as a reaction to it. The uses to which these diluted musics put the Afro-American forms were not historical, but cultural. Negro big-band jazz of the thirties is related to the development of bebop, but neither music has much to do with commercial swing. Swing simply does not exist in the history of the development of Negro music. Each dilution was simply a phenomenon based on cultural limitations (or excess) and, as such, was only related directly to the cultural elements which provided for its existence. Fletcher Henderson was not *responsible* for the Ipana Troubadours, just as Charlie Parker was not responsible for Boyd Raeburn.

When hard bop began to some extent to redefine the materials of Negro music, the general emotional climate of American society was certainly in need of some kind of revitalization. The catatonia of the forties popular song was plainly evident; analogies could be made to almost all areas of American life. Jazz had, with its conscious address to that broader emotional field of which I spoke, necessarily divided itself, as does all Western art, into strata, just as we can demonstrate the different levels into which classical music is divided. There is a different kind of prehension necessary, even expected, to enjoy music as different as

that of Dukas and Mozart. (That one music demands the fuller application of intellectual faculties for its enjoyment seems to me apparent.) Most cool jazz, for instance, was, almost in its intentions, a *middle-brow* music. Hard bop, though it sought to erase the strong middle-brow flavor that the jazz of the fifties had developed, provided nevertheless, because of its musical and extra-musical affectations and its conspicuous "exclusiveness," almost a group of anthems for another kind of American middle brow—a black one. But bop had moved in an opposite direction, just as the music of Armstrong and Ellington had moved toward the considerations and responsibilities of high art.

When the purely popular, purely "undignified," music of America, its mainstream folk music, had almost completely calcified with even more drastic dilutions of swing style, it was a contemporary blues form that was utilized to revive it, and not the middle-brow extensions hard bop and cool had become. The general public had no use for them, in many cases did not even know they existed (except that a form of the latter was used as background music for many television programs).

Rhythm & blues, the urban contemporary expression of blues, was the source of the new popular revitalization; rock 'n' roll is its product. And it is, ask any "average" American mother, a music for "low brows." But an Elvis Presley seems to me more culturally significant than a Jo Stafford.

> Take out the papers and the trash
> Or you don't get no spending cash.
> If you don't scrub the kitchen floor
> You ain't gonna rock and roll no more.
>
> (From *Yakety Yak*, words and music by Jerry Leiber and Mike Stoller)

To be sure, rock 'n' roll is usually a flagrant commercialization of rhythm & blues, but the music in many cases

depends enough on materials that are so alien to the general middle-class, middle-brow American culture as to remain interesting. Many of the same kinds of cheap American dilutions that had disfigured popular swing have tended to disfigure the new music, but the source, the exciting and "vulgar" urban blues of the forties, is still sufficiently removed from the mainstream to be vital. For this reason, rock 'n' roll has not become as emotionally meaningless as commercial swing. It is still raw enough to stand the dilution and in some cases, to even be made attractive by the very fact of its commercialization. Even its "alienation" remains conspicuous; it is often used to characterize white adolescents as "youthful offenders." (Rock 'n' roll also is popular with another "underprivileged" minority, *e.g.*, Puerto Rican youths. There are now even quite popular rock-'n'-roll songs, at least around New York, that have some of the lyrics in Spanish.) Rock 'n' roll is the blues form of the classes of Americans who lack the "sophistication" to be middle brows, or are too naïve to get in on the mainstream American taste; those who think that somehow Melachrino, Kostelanetz, etc., are too lifeless.

The reference hard bop (and an attendant "blues renaissance," wherein many of the older blues singers were re-recorded and in some cases, restored to a good measure of popularity) made to the older forms of Afro-American music and the implications of such a cultural reconstruction became even more significant by the end of the fifties and the beginning of the new decade. This was so despite the fact that hard bop, sagging under its own weight, had just about destroyed itself as the means toward a moving form of expression. But there were a few musicians, like saxophonists John Coltrane and Sonny Rollins and drummer Elvin Jones, who had been identified closely with this style, who emerged in the sixties working in new areas, though their way had been prepared to a great extent by the "funky" style.

Sonny Rollins, for instance, was one of the leaders of the hard bop school, but he has gone into a music that is much more profound, though the seeds of it are definitely to be found in his earlier "funky" style. John Coltrane played with the Miles Davis Quartet and Quintet during the middle and late fifties, when for all Davis' lyricism, his groups were constantly identified as hard boppers; he also played with Thelonius Monk's "perfect" group. But Coltrane, too, has moved off into a music quite unconnected, and almost antithetical, to the work of most of the hard groups. Elvin Jones, also associated with many leading hard groups, has worked for the past couple of years in Coltrane's new bands, contributing greatly to the excellence and freshness of their music. Pianist Thelonius Monk, one of the bebop innovators, also re-emerged in the late fifties as an uncompromising individualist whose real contributions to jazz were just beginning to be really understood.

With these men, there also emerged in the sixties a younger group of musicians who, along with Rollins, Coltrane, etc., began to answer some of the weighty questions of the fifties and even to propose some new ones of their own. These young musicians I will call, for lack of a more specific term, "avant-garde." It has been said many times that this generation of Americans (my own generation) was born during a Depression, grew up during World War II, and grew to maturity in college or elsewhere during the Korean War. A major catastrophe for each decade of their lives. And now that they are moving toward a fourth decade, an even more violent catastrophe is within easy reach of reality.

The musicians of this generation are old enough to have been impressed as adolescents by the Negro music of the forties, and they are certainly old enough to have understood the reactions, like Dixie, progressive, cool, and hard bop, that have, to varying degrees, served to obscure the valuable legacies of that music. They are mature enough

now to have produced a highly articulate musical language that makes profound use of the vital music of the forties. In doing this, they are also re-emphasizing the most expressive qualities of Afro-American musical tradition while also producing an American music which has complete access to the invaluable emotional history of Western art. Pianist Cecil Taylor and alto saxophonist Ornette Coleman are the most important of these recent innovators.

What these musicians have done, basically, is to restore to jazz its valid separation from, and anarchic disregard of, Western popular forms. They have used the music of the forties with its jagged, exciting rhythms as an initial reference and have restored the hegemony of blues as the most important basic form in Afro-American music. They have also restored improvisation to its traditional role of invaluable significance, again removing jazz from the hands of the less than gifted arranger and the fashionable diluter (though no doubt these will show up in time).

Coleman's music is that of an improvising soloist; like Charlie Parker, he is a brilliant soloist, and his purely extemporaneous statements cannot be reproduced by any notation. Taylor's music seems to lend itself more to notation —in fact, he has recently scored quite a few works for larger groups. But even though the music is arranged, there is still the feeling of freedom and unmeasured excitement that only the musician who has developed as an extemporaneous artist can produce.

While the music, with its contemporary dependence on older forms, is in many ways similar to the music of the forties, there are also reinterpretations of the uses of formal musical definitions, though these are not necessarily based on any *theoretical* re-evaluations (only perhaps after the fact). The music has changed because the musicians have changed. And it would be absurd to suppose (as many jazz hobbyists have done) that anything else could be the case. There is no basis in social, psychological, economic, cultural,

or historical fact for assuming that Ornette Coleman or Cecil Taylor should be trying to play jazz that sounds like the Fletcher Henderson orchestra:

"The boppers were tired of the same old chords and explored new ones. But essentially, most of them were still playing a riff style; it is just that their kind of riffs were built on a new approach to harmony—but not really so new as one thought. Again the best of them leaned on the melodic background of the blues for a melodic form and unity of mood . . ." [20]

By now, even the fresh uses to which the boppers put riff-based chords have been exploited and re-exploited to staleness. The hard boppers, if anything, increased to an even greater degree the improvising jazz musician's reliance on "changes" (recurring chords). Also, the "tonal centers" of this music, especially as influenced by pseudo-gospel harmonies, are so predictable and flat that in this context even the gifted improvisers began to sound dull. What Coleman and Taylor have done is to approach a kind of jazz that is practically nonchordal and in many cases atonal (meaning that its tonal "centers" are constantly redefined according to the needs, or shape and direction, of the particular music being played, and not formally fixed as is generally the case—what composer George Russell has called "pan-tonality"). Their music does not depend on constantly stated chords for its direction and shape. Nor does it pretend to accept the formal considerations of the bar, or measure, line. In a sense, the music depends for its form on the same references as primitive blues forms. It considers the *total area* of its existence as a means to evolve, to move, as an intelligently shaped musical concept, from its beginning to its end. This total area is not merely the largely artificial considerations of bar lines and constantly stated chords, but the *more* musical considerations of rhythm, pitch, timbre, and melody. All these are shaped by the emo-

[20] Martin Williams, as quoted in *The Jazz Life*, p. 180.

tional requirements of the player, *i.e.*, the improvising soloist or improvising group.

". . . chords have always helped the jazz player to shape melody, maybe to an extent that he is now over-dependent on the chord. Ornette seems to depend mostly on the overall tonality of the song as a point of departure for melody. By this I don't mean the key the music might be in. His pieces don't readily infer key. They could almost be in any key or no key. I mean that the melody and the chords of his compositions have an overall sound which Ornette seems to use as a point of departure. This approach liberates the improvisor to sing his own song really, without having to meet the deadline of any particular chord. Not that he can't be vertical and say a chord if he chooses." [21]

The implications of this music are extraordinarily profound, and the music itself, deeply and wildly exciting. Music and musician have been brought, in a manner of speaking, face to face, without the strict and often grim hindrances of overused Western musical concepts; it is only the overall musical intelligence of the musician which is responsible for shaping the music. It is, for many musicians, a terrifying freedom.

These young musicians also rely to a great extent on a closeness of vocal reference that has always been characteristic of Negro music. Players like Coleman, Coltrane, and Rollins literally scream and rant in imitation of the human voice, sounding many times like the unfettered primitive shouters. Charlie Parker also had to restore this quality to jazz timbre after the legitimatizing influences of commercial swing.

Along with the music that men like Ornette Coleman and Cecil Taylor are making, there are a few older musicians who are also helping to revitalize the jazz of the late fifties and early sixties. Two of these, as I have mentioned be-

[21] George Russell, "Ornette Coleman and Tonality," *Jazz Review* (June, 1960), p. 9.

fore, are John Coltrane and Sonny Rollins. In many ways the music these two men are making falls in direct contrast to the music of younger men like Coleman and Taylor. But its emotional directness and fresh reconsideration of all the elements of its musical existence have had an effect on jazz very similar to that of the younger musicians.

If Coleman's music can be called nonchordal, John Coltrane's music is fanatically chordal. In his solos, Coltrane attacks each chord and seems to almost want to separate each note of the chord (and its overtones) into separate entities and suck out even the most minute musical potential. With each instance, Coltrane redefines his accompanying chords as kinetic splinters of melody, rather than using the generalized block sound of the chord as the final determinant of his music's direction and shape.

Rollins, a marvelously gifted improviser, has recently shown signs of abandoning a purely chordal concept of playing, combining the overall direction Coleman, Taylor, and the other younger musicians have taken with his own ability to utilize both thematic, or melodic, variation as well as harmonic variation in shaping his music. He has also recently brought together a group with two former members of Ornette Coleman's original band: trumpeter Don Cherry and drummer Billy Higgins. The results have been extremely gratifying, and show how indelible an impression Ornette Coleman's music has made—though Rollins has made his own highly original appropriations of it.

In a sense, men like Coltrane and Rollins (especially Coltrane) are serving as this new generation's private assassins —demonstrating, perhaps, the final beauties to be extracted from purely chordal jazz, and in so doing, making it almost impossible for the music to continue to be committed to free emotional statement without coming to grips with the ideas that Coleman, Taylor, and some others have put forward.

There is another body of music emerging recently that seems to have developed out of the same concepts that pro-

duced progressive jazz. It is called "third stream jazz," and it is a music that utilizes as blatantly as possible some of the formal ideas and techniques of contemporary classical music. As one example, trumpeter Don Ellis, one of the musicians associated with third stream, has recently recorded a piece written by the contemporary German composer Karlheinz Stockhausen. Composers such as Gunther Schuller have also contributed to the music, as well as such jazzmen as Jimmy Giuffre and John Lewis. Lewis and his Modern Jazz Quartet have even recently recorded with the Beaux Arts String Quartet, and Lewis once performed some of his own compositions with the Stuttgart Symphony Orchestra. Older classical forms are utilized in many of Lewis' compositions with varying degrees of success. Most of the time, his ambitious "serious" music, such as *European Windows,* which was played with the Stuttgart Orchestra, or the ballet score *Original Sin,* has seemed to me very close to the lifeless string music one is apt to hear in modern elevators. However, as I have said, Lewis himself can be a deeply moving pianist, and his group, the Modern Jazz Quartet, has been responsible for some of the most exciting jazz of the last few years. But Lewis' attempts to "combine" classical music and jazz have more often than not been frightening examples of what the *final* dilution of Afro-American musical tradition might be.

The attempt itself is an old clutch, and one that immediately revives memories of progressive jazz. And, of course, there are people who are lumping the efforts of men like Coleman and Taylor into the third-stream category in much the same way as bop was called progressive jazz. There is no doubt in my mind that the techniques of European classical music can be utilized by jazz musicians, but in ways that will not subject the philosophy of Negro music to the less indigenously personal attitudes of European-derived music. Taylor and Coleman know the music of Anton Webern and are responsible to it intellectually, as they would

be to any stimulating art form. But they are not responsible to it emotionally, as an extra-musical catalytic form. The emotional significance of most Negro music has been its separation from the emotional and philosophical attitudes of classical music. In order for the jazz musician to utilize most expressively any formal classical techniques, it is certainly necessary that these techniques be subjected to the emotional and philosophical attitudes of Afro-American music—that these techniques be *used* not canonized. Most third stream jazz, it seems, has tended to canonize classical techniques rather than use them to shape the expressive fabric of a "new" jazz music. The controversy over whether this music is jazz or not seems foolish and academic, since the genre does not determine the quality of the expression. However, in the case of third stream jazz the quality of the expression has been, in most instances, unimpressive.

The "artist's life" has many definite social and historical connotations in the West. In Europe an artist or Bohemian is tolerated, even looked up to as a person of mysterious but often valuable capabilities, but in America no such admiration (nor even an analogous term of toleration) exists. The artist and his fellow-traveler, the Bohemian, are usually regarded in this society as useless con-men and as such, are treated as enemies. (If the political tone of contemporary American democracy can be perhaps too easily summed up as "anti-communist," its cultural tone, with equal vagueness, can be called "anti-artistic.") The complete domination of American society by what Brooks Adams called the economic sensibility, discouraging completely any significant participation of the imaginative sensibility in the social, political, and economic affairs of the society is what has promoted this hatred of the artist by the "average American." This phenomenon has also caused the estrangement of the American artist from American society, and made the formal culture of the society (the diluted formalism of the

academy) anemic and fraught with incompetence and un-reality. It has also caused the high art of America to be called "an art of alienation." The analogy to the life of the Negro in America and his subsequent production of a high art which took its shape directly from the nature and meaning of his own alienation should be obvious. This consideration (dealt with consciously or instinctively) certainly reshaped certain crucial elements of the American art of the last two decades, and gave a deeply native reference to the direction of American Bohemianism, or artist's life, of the fifties.

It was a lateral and reciprocal identification the young white American intellectual, artist, and Bohemian of the forties and fifties made with the Negro, attempting, with varying degrees of success, to reap some emotional benefit from the similarity of their positions in American society. In many aspects, this attempt was made even more natural and informal because the Negro music of the forties and again of the sixties (though there has been an unfailing general identification through both decades) was among the most expressive art to come out of America, and in essence, was possessed of the same aesthetic stance as the other high art of the period.

But the reciprocity of this relationship became actively decisive during the fifties when scores of young Negroes and, of course, young Negro musicians began to address themselves to the formal canons of Western nonconformity, as formally understood refusals of the hollowness of American life, especially in its address to the Negro. The young Negro intellectuals and artists in most cases are fleeing the same "classic" bourgeois situations as their white counterparts—whether the clutches of an actual black bourgeoisie or their drab philosophical reflectors who are not even to be considered a middle class economically. The important development, and I consider it a socio-historical precedent, is that many young Negroes no longer equate intelligence

or worth with the tepid values of the middle class, though their parents daily strive to uphold these values. The "New Negroes" produced a middle-class, middle-brow art because despite their desired stance as intellectuals and artists, they were simply defending their right, the right of Negroes, *to be* intellectuals, in a society which patently denied them such capacities. And if the generation of the forties began to understand that no such "defense" or explanation was necessary, the young Negro intellectuals of the fifties and sixties realize—many of them perhaps only emotionally— that a society whose only strength lies in its ability to destroy itself and the rest of the world has small claim toward defining or appreciating intelligence or beauty. Again, this address to Western nonconformity must be predicated on a fluency with, an understanding of, those canons, those attitudes; a fluency whose accomplishment is as available to analysis, and the results of this analysis as real, as the Negro's accomplishment of musical fluency with European instruments, which eventually resulted in the emergence of jazz.

The jazz of the forties was given its classic shape in Harlem, where most Negro musicians played. And traditionally, one had to go to the Negro ghetto in whatever city to hear the most legitimate and contemporary Afro-American music. The musicians, also, generally lived in those ghettoes (which is what I meant earlier by "a natural reference" to the folk origins of the music). But Charlie Parker, during the later forties and fifties, used to frequent New York's Greenwich Village, traditionally a breeding ground of American art and the open-air fraternity house of a kind of American Bohemianism. Parker, in fact, at one point, was living in the village with a young Negro painter, Harvey Cropper, and in exchange for painting lessons, "Bird" was supposed to teach Cropper how to play the tenor saxophone. Many of Parker's closest acquaintances were painters and writers, and he moved in that society with relative ease. Dizzy

Gillespie has said about Parker: "No, he wasn't a big conversationalist about music . . . But he would talk. Oh, he was a great talker . . . about any subject you'd want to talk about. Like philosophy, or if you wanted to talk about art he'd talk with you. Or if you wanted to talk about History—European History, African History, or Middle Ages, or Stone Age History. Oh, he knew about current events and things like that." [22]

The jazz of the late fifties and sixties, though it has been given impetus and direction by a diversity of influences, is taking shape in the same areas of nonconformity as the other contemporary American arts. In Greenwich Village, for instance, a place generally associated with "artistic and social freedom," based on willing (though sometimes affected) estrangement from the narrow tenets of American social prescription, young Negro musicians now live as integral parts of that anonymous society to which the artist generally aspires. Their music, along with the products of other young American artists seriously involved with the revelation of contemporary truths, will help define that society, and by contrast, the nature of the American society out of which these Americans have removed themselves.

The feeling of rapport between the jazz of the forties, fifties, and sixties with the rest of contemporary American art is not confined merely to social areas. There are aesthetic analogies, persistent similarities of stance that also create identifiable relationships. And these relationships seem valid whether they are found in the most vital contemporary American poetry or the best new American painting. The younger musicians sense this as much as, say, the younger writers.

The writers who have been called the "Beat Generation" (usually with great bitterness and imprecision) have gained much notoriety because of their very vocal attachment to jazz. Jack Kerouac's characters are always talking about

[22] Felix Manskleid, "Diz On Bird," *Jazz Review* (January, 1961).

one jazz musician or another, and he has prefaced his book of poetry, *Mexico City Blues*, with the note: "I want to be considered a jazz poet/blowing a long blues in an afternoon jam/session on Sunday. I take 242 choruses;/my ideas vary and sometimes roll from chorus/to chorus or from halfway through a chorus to halfway into the next."[23] Also, poet Allen Ginsberg has spoken, perhaps somewhat ingenuously, of Kerouac's work exhibiting an authentic "bop prosody." And in the same vein, Ornette Coleman's recent recording, *Free Jazz*, perhaps his most important recording to date, has for its cover a reproduction of a Jackson Pollock painting; Coleman has also stated that he thought his playing had some rapport with Pollock's work.

Even the critical language of the Establishment has been very recently used almost interchangeably when talking about diverse areas of contemporary Western art. Thus it is that a somewhat reactionary *Downbeat* jazz critic can call the music of Ornette Coleman and John Coltrane "anti-jazz," apparently appropriating the term from reactionary critics in other fields—the terms in those other fields being "anti-theater," usually referring to the plays of Eugene Ionesco, Samuel Beckett, etc.; and "anti-painting," usually meaning the work of painters like Jackson Pollock, Willem de Kooning, Franz Kline, etc. It is also these general aesthetic empathies and the flattening of the distinction between the intents of contemporary American art and contemporary jazz that led one middle-brow "literary" magazine to refer to Coleman's music as "abstract" and "beatnik jazz." (But then I have even heard a tieless traveling salesman passing through Kankakee, Illinois, in a sports car, called a beatnik.) In jazz criticism this cross-fertilization between recent jazz and other areas of American art has met with predictable hostility. The same kinds of comment and misguided protest have greeted the music of Coleman and other young musicians that greeted the music of Parker, Gillespie, and

[23] *Mexico City Blues* (New York, Grove Press, 1959).

Monk in the forties. Where the music of Parker, *et al.*, was called in *Downbeat* magazine "ill-advised fanaticism," Coleman's music is called "anti-jazz." But as A. B. Spellman has written in a rebuttal to such criticisms, "What does anti-jazz mean and who are these ofays who've appointed themselves guardians of last year's blues?"

The most contemporary Negro music of the late fifties and sixties has again placed itself outside any mainstream consideration. Also, many musicians hate and misunderstand what Coleman, Taylor, Coltrane, and the others are doing, just as if they were any middle-brow magazine editor who still somehow connects Afro-American music with Kay Kayser. This recent music *is* significant of more "radical" changes and re-evaluations of social and emotional attitudes toward the general environment. But I cannot think that the music itself is a more radical, or an any more illogical, extension of the kinetic philosophy that has informed Negro music since its inception in America. Negro music is *always* radical in the context of formal American culture. What has happened is that there are many more Negroes, jazz musicians and otherwise, who have moved successfully into the featureless syndrome of that culture, who can no longer realize the basic social and emotional philosophy that has *traditionally* informed Afro-American music. (The hard boppers finally were left with a music as cultureless in its emotional propensities as mad Mantovani—a mood music for Negro colleges.) But even this phenomenon seems an old consideration if we can imagine the old secular shouters being reprimanded by the freedmen and new "sisters" for hollering all night "devil music," and songs not found in the "Sankey." It is simply that there is a more widespread fluency among Negroes with the "Sankeys," *i.e.*, more Negroes now have purged themselves of "stink" and color to crawl into those casually sanctified halls of white middle-brow culture. (In one sense, they have traveled a complete circle, stepping

The Modern Scene / • • • / 235

right back into the heart of a paternal and parochial society —from slave to citizen—and have run through blues and discarded it on the way. But they had to, it was one of those ugly reminders that they had once been outside the walls of the city. And there are not too many people in this country, black or white, who'd be willing to admit that.) But perhaps the proportion is being significantly adjusted as even more young Negroes begin to consciously flee the stale purity of the missionaries' legacy. It is a curious balance, though one, as the West finds itself continuously redefining its position in the world and in need of radical reassessment of its relationships to the rest of the world, that will prove of the utmost importance. It is no secret that the West, and most particularly the American system, is in the position now of having to defend its values and ideas against totally hostile systems. The American Negro is being asked to defend the American system as energetically as the American white man. There is no doubt that the middle-class Negro is helping and will continue to help in that defense. But there is perhaps a question mark in the minds of the many poor blacks (which is one explanation for the attraction of such groups as the Black Muslims) and also now in the minds of many young Negro intellectuals. What is it that they are being asked to save? It is a good question, and America had better come up with an answer.

Index / • • • • / 238

Index / • • • • */ 243*